Steve Simmons

Revised Edition

USING
THE VIEW
CAMERA

AMPHOTO
An imprint of Watson-Guptill Publications/New York

ACKNOWLEDGMENTS

No book like this is ever done completely alone. Friends have critiqued drafts of this material, loaned equipment to photograph, contributed images of types of work I have not done, and made suggestions of what should and shouldn't be included in this kind of book. Without their help this book would have been much more difficult to prepare, and it certainly wouldn't have been done as well. To the following friends and colleagues I extend my deepest appreciation: Gary Adams, who contributed the image on page 95; Dick Arentz, who contributed the image on pages 108–109; Morley Baer, who taught me to appreciate what the skilled use of an 8×10 camera can do to architecture and the landscape; Morley and the Sierra Club for allowing me to use the image on page 118 from their book *The Wilder Shore*; DeWitt Bishop, who loaned equipment; Dave Brooks, who contributed two photographs and loaned me his studio on numerous occasions; Dan D'Agostini, who contributed the image on page 115; Jim Galvin, who made my first view camera, critiqued several of the chapters, mounted several of my lenses for my 8×10 camera, loaned me one of his cameras, and contributed the image on page 138; Kirk Gittings, who contributed the image on page 133; Sharmon Goff, who contributed the image on page 126; Gordon Hutchings, who nurtured much of my growth as a photographer, loaned several pieces of camera equipment, allowed me to use his Filter Factor System, contributed greatly to Chapters 4 through 7, and added the image on page 129; Kent Lacin, who contributed the image on page 124; Ray McSavaney, who helped me in my own work and contributed the image on page 141; Penina Meisels, who loaned equipment and contributed the image on page 113; Gary Mingus and Richard Engeman of the Special Collections Library of the University of Washington, who provided information about Edward Curtis and the photograph on page 130; Nikki Pahl, who contributed the image on page 96; John Palmer, who contributed the image on page 132; Pam Roberts and members of the Royal Photographic Society in Bath, England, who allowed me to use the photograph by Frederick Evans on page 128; *Sacramento* magazine, which gave me the assignments that resulted in the photograph on page 100; Timothy Greenfield-Sanders, who contributed the image on page 105; Don Satterlee, who contributed the image on page 125; Janis Tracy, who contributed the image on page 116; and to Ron Wisner, who contributed the image on page 136 and helped me organize my thoughts on Scheimpflug, depth of field, and lens design.

I am also indebted to: Ansel Adams, whose work first inspired me to pick up a camera and to whom we all owe so much; Frederick Evans, Paul Caponigro, Edward Curtis, Carleton Watkins, Edward Weston, Ezra Stoller, Paul Strand, Walker Evans, and the hundreds of other photographers whose work I have admired over the years; and the readers of the first edition of this book and the subscribers of *VIEWCAMERA: The Journal of Large Format Photography*, whose comments over the years have provided much valuable insight that, in turn, helped immensely in the organization of material for this second edition.

Copyright © 1987 Steve Simmons
All rights to the photographs in this book remain in the possession of the individual photographers.

Revised edition published 1992 in New York by AMPHOTO, an imprint of Watson-Guptill Publications, a division of BPI Communications, Inc., 1515 Broadway, New York, NY 10036

Library of Congress Cataloging-in-Publication Number: 87-1105

ISBN 0-8174-6353-4 (pbk.)

All rights reserved. No part of this publication may be reproduced or used in any form or by any means—graphic, electronic, or mechanical, including photocopying, recording, taping, or information storage and retrieval systems—without written permission of the publisher.

Manufactured in Singapore

1 2 3 4 5 6 7 8 / 99 98 97 96 95 94 93 92

Editorial concept by Marisa Bulzone
Edited by Robin Simmen
Designed by Jay Anning
Graphic production by Ellen Greene

CONTENTS

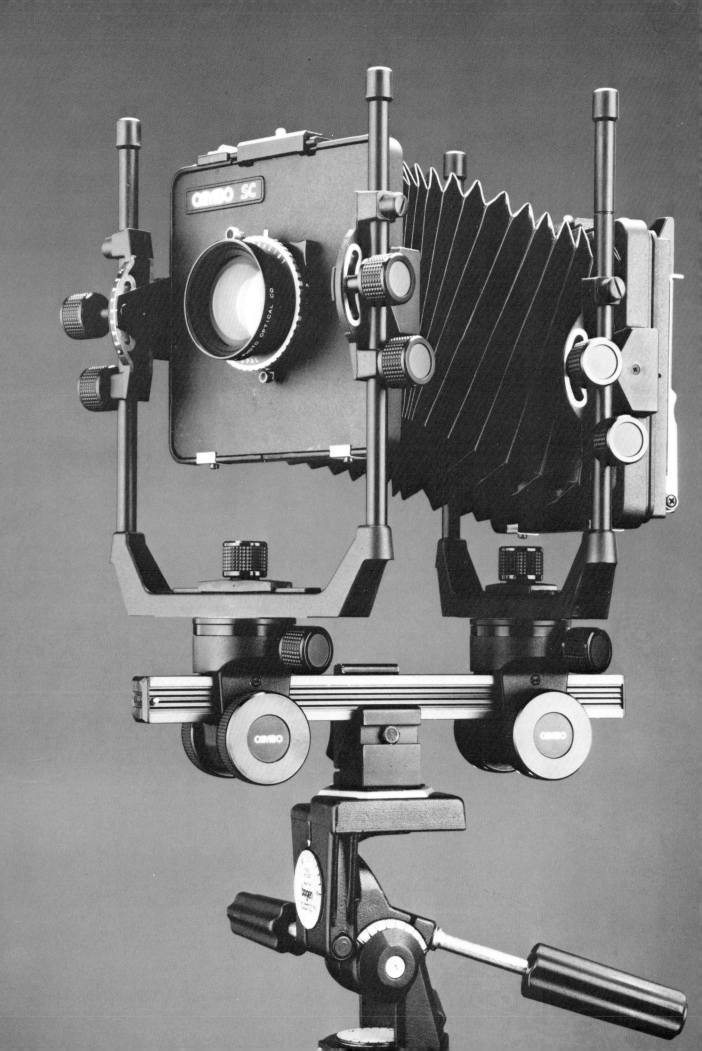

FOREWORD

It's a big step. Moving from a small, hand-held camera to a view camera can be an anxiety-provoking experience. Everything seems new—it is almost like starting over again. The view camera can do so much more, but it won't do anything automatically. Among other things, lenses have to be set manually, each sheet of film has to be loaded into the camera, a tripod is a necessity, you'll have to learn to use a hand-held exposure meter, the image on the groundglass will be upside down and backwards, and the film is developed differently.

I made the transition from shooting with a 35mm camera to using a view camera several years ago. I was living in a small town, and there wasn't anyone around to help guide me through the pitfalls and practical difficulties inherent in making this change in tools and vision. The books I could find didn't seem to address my questions or help solve the problems I encountered.

But I can now say I've made the transition successfully. My growing mastery has evolved through many hours of hard, enjoyable work. I've had the assistance of several other photographers who taught me how to avoid or solve the problems they encountered early in their careers.

I've written this book to help other photographers make the transition as smoothly as possible. Several of the photographers who helped me have contributed their thoughts and suggestions to this book—the information about lens recommendations, suggested camera styles, methods of developing film, and the use and sequence of the camera's adjustments is well-accepted and commonly used by view-camera photographers.

The example photographs in this book are "real" in the sense that they were done on assignment or because of a sincere interest in the subject. This should make them similar to the types of situations you encounter, whether it be with architecture, landscapes, portraiture, or in the studio.

I doubt that you will sit down and read this book from cover to cover. View-camera books are not exciting reading. But I think that as a reference guide to a new way of working and seeing, this book can be a valuable tool to help chart the way through what might seem to be a confusing undertaking.

INTRODUCTION

In this age of small, electronic, 35mm cameras and fast films, why is the ancient view camera undergoing a revival in popularity? Because more and more photographers are discovering that the view camera can create images that are impossible to make with a nonadjustable roll-film camera.

Unlike 35mm and 2¼ cameras, in which the camera back and the lens are always held parallel to each other, the view camera's front (lensboard) and back (film plane) can be adjusted independently of each other. This permits for an extraordinary degree of control over image shape, distortion, and depth of field. An infinite number of view-camera configurations are possible, and they all come from four kinds of movement: the rise and fall, the shift, the tilt, and the swing of the lensboard and the film plane. These four basic adjustments and the larger film format are the view camera's most attractive features.

The view camera has a reputation for demanding a lot of self-discipline from those who use it, so it may not be a useful tool for every photographer. Working with a view camera is a slow, methodical process that requires careful attention and dedication to detail. Eventually, this self-discipline ripens into a real love for the craft involved in creating large-format images.

If you are willing to put in the time and effort required, the view camera will stretch your imagination and your involvement with your subject matter. You will find yourself making wonderful photographs unlike any you've made on a smaller camera because the view camera can take you into photographic regions where a smaller camera is ineffective. And you can say goodbye to the days of shooting rolls and rolls of film hoping for one good image. A view-camera image appears on film just as you've seen it in your mind's eye and in the camera.

Ansel Adams called this process "visualization." Although he is best known for his landscape work, this process of visualizing the picture is the same for all view-camera photographers regardless of their specialization. The studio photographer who works with food, the architectural photographer who works with space and form, the portrait photographer who captures personality, and the landscape photographer who blends light with nature's forms first create their images in their minds.

The film used with the various view-camera formats is much larger than 35mm film. Film for the 2½ × 3¼ camera is five times larger, 4 × 5 film is more than 13 times larger, and 8 × 10 film is fifty-three times larger. The increased film size produces clean, crisp images with a captivating sharpness. The surface textures of such materials as stone, brick, and wood look almost three-dimensional in view-camera prints and transparencies. Large display prints have unblemished clarity and depth because the negative doesn't have to be overenlarged.

When commissioning a photographer to do an assignment, many professional and trade magazines expect to receive a 4 × 5 transparency or one that is larger. Architects, interior designers, art directors for ad agencies, calendar companies, catalog publishers, and corporate agencies are among the other clients needing photographers who work with large, adjustable cameras. The photographer who can complete an assignment with a view camera frequently has an advantage over someone who prefers to work in smaller formats.

In addition to its commercial advantages, the view camera has a long tradition of producing wonderful fine-art photographs in color and black-and-white. It has attracted such masters as Ansel Adams and Edward Weston, who trudged their 8 × 10 cameras up and down mountains, through the desert, and along California's coast; and Minor White, Richard Avedon, Joel Meyerowitz, Paul Caponigro, Morley Baer, Edward Curtis, Frederick Evans, George Tice, Walker Evans, and many others who appreciate the slow, contemplative way of working dictated by the large format.

THE HISTORY OF THE VIEW CAMERA

The view camera is the oldest style of camera. It has been improved since its inception, but its basic design has remained unchanged for over a hundred years.

The concept behind the camera appeared in the tenth century with the invention of the camera obscura (literally, "dark chamber"). The camera obscura was a large dark room with a very small hole at one end or, in other words, a large pinhole camera. An image of something outside the camera was projected into the room through the hole and onto the opposite wall. This device fascinated people for almost eight hundred years before film was invented and was used by artists who traced the projected images to make drawings of landscapes and large European cathedrals.

The invention of light-sensitive materials in the early nineteenth century created a great deal of excitement and inspired a variety of efforts to make the camera lighter, smaller, and easier to use. This in turn led to various improvements in lens design.

The first studio view cameras were constructed of two boxes that fit one inside the other so they could be pushed together and pulled apart for focusing. A lens that was primitive by today's standards was inserted at the end of one box, and a glass plate with a light-sensitive silver emulsion was fitted into the other box. The first exposures sometimes took hours, which restricted potential subjects to architecture, landscapes, and studio still lifes. After several years, film speeds slowly improved, and exposure times

The camera on the left is a 4 × 5 Tachihara Field Camera, and the camera on the right is an early model 4 × 5 Korona field camera.

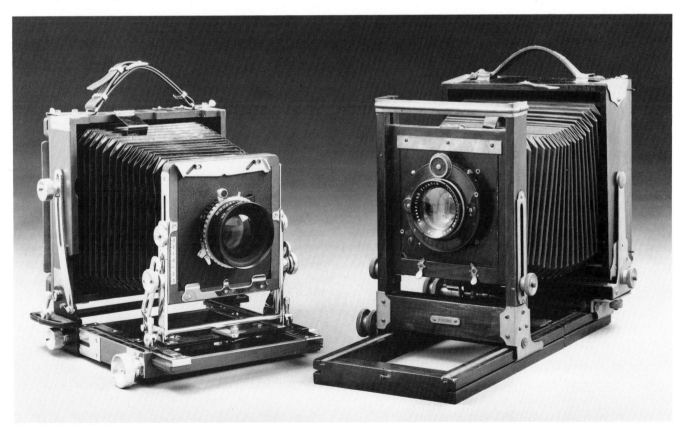

shortened to only a few minutes. Portraits were certainly taxing for the subjects, since they had to sit absolutely motionless for several minutes. Have you ever wondered why these early portraits show people with such stern expressions? Well, it just isn't possible to hold a frozen smile for the long exposures, that were necessary then, so a deadpan look was the only alternative.

The first view cameras came in a variety of sizes. Early models included the 8 × 10, the 4 × 5, the 11 × 14, the 16 × 20, the 6½ × 8½ (referred to as a "plate size"), the 4½ × 5½ (a half-plate camera), the 3¼ × 4¼ (a quarter-plate camera foreshadowing the size of many of the press cameras) the 5 × 7, and the 2¼ × 3¼. There were even 8 × 20 and 12 × 20 sizes called banquet cameras, which were designed to take pictures of large groups of people.

During the 1850s the boxes were gradually replaced by leather bellows that were more flexible and lighter. The first camera with bellows resembled the present-day field camera. The first monorail camera was invented in the early 1850s. As the films available became more sensitive to light, the camera was able to be used outside the studio to record historic events, architecture, landscapes, and people throughout the world. In the United States, Mathew Brady and his group photographed the Civil War, and such photographers as William Henry Jackson, Timothy O'Sullivan, Carleton Watkins, and Edward Curtis documented much of the American West using large bulky view cameras with glass-plate negatives that were prepared in tents and wagons just moments before they were exposed. In Europe, David Octavius Hill, Roger Fenton, and William Henry Fox Talbot (who is generally considered to be the father of photography) used view cameras to record their environments.

Around the turn of the century such photographers as Frederick Evans, Eugène Atget, and Peter Henry Emerson worked in Europe, while Paul Strand, Alfred Stieglitz (who also worked in Germany), and Edward Steichen created wonderful portfolios in the United States.

In addition to most fine-art photography, a lot of work seen in architectural, interior-design, and food magazines and in cookbooks and a great deal of the best scenic work shown in calendars and corporate brochures is done with a camera that some people thought would fade into history when the smaller formats became so popular in the fifties and sixties. Today there is a resurgence of interest in the view camera as photographers again appreciate the advantages of working with a large piece of film as well as the opportunity to take a more contemplative approach to their work.

The most significant improvements in the view camera have been in terms of the films and lenses available for it. Gone are the days when uncoated lenses weren't even corrected for astigmatism. These lenses created the soft images so admired by the pictorialists of the early twentieth century. Also gone are the days when a photographer had to coat a glass-plate negative with light-sensitive emulsion just moments before the exposure was made. Many old-time landscape photographers had to roam the countryside with horse-drawn darkrooms. Not only was the coating process an onerous and odorous task, the fragile glass plates often broke before they could be returned to a home darkroom for printing.

The multilayered coatings now being applied to lenses have improved their sharpness, contrast, and color transmission tremendously. Light is now transmitted more directly to the film plane, rather than being bounced around between the elements. A photograph made by an older, uncoated lens looks soft and a little flat by today's standards because internal flare in the old lens lightly fogged the entire image. Also, the elements of the lens weren't corrected for astigmatism and weren't able to bring the light rays into really sharp focus at the film plane.

Films have improved in terms of their speed, sharpness, and color and tonal rendition. Today's black-and-white films respond evenly to all colors of the spectrum, whereas older films were orthochromatic, or very sensitive to blue light (that is why white skies were so prevalent in nineteenth-century photographs) and undersensitive to red light. Film speeds for black-and-white films now reach ISOs between 320 and 400 as opposed to the film speeds of less than 10 that were the only ones available as recently as the turn of the century. The new, thinner layers of light-sensitive emulsion are capable of producing sharper, fine-grained images. Color films, which were generally unavailable until the mid forties, are being improved all of the time. Their speeds have increased, and their sharpness and grain structure have been steadily refined.

VIEW-CAMERA APPLICATIONS

Historically, to make a large print a large negative was necessary. It was impossible to enlarge the image after it was recorded on film. Smaller cameras became more

popular when enlarging became possible, films became more finely grained, and lenses began producing sharper, cleaner images. These new cameras were used to shoot every conceivable subject matter. The first area of conquest was journalism, as the press photographer quickly took to using the smaller and lighter tool. Weddings, portrait work, sports and action photography, candids of people and places, studio photography, and corporate and industrial work on location, also became popular small-camera subjects.

But over the years a devoted group of photographers who like the view camera's capabilities have remained loyal to it, and there are always clients who demand its use because of its well-deserved reputation for producing wonderful images. About the only applications ill-suited for a view camera are those that involve action or candids of people. Following are some of the most appropriate current applications for view-camera photography.

Photographing Architecture and Interiors. This subject matter poses the greatest demand for the large film format and the adjustment capabilities of the view camera. The necessity of maintaining perfectly vertical lines and the correct perspective, the demand for technical excellence in the finished image, the opportunity for tailoring the exposure and development of each piece of film according to what the scene requires, and the opportunity to work carefully and slowly with a stationary object all call for a view camera.

Another attractive view-camera attribute is that it affords you the opportunity to make multiple exposures on the same piece of film. Many interior views require multiple exposures in order to balance uneven light or various types of light sources within a scene. On many roll film cameras it is difficult to recock the shutter without a risk of advancing the film at the same time. On a view camera there is no mechanical link between the shutter-cocking lever and the film support system.

The view camera also enables you to shoot a scene with large-format Polaroid film, so if your client is attending the shooting session, you can demonstrate exactly how the final image will appear. This gives clients a chance to make suggestions for changes, which helps to assure that the final photograph will please everyone concerned. If strobe lighting is being used, the Polaroid example is essential because the flash's effect can't be judged with the human eye alone.

Architects and interior designers are very

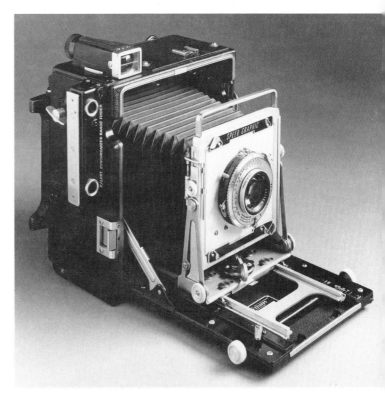

This 1950 model 4 × 5 Speed Graphic was the standard camera for newspaper photographers for many, many years. Even after the introduction of the 35mm camera in the 1930s, many newspaper people continued to use the Speed Graphics that first appeared in the mid 1920s. The Speed Graphic, and its cousin the Crown Graphic, came in three sizes: 2¼ × 3¼, 3¼ × 4¼, and 4 × 5.

These cameras had some front rise and fall movements, but they never functioned or were used as a true view camera. It was possible to focus on the groundglass, but the more common practice was to use the rangefinder apparatus on the side of the camera. Graphmatic film holders carrying six sheets of film were used rather than individual film holders because they allowed the photographer to keep working during a fast-breaking news story. The lens on this camera is a Kodak Ektar 127mm F4.7. This is a slightly wide-angle lens, but it made it easier for the photographer to get all of the action onto the film.

demanding clients, and anything short of technical and esthetic excellence will disappoint them, which will probably cost the errant photographer any more assignments. These clients look at work done with 4 × 5 cameras in architectural and interior-design publications all the time, so they have some concept of what to expect in a photograph. Converging vertical lines, areas that aren't sharp, intrusive telephone poles, empty black shadows, washed out high values, uncorrected light sources (for example, fluorescent lights look blue-green on color film) and obtrusive grain on large display prints are all cardinal sins for any photographer who does this type of work.

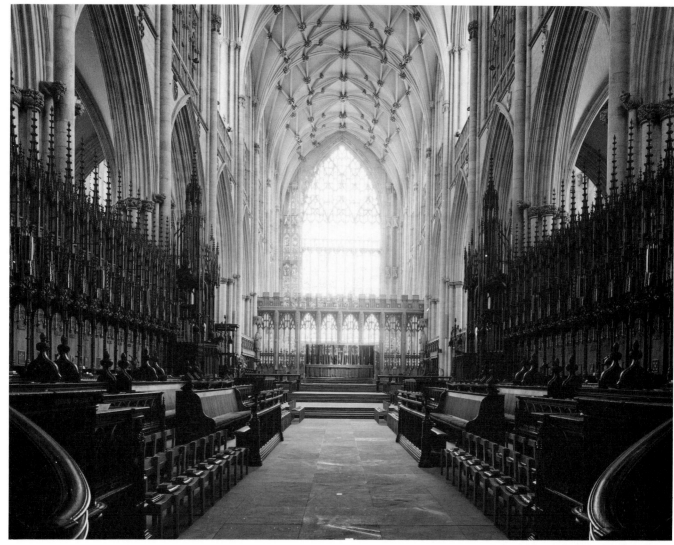

taken by the kind permission of the Dean and Chapter of the

This picture is a good example of the absolutely horizontal and vertical lines that are the hallmarks of architectural photography. York Cathedral is one of the most elegant buildings in Britain. The window pictured here at the east end of the choir and the presbytery is the size of a tennis court and is the largest window in England.

I used a 4 × 5 monorail camera with a 90mm lens to make this photograph. I was standing in a doorway and couldn't back up to use a longer lens. However, in this situation I don't object to the perspective created by the camera position and the wide-angle lens.

This photograph was made early on a June day to capture the morning sun blasting through the window, which created a tremendous range of contrast between the sunlit window and the dark wooden choir stalls. My spot meter gave me a reading of 12 on the window and a 3 on the choir stalls. This nine-stop spread required an N-4 (normal-minus-four) treatment of the film's exposure and development if I wanted to be able to print the negative on my regular grade of paper.

Placing the meter's reading of 3 for the wooden stalls in Zone III meant a very long exposure time with my exposure index of 25. In addition, I felt I needed to use $f/32$ to obtain enough depth of field. The camera movements couldn't help because there were four major planes in the subject—two walls, the floor, and the ceiling—which meant a meter-indicated exposure of 2 minutes. I knew from my testing that I needed to expose the film for 40 minutes to make up for the reciprocity failure that occurs with exposures longer than 1 sec. The advantage of this long-exposure time was that church visitors could wander by at their leisure without registering on the film, as long as they didn't stand anywhere longer than a couple of minutes.

Studio Photography. The view camera is very useful and sometimes essential for such studio subjects as food, illustrations of large and small products, sales catalogs and brochures, and some portraiture, as well as advertising and cover images for local and national magazines. Clients and thousands of publications frequently use photographs of these subjects, and as already mentioned, they expect a 4 × 5 color transparency from the photographer.

One of the advantages to using larger film is the case of retouching a large negative or transparency. Shadow lines can be enhanced or reduced, facial blemishes can be minimized or removed, and the color in different sections of the image can be altered. Also, using large-format Polaroid film is handy in the studio. If the client attends the shooting session, seeing a Polaroid gives the client a chance to make changes before the final image is made on "real" film. As with interior work, using strobe lights in the studio necessitates making test exposures with the Polaroid film to judge the effects of the lighting setup.

The view camera most often used in the studio is the 4 × 5, but the 8 × 10 still has a strong following, and its larger color transparency is a very impressive product to give to the client.

Landscape Photography. Another subject that offers wonderful material for the view camera is the landscape because it is a stationary subject (although the light can sometimes change quickly) that permits a quiet, contemplative approach to the work. Many of the landscape photographs shown in art and photo galleries are made with the view camera, as are many of the scenic images on calendars and posters and in books and magazines.

The primary advantages to shooting the landscape with a view camera are the large negative and the opportunity to tailor the exposure and development of each sheet of film to fit the needs of the scene. The camera's adjustments are useful, too, but other than the tilt movements, they are not as necessary as with architectural work.

The 4 × 5 camera is popular among photographers who work extensively with landscape. The 8 × 10 has a wide following with many landscape specialists, but the drawback is its size and weight. The 5 × 7 camera is still used by a few landscape photographers because of its more rectangular proportions.

Location, Editorial, and Corporate Photography. Under this heading comes a variety of subjects, including

Doing closeup work of small products can be simultaneously challenging, intriguing, and frustrating. This photograph is a typical example of general studio and commercial photography and was reproduced in a gift catalog that encouraged contributions to a local public radio station.

The client wanted an extreme closeup of the objects, and the result was a 1:1 reproduction ratio, making the size of the objects on the groundglass the actual size of the objects. This meant that the bellows had to be extended to twice the length required for an infinity-focus position. I used a 240mm/9.5" apochromatic lens designed for closeup work and a monorail camera with a 19-inch bellows that was completely extended. The only camera adjustment I made was tilting the front to align the depth-of-field area more closely with the subject plane. Doubling the infinity-focus length of the bellows meant a two-stop decrease at every *f*-stop in the amount of light striking the film plane. I determined the exposure for the strobe lighting with Polaroid Type 52 instant black-and-white film. Once I had a good Polaroid, the image was recorded on black-and-white sheet film.

environmental and executive portraiture, industrial and corporate brochure pictures, and large-product illustration work that must be done on location because the subject can't be moved to a studio. Again it is the large film format, the adjustment possibilities, and the opportunity to show the client instant Polaroid prints that make the view camera a desirable tool for this type of photographic work.

In many ways the view camera may be the easiest camera to use. It doesn't force you to do anything, but it allows you to do everything. Once you've learned the basics of the camera's operation and the principles behind them, using the view camera will become second nature. After all, in the end it is simply a tool waiting for you to exercise your creative judgment.

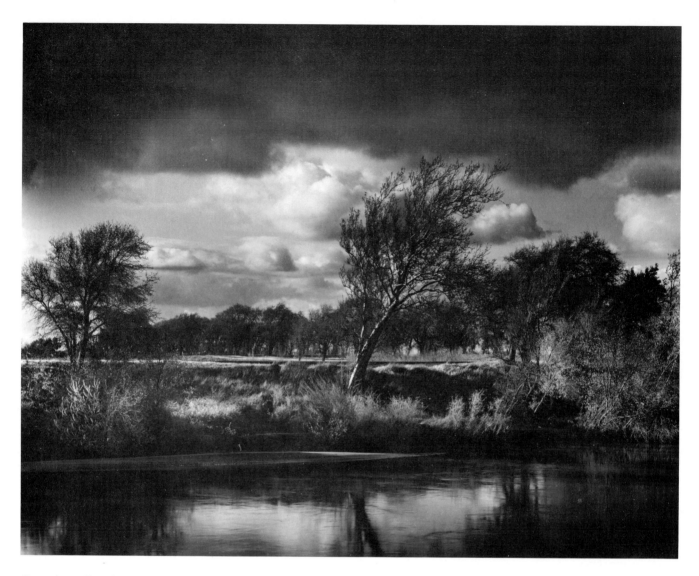

Steamboat Slough was once a part of the main steamboat route between Sacramento and San Francisco. Now it is a quiet slough that drains water off the Sacramento River and then rejoins the main channel several miles downriver. This photograph was taken as part of a larger series done about the Sacramento River Delta for a history book published in 1982. The picture happened because I was at the right place at the right time under the right conditions, all precursors for effective landscape photography. I had been driving for a couple of fruitless hours before I suddenly came upon this scene. I was so excited I almost fell in the water trying to make this photograph before sunset.

The camera was an old 8 × 10 Calumet C-1 with a 480mm/18½" Kodak Anastigmat lens mounted in an Acme #4 shutter. Finding the right camera position was a fairly simple process. I wanted the bent tree to be slightly off center and flanked by trees on either side. I raised the front standard slightly, putting the horizon line just below the center of the frame.

To make this image I used a light orange #16 filter. I generally stay away from the red filters because they create a harsher feeling. I metered through the filter and determined that the darkest area where I wanted to hold detail was on the lower left of the scene, just above the water line. The brightest area was the tree trunk lit directly by the sun. At the time I made this photograph, I didn't know about Gordon Hutchings' filter-factor system (see page 28) so I didn't give the negative an additional one stop of exposure as recommended for a #16 filter. Consequently, the negative is a little thin and somewhat difficult to print. However, it is one of my favorite pictures from the series, so I do the best I can to print it well.

Printing it was much easier after I toned the negative according to the recommendations in the most recent edition of *The Negative* by Ansel Adams. Toning the negative adds density and contrast to the high values, but it doesn't really help the low values. Consequently, the negative remains a little thin and difficult to print.

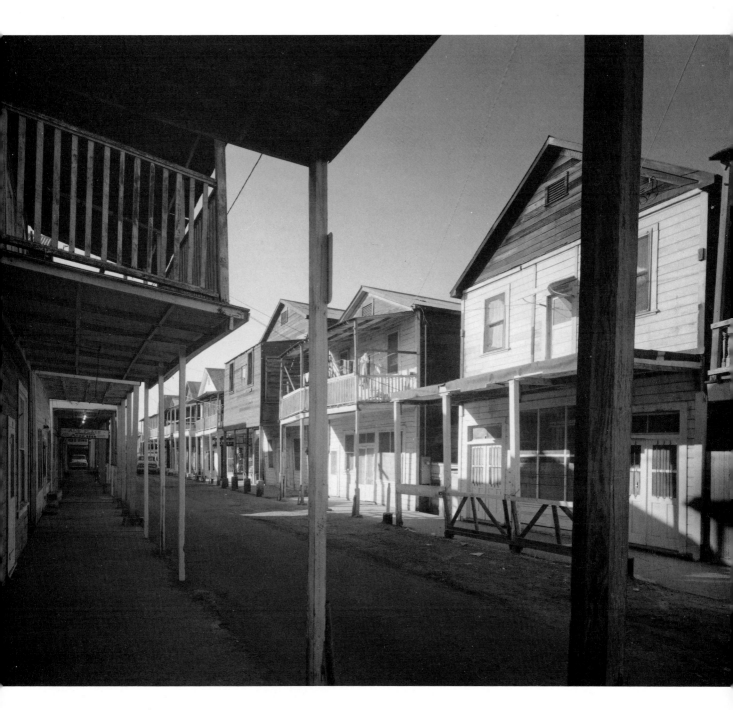

Locke is an historic Chinese town located in the Sacramento River Delta region in northern California. When I took this photograph in October 1980, Locke was inhabited by a few elderly Chinese residents. Since then, the population has increased, and the area is attracting a large number of tourists each year. This photograph has an editorial purpose; my intent was to bring the viewer into the street in order to develop a pedestrian's vantage point on life in this historic town.

I made the picture with an 8 × 10 Calumet camera and a Cooke 165mm/6¼" F6.8 wide-angle lens. (This lens is roughly equivalent to a 24mm lens on a 35mm camera.) I used a small amount of front rise and Kodak Super-XX Film with a medium-yellow #12 filter to make this photograph. One of the problems I encountered is that the Cooke lens doesn't produce a truly sharp negative. A contact print looks okay, but the image begins to soften noticeably with any enlargement. It is difficult to find wide-angle lenses in this focal length for an 8 × 10 camera, but there are some other choices available (see chapter 3).

Chapter One

VIEW-CAMERA DESIGN

The basic design of the view camera has changed very little over the last one hundred years. Actually, there was very little to change. The camera is simply a light-tight box with a lens mounted on one side. The lens projects an image onto a piece of light-sensitive material on the opposite side of the box. Unlike some 35mm cameras, view cameras are completely manually operated and lack such features as automatic focusing, built-in exposure meters, and motor winders. Instead, a view camera always has the following standard features:

Monorail or flat bed. The bottom of the camera consists of either a rail or a flat bed that attaches to the tripod. The rail or bed is the foundation of the rest of the camera and all its movements.

Front standard. This frame holds the lensboard in place. On most cameras the front standard can be moved along the rail or bed and in some cases this movement is used for focusing.

Lens. This glass focuses the rays of light reflected from the scene back onto the groundglass and the film plane at the rear of the camera. The lens is mounted into a lensboard that fits into the front standard of the camera. These lensboards are interchangeable so lenses of different focal lengths can be used on the camera.

Rear standard. This is similar to the front standard, except the back standard carries the groundglass. The rear standard can be moved along the bed or rail of most cameras, and in some cases this movement is used to focus the image on the groundglass. A film holder is inserted on the rear standard when the exposure is made.

Groundglass. The groundglass is a frosted piece of glass that captures the image projected back from the lens. The image will appear upside down and reversed from right to left because there is no reflex-mirror system in a view camera to orient the scene correctly for the viewer.

Bellows. This accordian-pleated, light-tight tube connects the front and rear standards. It is flexible, allowing the standards to be moved closer together and farther apart for focusing and for using various camera adjustments and lenses.

Cable release. This long thin device attaches to the shutter and allows it to be triggered without jarring or touching the camera.

Although the view camera's basic design remains unchanged, there have been several refinements in it over the years. Some of the high-tech studio cameras

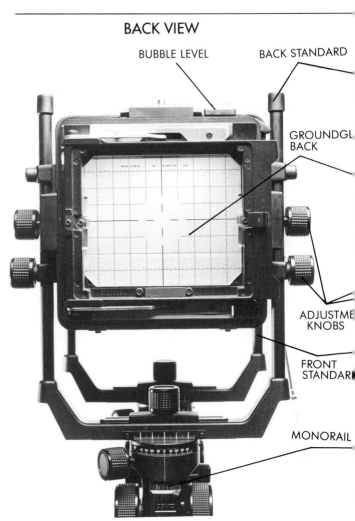

BACK VIEW

BUBBLE LEVEL

BACK STANDARD

GROUNDGL
BACK

ADJUSTME
KNOBS

FRONT
STANDAR

MONORAIL

Modern cameras and their applications

have sophisticated focusing devices that determine the amount of tilt and swing and the f-stop settings necessary for a given situation; electronic shutters are now used on some cameras in studio situations; and exposure meters that slip into the camera back have also been invented. Some camera systems include interchangeable bellows, film backs of different sizes, monorails of different lengths, and such accessories as lens shades, roll-film backs, viewing hoods, and special filter holders. Whether or not the precision and interchangeability is worth the additional expense is a decision each photographer has to make.

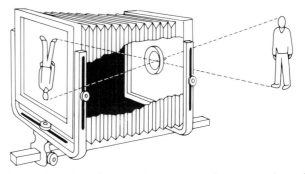

Light rays from the subject on the right enter the camera through the lens (seen through the cutaway bellows) and are projected upside down onto the film plane on the left.

SIDE VIEW FRONT VIEW

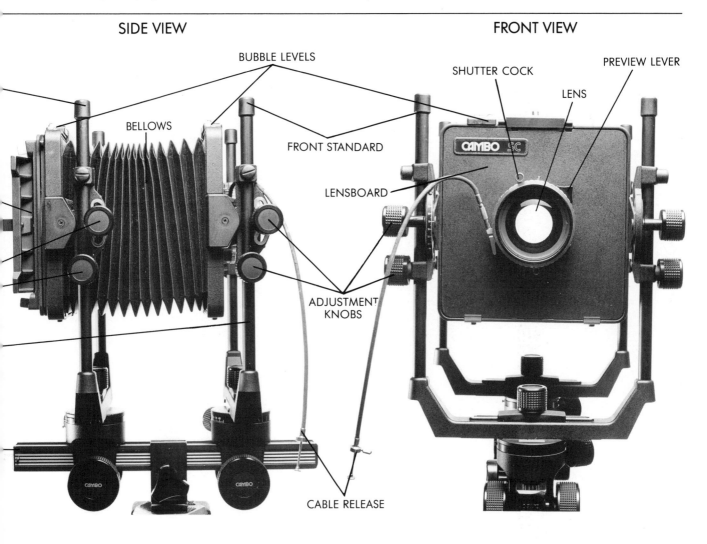

BUBBLE LEVELS

BELLOWS

FRONT STANDARD

SHUTTER COCK

PREVIEW LEVER

LENS

LENSBOARD

CAMBO SC

ADJUSTMENT KNOBS

CABLE RELEASE

There are two primary styles of view cameras: the monorail camera and the flat bed, or field, camera. They are generally used for different kinds of subjects, but there is some overlap in their applications. The wide-angle camera and the closeup camera represent further refinements of the monorail design, and the press camera is a variation of the field camera.

The Monorail Camera. On a monorail camera, the front and rear standards are supported by a long monorail that attaches to the tripod. Each standard can be moved independently along the rail, although focusing is generally done by moving the rear standard. Because of its design, the monorail camera offers more adjustment possibilities than a field camera.

The monorail camera is generally used in studio work for food photography and for large and small product work. On location, it is used for some corporate and industrial work and possibly some environmental portraiture. This style of view camera can be modified to do scientific and close-up photography or serious architectural and interior work. The monorail camera can also be used to photograph landscapes, although landscapes can be shot without using many of the adjustments available on this type of camera.

A good monorail camera should be capable of the following adjustments:

- front rise and fall
- front shift
- front swing
- back swing
- front tilt
- back tilt

The Sinar F1 camera on the left is a monorail view camera. The Tachihara model on the right is a field, or flat-bed, camera.

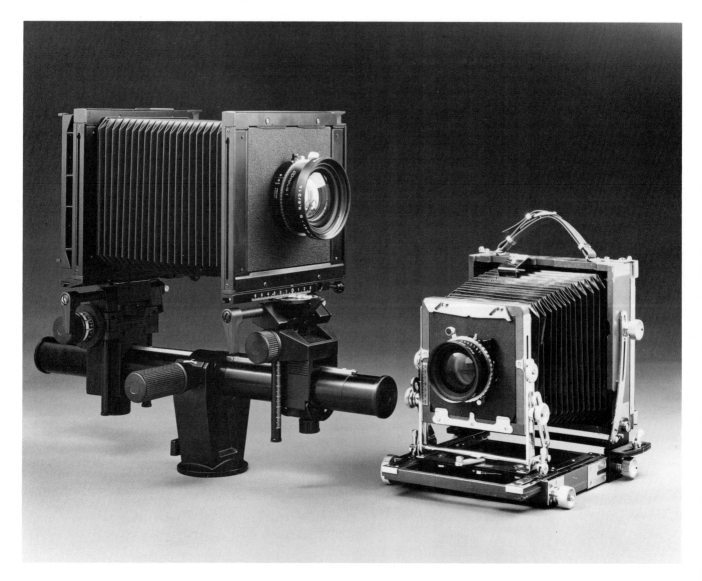

Additional movements that are recommended, but not essential, are:

· back rise and fall · back shift

The monorail camera generally comes with a rail and a bellows that measure 2.5 to 3 times the length of the normal lens for its size. For example, a 2¼ × 3¼ view camera (with a 100mm/4″ normal lens) will have a monorail and bellows that are 9-to-14-inches long; a 4 × 5 camera (with a 150mm/6″ normal lens) will have a monorail and bellows that are 16-to-20-inches long; and an 8 × 10 camera (with a 300mm/12″ normal lens) will have a monorail and bellows that are 24-to-36-inches long. The longer rails make it possible to do closeup work having a 1:1 reproduction ratio. Doing this kind of life-size reproduction requires you to double your bellows from its original length at the infinity focus of whatever lens you are using.

The Closeup Camera. It is relatively easy to do closeup work with a monorail camera. There is no need to add any closeup attachments, and the bellows extension generally makes 1:1 reproductions possible with a normal lens or a slightly longer-than-normal lens.

For extreme closeup work and larger than life-size reproductions, it is possible to add another section of bellows onto some cameras. The additional extension provides much more flexibility when working with extreme magnification.

Depending on the camera, it may be necessary to add another standard in the middle of the camera where the two bellows sections are joined. This will prevent their inevitable sagging that will otherwise block off part of the image. Where another standard is not necessary, some type of monorail-support device is generally used.

Extreme closeup work presents a variety of problems, but all of them can be solved and are discussed later. For instance, increasing the bellows extension requires additional exposure. There are some lenses that are more suited to closeup and flat-copy work than others. These lenses are called 'apochromatic' lenses (see page 39).

The Wide-Angle Camera. Photographing architecture and interiors often means using a monorail camera modified to work with wide-angle lenses. These shorter lenses, in addition to the extreme camera adjustments required by this kind of work, almost necessitate a more flexible bellows than the traditional, accordion configuration. The short wide-angle bellows, sometimes called a "bag" bellows, allows almost

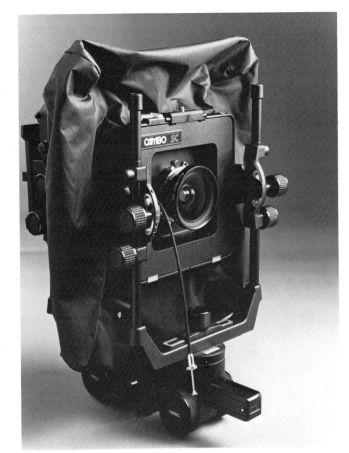

This wide-angle 4 × 5 camera is just a variation on the basic monorail camera design. This 90mm lens is mounted on a special recessed lensboard made for wide-angle purposes. The shorter bag bellows doesn't restrict the adjustments the way a regular bellows would, and the short monorail won't interfere with the foreground area. Some cameras don't require a recessed lensboard for wide-angle lenses.

unrestricted camera movements. A normal bellows is too long for wide-angle work and will restrict the use of the camera's adjustments.

The wide-angle camera usually includes a shorter-than-normal monorail. The standard monorail is so long that it may protrude into the subject area captured by a very wide lens (this would happen, for example, when using a 75mm lens on a 4 × 5 camera). Sometimes the short monorail is a section from a longer rail, and sometimes it is a totally separate piece, depending on the camera system.

A third oft-needed modification to create a wide-angle camera is a recessed lensboard. This special lensboard is indented 1-1¼ inches from the normal lensboard plane, which thrusts the lens back into the body of the camera. The front and rear standards can thus be somewhat farther apart when the camera is focused on the scene. The extra distance allows for a little more flexibility in using the camera's adjustments.

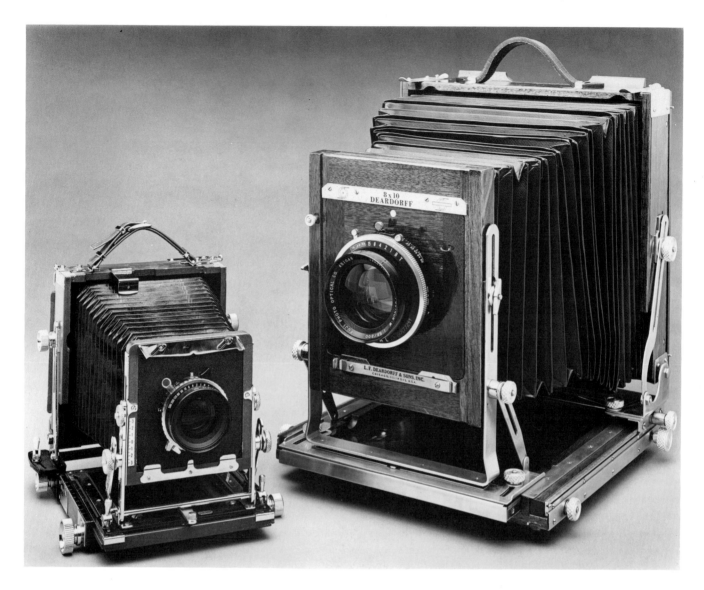

The Field Camera. The field camera, sometimes referred to as a flat-bed camera, has a very different design than the monorail camera. The front and rear standards on the field camera are supported by a flat bottom that sits on top of the tripod. On the 4 × 5 field camera the back standard is generally fixed to the camera bed, so you focus by moving the front standard. On the 8 × 10 field camera both the front and rear standards can be moved along the bed, and focusing can be done with either one. The field camera's design has some advantages and some disadvantages that need to be taken into account when choosing a camera.

The field camera's primary advantage is that it is more portable than a monorail camera. The field camera folds into a neat box that can be dropped into a backpack or a camera bag. Traveling and doing location work (environmental portraiture, landscape work, some architectural photography) is much easier with

Here are a 4 × 5 field camera on the left and an 8 × 10 field camera on the right.

this camera because it is usually more lightweight than a monorail counterpart of the same size.

The big disadvantage to using the field camera is that its design restricts the number of adjustments that it can incorporate. Serious studio work, commercial architectural work, and some environmental portraiture are difficult, if not impossible, to do with a field camera. But it is very good for general landscape work, and it can be useful for some architectural photography and for occasional studio applications.

There are many new and used field cameras on the market. Some have more adjustment capabilities than others. For straight-forward portrait work, the adjustments are not very important, but if the camera is going to be used for general landscape photography, documenting historic architecture, or minimal studio

applications, the following adjustments are absolutely essential:

- front tilt
- back tilt
- front swing
- back swing

Any camera that didn't have all of these movements would become very limiting as a photographer became more familiar with the uses and advantages of a view camera. Additional movements that would prove helpful are:

- front rise and fall
- front shift

Rarely will a field camera have any back rise and fall or any back shift adjustments. However, it is possible to compensate for this by using the other adjustments.

Field cameras generally have a bellows extension capability of approximately twice the length required for a normal lens. For example, a 4 × 5 field camera will have 12-to-14 inches of bellows, and an 8 × 10 camera will have 24-to-30 inches of bellows.

The Press Camera. The press camera is not really a fully functioning view camera. It does offer the possibility of using individual sheets of film, but it only has very limited adjustments and is capable of only a very short bellows extension (usually less than twice the length of a normal lens).

The advantage of using a press camera lies primarily in its portability—it folds up like a field camera. The press camera can be used for straight-forward portraiture and some very limited landscape work. Its limited adjustments make it impractical for any studio, architectural, or interior applications, and its limited bellows make close-up work almost impossible.

CAMERA SIZES

During the last twenty-five years or so, the number of different–sized view cameras has decreased. The 4 × 5 is now the most popular size, but the 8 × 10 is used extensively in studio work and by a few landscape and fine-art photographers. Other current sizes include the 2¼ × 3¼ (6 × 9 cm) and the 5 × 7. There are still a few 11 × 14, 16 × 20 and 12 × 20 cameras around, but these larger sizes are something of a novelty and are only used by a few individuals.

The 4 × 5 View Camera. Because of its popularity, there is a great deal of new and used equipment readily available for the 4 × 5, including many brands and styles of monorail and field cameras, as well as a good

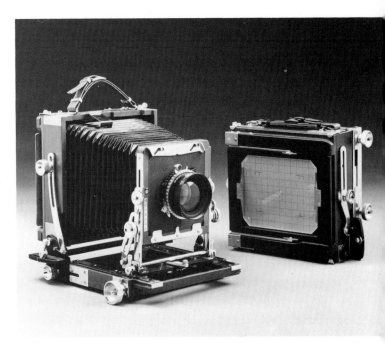

The 4 × 5 field camera can fold up neatly into a small package for backpacking or travel.

selection of lenses, film holders, films, and camera cases.

The advantage of working with a 4 × 5 camera is that the negative or transparency is large enough to produce a very clean and crisp image, but the camera itself is small enough for easy transport. In fact, a handy 4 × 5 system is not much heavier than a 2¼-roll-film camera system, and the 4 × 5 system provides special camera adjustments and individual exposure and processing of each negative or transparency.

The 4 × 5 color transparency has become the industry standard for most architectural and interior-design magazines, catalogs, and sales brochures. Food photography for magazines and books, and editorial photography for calendars and various scenic publications are also usually done with 4 × 5 cameras. Many current, fine-art, landscape photographers use 4 × 5 cameras because of the large negative.

A basic 4 × 5 system—one camera body, three film holders, a tripod, one lens, some filters, and a hand-held exposure meter—will cost from a few hundred dollars to several thousand dollars, depending on the brand, style, and degree of sophistication. Some of the more simple monorail cameras and some of the field cameras will be less expensive than the precision-engineered studio cameras. But with careful and dedicated use, all 4 × 5 camera styles can produce wonderful images.

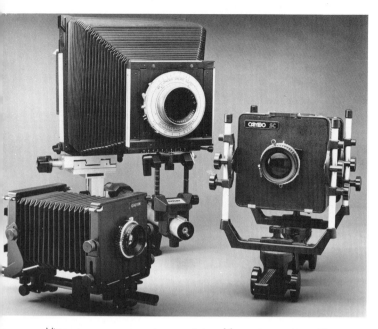

View cameras come in a variety of formats, or sizes. These monorail cameras are clockwise from the lower left: 2¼ × 3¼, 8 × 10 and 4 × 5.

One possible disadvantage to using a 4 × 5 camera is the need for a 4 × 5 enlarger and a longer enlarging lens. The smaller enlargers that are designed for 35mm and 120 film will not handle the 4 × 5 negative. Enlargers for 4 × 5 negatives are plentiful and are available on the new and used market. A good, used enlarger will cost a few hundred dollars, while the new precision models may cost four to five times as much.

The 8 × 10 View Camera. This camera size has held its own over the years, in spite of the increased competition from the smaller, lighter, more portable 4 × 5 and 2¼ × 3¼ view cameras. One of the most appealing characteristics of the 8 × 10 camera is the convenience of looking through such a large ground glass (200 percent larger than the one on a 4 × 5 camera) and seeing such an expansive image.

The 8 × 10 camera is primarily used in the studio, where it is producing some of the best still lifes, food shots, and large and small product work. Outside the studio, the 8 × 10 camera is used to shoot scenic calendar images, some of today's most beautiful black-and-white and color landscape images, and some architectural work. There are even photographers who insist on taking their 8 × 10 cameras on overseas assignments and excursions because of their dedication to the camera and how it helps them interpret their chosen subject matter (usually architecture and the landscape).

A beginning 8 × 10 system should include one body, one lens, three film holders, a sturdy tripod, an exposure meter, and a dark cloth. The cost of this beginning outfit will range from several hundred to several thousand dollars, depending on the choice of new or used equipment and the brand and style of the camera. New and used equipment can be found without too much effort, and there is a good variety of 8 × 10 film available. However, it will be more expensive to get started with an 8 × 10 camera than with either a 4 × 5 or a 2¼ × 3¼ camera.

The advantage to using the 8 × 10 camera is that it produces a negative that is large enough to be contact printed, so an enlarger is not really necessary. A well-made print contacted from an 8 × 10 negative has exceptional sharpness, a rich tonal scale, a smooth transition from one tone to another, and a feeling of real texture in the material (for example, grass, wood siding, bricks and masonry) recorded on the film. This tactile quality cannot be duplicated by enlarging a smaller image. At the same time, there is a total lack of grain or any intrusion by other photographic by-products. When enlarged, the negative will still produce a richness and depth that are unmatched. An 8 × 10 color transparency displays colors, depth, and brilliance that are truly impressive.

One drawback to working with an 8 × 10 negative is the difficulty in enlarging it. There are vertical enlargers (the type you're probably using now with your smaller negatives) available for the 8 × 10 format, but they tend to be very large and heavy. They take up a lot of space in the darkroom, and they can be quite expensive. The older used models may require a new, modern light source, such as an 8 × 10 or 12 × 12 cold light.

If you are a real do-it-yourselfer, you can buy an old camera and convert it into a horizontal enlarger. The back of the camera will need to be remodeled for a new light source—a 12 × 12 cold light is best—and a negative carrier will have to be fashioned to insert into the side of the camera/enlarger. The enlarger can be used as a portable unit that is put away when not in use, or if you have a large darkroom, you can build a mobile table that glides across the floor on tracks in order to move the enlarger back and forth, facilitating prints of various sizes.

The other difficulties posed by using the 8 × 10 camera are its size and weight. It is four times larger than a 4 × 5 camera and is considerably heavier. Its film holders are also four times larger, its tripod must be heavier and sturdier, its dark cloth must be larger, and its film will cost two-to-four times as much as a 4 × 5 film.

The 2¼ × 3¼ View Camera. With the improvements made in lenses and films, it is possible to do better work with smaller cameras. The 2¼ × 3¼ view camera is a nice compromise, offering the advantages of the view camera's adjustments while keeping the size, weight, and expense of the system to a minimum.

The primary advantage to using the 2¼ × 3¼ camera is that it offers you a choice between using individual sheets of film or 120 roll film. In fact, 120 roll film seems to be the better way to go because there is a wider selection of it readily available. The slower-speed 120 roll films are very sharp and fine grained. By using two or more roll-film holders, you can still obtain the advantages offered by the Zone System of exposure and development control. And it is actually possible to choose the roll-film size you want with this size camera. Roll-film holders come in the 2¼ × 3¼ size (6 × 9 cm), the 2¼ × 2¾ size (6 × 7 cm), and 2¼-square (6 × 6 cm). Kodak's recent introduction of its well-respected Kodachrome transparency film in the 120 size will probably create some additional interest in the 2¼ × 3¼ view cameras.

Another advantage to this camera is the fact that using it may not require the purchase of another enlarger. Any enlarger that will handle 120 roll film will take a negative produced by this camera. These enlargers are plentiful on the new and used market. Therefore, the expense of setting up a 2¼ × 3¼ view-camera system may be less than that of setting up a 4 × 5 system. The smaller bodies may cost a little less, but the lenses (most of which are also used on a 4 × 5), a tripod, an additional exposure meter, and a dark cloth will cost the same. Lenses for the 2¼ × 3¼ camera are readily available on the new and used market. Used camera bodies are a little more difficult to find, but they can be located without too much effort.

Unusual sizes. The 5 × 7 view camera was once very popular, but its use seems to be fading. This is unfortunate because the 5 × 7 format has many advantages. The range of lenses is the widest of any format; anything from wide-angle lenses for the 4 × 5 format to long lenses for the 8 × 10 format can be used on a 5 × 7 camera. The 5 × 7 format seems to be more popular among photographers in Europe than in the United States. Film, film holders, and cameras for this format are scarce. The 5 × 7 camera's

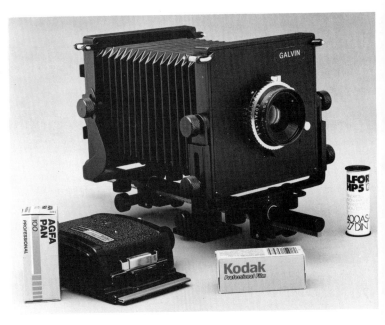

The 2¼ × 3¼ view camera's advantage over other view-camera formats is that it uses 120 roll film. The roll-film holder in the lower left corner of this picture is a Singer Graflex model.

proportions are slightly more rectangular than either the 4 × 5 or 8 × 10 format, which makes the 5 × 7 camera popular among some landscape photographers. In addition, the fact that the camera is smaller than the 8 × 10, but the film area is almost twice the size of 4 × 5 film (35″ sq. as opposed to 20″ sq.), makes this camera size an attractive compromise. The 5 × 7 negative can be contact printed, although most users of this format want to make enlargements. A used 5 × 7 enlarger is only slightly higher priced than a used 4 × 5 model.

The 11 × 14 and 16 × 20 cameras are still used but usually only for landscape photography. Both these cameras are very large and bulky: an 11 × 14 camera is twice the size of an 8 × 10, and the 16 × 20 is four times larger than the 8 × 20 and is very difficult to handle. Film for these cameras is quite expensive, depth of field is a real problem, and transporting these large cameras is a major task. However, the idea of being able to do an 11 × 14 or 16 × 20 contact print is enough to motivate some people to undertake the extra cost and labor.

These banquet formats, especially the 12 × 20 size, are undergoing a minor resurgence in popularity, and film and equipment are becoming easier to obtain.

Chapter Two

ACCESSORY EQUIPMENT

In addition to the camera body there are other pieces of equipment needed to make photographs with a view camera. These essential accessories include the lens, (see chapter 3), a tripod, an exposure meter, a dark cloth, and film holders. Other useful accessories that are not immediately necessary, but can be added later, include filters, a lens shade, a Polaroid film holder, a Fresnel screen for the ground glass, and various focusing hoods.

THE TRIPOD

Having a tripod for your view camera is a necessity because practically speaking, the view camera cannot be hand-held. The size, sturdiness, and weight of the ideal tripod will vary with the size of the camera. In any case, you will probably need one that is larger than the tripod you currently use for a small, hand-held camera.

There are many tripods available that function quite well with view cameras. Some large tripods have legs that can be tightened into place in a variety of positions, from almost straight down to almost horizontal. These tripods can accommodate different kinds of floors or uneven surfaces, and some can even butt a raised leg up against a wall if necessary. They will also spread their legs so wide that the camera can be placed almost flat on the ground. The center columns of some tripods can be removed and reinserted from the bottom to facilitate very low camera positions.

Smaller tripods are available for location and landscape work, but it is important to remember that the view camera is larger than a small camera. The view camera is commonly used for long and multiple exposures, and these require a tripod capable of holding the camera absolutely rigid, even when the shutter is re-cocked or when the lens is left open for several minutes.

The best-designed tripod head is the three-way type that enables you to make horizontal and vertical corrections when leveling the camera. The three-way

tripod head also permits horizontal rotation for aiming the camera in the desired direction. For studio work there are large, sturdy, studio stands that can be used in place of a tripod. These have wheels that lock into place once the desired camera position is obtained.

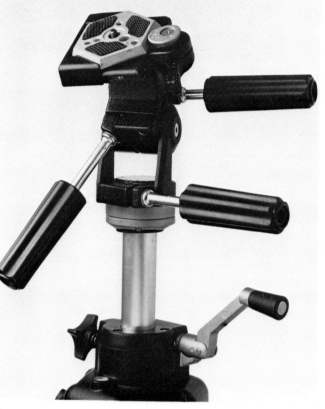

This three-way tripod head has several functions that are valuable in view-camera photography. The handle on the left is used to aim the camera up or down from front to rear. Its primary use is to level the camera so that vertical lines in the subject appear vertical on the groundglass and on the film. The upper right-hand handle is used to orient the camera left to right. This handle can also be used to level the camera if the tripod is on an irregular or tilted surface. The middle handle on the right is used to pan the camera and aim it in the desired direction.

The crank handle on this model is used to raise and lower the center column. Moving the center column is usually discouraged unless additional height is absolutely necessary. The raised extension cannot hold the camera as securely as when the camera rests directly on the top of the tripod.

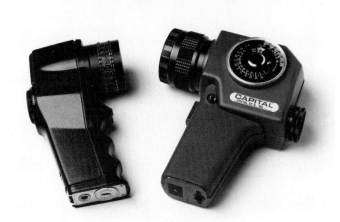

Shown here are two types of 1-degree spot meters used by many view-camera photographers. The meter on the right is made by Capital, and the meter on the left is made by Pentax. Spot meters allow the user to measure the light reflected from small sections of the scene, rather than measuring the general light level by taking an average reading. Spot-meter readings are useful for making the Zone-System exposure and development calculations that allow you to exercise control over the contrast of the scene.

THE EXPOSURE METER

A view camera doesn't have an internal exposure meter. It is possible to purchase a meter that will fit into the film-plane area, but most view camera photographers use a hand-held 1-degree spot meter.

The spot meter lets the photographer carefully measure the reflected light from several different high-value, mid-value, and shadow areas in the scene in order to determine the best exposure and development procedure (see chapter 8). This opportunity to calculate and determine the film's exposure and development before it is exposed is one of the primary advantages of working with the view camera and its individual sheets of film (or multiple roll-film backs for the 2¼ × 3¼ size).

For studio and location photography done with strobe lights, there are several flash meters available. Some of these will only read the amount of strobe light, and some will be sensitive to the strobe light combined with any available ambient light in a scene. For architectural and location work, the latter type of flash meter is better, even though it may be slightly more expensive.

FILM HOLDERS

Sheet-film holders come in two varieties: the standard holder and the Grafmatic holder. The standard holder accepts two sheets of film, one on each side. Once the first sheet is exposed, the holder is turned over, and the second sheet is ready to go. Standard sheet-film holders for 4 × 5 and 8 × 10 film sizes are readily available on the new and used market. Film holders for other sizes may or may not be available new, but they are available on the used market. In either case, unusual-size holders are more difficult to find.

The Grafmatic holder contains six sheets of film in a device that is not much larger than one regular film holder. In a Grafmatic holder, the sheets of film are inserted into six septums. These are placed inside a smaller box that is then pushed inside a larger container. After the holder is inserted into the camera, the dark slide is pulled out, and a set of internal springs pushes all six septums in the inside box forward. The dark slide is pushed back in behind the front sheet, sealing off the five rear sheets of film. After the first sheet is exposed, the inside box is pulled out and the exposed sheet of film is automatically pushed to the rear of the larger container. Then the inside box is pushed back into the larger container, and the holder can be removed from the camera.

A small "x" near the handle indicates when all six sheets have been exposed. The "x" is on a dial with numbers 1 through 6 that indicate how many sheets of unexposed film remain in the holder. You can write with a pencil on the white card on the side of the holder to indicate what type of film is inside and what the appropriate development should be for each negative or transparency.

The advantage of the Grafmatic holder is that it is smaller than three standard holders. Unfortunately, it is also considerably more expensive than three standard holders. New and used Grafmatic holders are available for 4 × 5 formats, and used Grafmatics are available for 2¼ × 3¼ sheet film. Grafmatic holders aren't made in larger sizes.

Roll-film holders (for 120 roll film) are available on the new and used market for the 2¼ × 3¼ cameras and the 4 × 5 cameras. Many 2¼ × 3¼ view camera photographers use roll film as their standard material and carry two or more film backs so they can work with the Zone System or accommodate both black-and-white and color film.

The Polaroid back is necessary if you intend to use any of the instant Polaroid films. For studio or location work with strobe lights, using Polaroid film to check the exposure is almost essential because the flash is so quick it is difficult to predict its results simply by looking at the scene.

These are standard 4 × 5 sheet-film holders. The dark slide on each holder has a handle that is silver on one side (to indicate that the holder contains unexposed film), and black on the other (to indicate exposed film inside the holder).

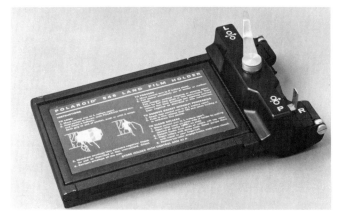

This 4 × 5 Polaroid film holder can handle several Polaroid films: Type 52, a 400 speed film that produces a black-and-white print; Type 54, a 100 speed black-and-white print film; Type 55 that produces both a black-and-white negative and print; Type 59 that produces a color print; and Polachrome, 4 × 5 transparency film that must be color-lab processed.

This is a roll-film holder for a 4 × 5 camera. The numbers 6 × 9 on the left-hand side of the holder means that the image size is 2¼ × 3¼ (6 × 9 cm). Roll-film holders also come in 2¼ × 2¾ (6 × 7 cm), 2¼-square (6 × 6 cm), and 2¼ × 4¼ (6 × 12 cm).

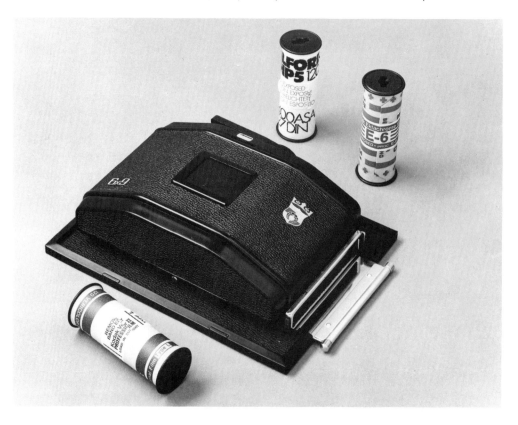

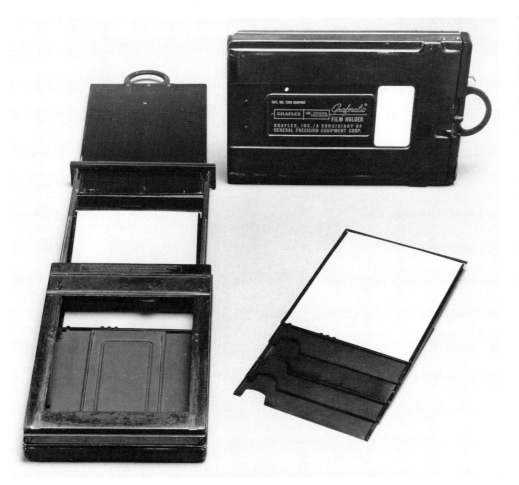

This picture gives you a good look at the Grafmatic sheet-film holder. It can hold up to six sheets of film, as compared with a standard film holder that only holds two sheets at a time. On the lower right, you can see five of the six septums that are loaded into a small box that is then placed inside the larger container shown on the left. The sideview of the top film holder shows a small dial near the handle, and the number 1 showing on the dial means that the first sheet of film is waiting to be exposed. You can write the name of the film and the development time you intend to use for it on the white card on the side of the film holder.

FILTERS

Most view-camera photographers use universal gelatin filters, rather than glass screw-in filters. View-camera lenses have a variety of diameters that require different filter sizes, which makes buying a set of screw-in filters impractical. There are universal filter holders available as optional accessories for many view cameras. When not in use, a gelatin filter should be removed from the filter holder and stored in a safe place. Gelatin filters are very thin and optically flat, and if well-cared for, they should last several years.

A beginning filter set for black-and-white photography should include the following filters:

#8—medium yellow

#12—dark yellow (also called a "minus blue")

#16—medium orange

#21—light red

#25—medium red

Additional filters that may be added later include:

#44A—cyan (usually called a "minus red," it is used with panchromatic film to simulate the effect achieved with orthochromatic film)

#11—light yellow-green

#29—deep red

Gelatin filters with a diameter of 3 inches can be used by most lenses for the 2¼ × 3¼ and 4 × 5 cameras and on some 8 × 10 camera lenses. However, some lenses for the 8 × 10 camera will require a 4-inch filter.

Filter manufacturers give recommendations for increasing the exposure of black-and-white film for any given filter. These recommendations are supplied as filter "factors" such as 1.5 (which means a half stop more exposure), 2 (one stop more exposure), 3 (one-and-a-half stops more exposure), 4 (two stops more exposure) and 8 (three stops more exposure). The manufacturer's data doesn't take into consideration the

altitude (there is more blue light in the mountains), the time of day (the color temperature is warmer early and late in the day), or the color of the subject.

A more reasonable approach is to think about the color temperature of the available light and the color of the objects in the scene because light and subject color interact, influencing the amount of light reflected into the camera. Consequently, the best practice is to measure the light reflected from the brightest areas, the middle tones, and the shadow areas. Take your light reading through the filter by holding it in front of the exposure meter. When you've obtained your range of values and have decided on your exposure and development, then add a filter factor from the accompanying box to the exposure you've determined from the meter reading.

Filters for color work are quite different from those needed for black-and-white photography. For general outdoor work with negative film, a polarizer is all that is really needed. Any warming or cooling of the image can be done in the printing.

If you plan to use color transparency film to do outdoor portraits, architectural, or landscape work, or if you want to do indoor portrait work with flash, then buying a set of the #81–series filters is recommended. These filters combine yellow and magenta tones, and they will warm up the sometimes cool cast of Ektachrome film.

If you will be doing interior, corporate, or industrial work on location, then a set of color compensating filters (available in densities designated 05, 10, 20, 30, 40, and 50), in the yellow, magenta, and red series,

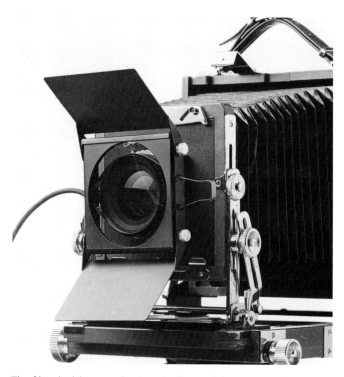

The filter holder attached to the front of this camera has an expandable spring clip that fits over any lens up to 3 inches in diameter. This type of filter holder secures 3-inch gel filters over the lens. The barn doors above and below it protect the lens from extraneous light that might cause flare. I prefer to remove the doors and place the holder inside the camera body by attaching it to the rear element of the lens. If I need to shield the lens, I either use a lens shade or my hand.

and a #85B filter will be necessary. Interior settings frequently have fluorescent, metal-halide, mercury-vapor, or sodium-vapor lights, which produce varying degrees of off-color blue and blue-green on color film. Some of this can be removed from negative film during the printing process. However, if you are working with transparency film, you must use color compensating filters when you shoot to balance the color of the light for the type of color film you're using.

THE LENS SHADE

The lens should always be shaded from any direct light hitting its glass surface, unless the light source is part of the scene. Otherwise, such problems as ghost images of the light, the shape of the diaphragm, or general flare will appear on the film. When you are working outdoors, the lens can be shaded from the sun by your hand. This simple solution is possible because the sun comes from only one direction, and your exposure will be relatively short.

When working in the studio or at an interior location, you might position several lights just outside the image

FILTER FACTORS FOR BLACK-AND-WHITE FILM

FILTER	EXPOSURE INCREASE
#8	no increase necessary
#11	one stop
#12	no increase necessary
#16	one stop
#21	one stop
#25	two stops
#29	two stops
#44A	one stop

This filter-factor system was developed by Gordon Hutchings of Orangevale, California. He designed it to make sure that a scene's shadow areas receive enough exposure and aren't thin and underexposed on the negative. Shadow areas are primarily illuminated by blue light, and blue light is most severely curtailed by yellow, orange, and red filters.

frame, which could cause some flare to degrade the image. In this situation the best practice is to attach a compendium-bellows lens shade to the front of your camera. These lens shades look much like a camera bellows and are flexible, so they can be manipulated to protect the lens from light even when severe adjustments are utilized. The lens shade can be adjusted to be longer or shorter, depending on the focal length of the lens being used. Some lens shades have built-in filter holders, but others require a separate filter holder.

THE FRESNEL LENS

In some situations, depending on the maximum lens aperture, the image on the groundglass can be quite dark and hard to see. It is particularly difficult to see the corners of an image when a wide-angle lens is on the camera, especially if you are working inside a dark building with a lens that has a wide-open f-stop of $f/8$ or smaller. To solve this problem, you can attach a Fresnel lens or an intense screen to the back of the camera where the grandglass is located.

The Fresnel lens is a piece of plastic with concentric circles cut into one surface, which is mounted just in front of the groundglass. The pattern of circles scatters some of the most intense light hitting the center of the image to its corners. This evens out the brightness on the groundglass and brightens the overall image by 50 to 100 percent (the equivalent of one-half to one full stop). An alternative to the Fresnel lens is a replacement groundglass called an intense screen. The intense screen has a smoother finish than the standard groundglass and increases the brightness of the image by about two stops.

THE DARK CLOTH

The image projected on the groundglass of a view camera is difficult to examine without using a large, dark, focusing cloth draped over the back of the camera to eliminate any extraneous light.

Although a dark cloth can be purchased, the best and cheapest way to obtain one is to make it yourself. Buy a large piece of heavy, black cloth from any fabric store, fold it over double, and sew the corners together. Some photographers sew a piece of white cloth on one side, which serves two purposes: Outdoors on a hot day, the white cloth keeps the temperature under the dark cloth several degrees cooler (on a cold day you can wear the cloth as a cloak with the black side out for warmth), and white also

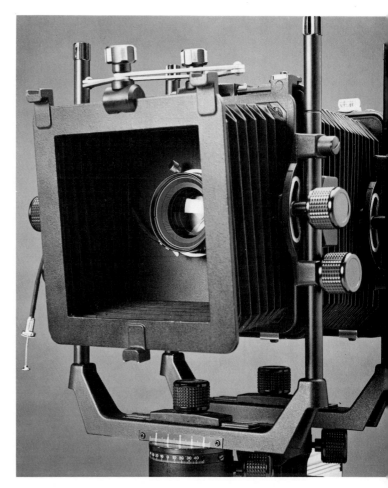

This compendium-bellows lens shade is attached to the front of the camera to protect the image from lens flare. When using a lens shade, it is important to examine the corners of the groundglass to make sure the shade isn't covering parts of the image.

makes you more visible, which is important if you do much architectural work along busy streets.

The size the cloth should be will vary with the size of the camera. A good cloth for the $2\frac{1}{4} \times 3\frac{1}{4}$ view camera will measure approximately 2×3 feet. The 4×5 camera's cloth should be roughly 3×4 feet. An 8×10 camera's dark cloth should be almost 4×5 feet.

THE VIEWING HOOD

The viewing hood, or reflex back, can be used instead of the dark cloth. Some viewing hoods are designed for straightforward viewing. Others are made with internal mirrors for right-angle viewing and for looking down or at right angles into the camera. Some viewing hoods turn the image right-side up, while others leave it upside down. These hoods are only available for a few view cameras and mostly only for the monorail style.

Chapter Three

LENSES AND SHUTTERS

Lenses for view cameras come in many shapes, sizes, and focal lengths. Some of them are designed to be used on view cameras of various sizes, while others are limited to only one format. View-camera lenses are sometimes given focal-length designations in both millimeters and inches: for example, a 210mm/8″ lens. This happens more frequently with the longer focal-length lenses and with many of the older lenses made for 8 × 10 cameras.

If you have been using a smaller camera and have found a favorite focal-length lens, you can find a comparable lens for a view camera on the accompanying chart. The chart shows the comparable focal lengths for different film sizes. The angle of view measures the spread between two imaginary lines running from the center of a lens back to the diagonal corners of the film area in a camera. This angle determines how much of a scene can be projected onto the film plane. All lenses fall into one of three, informal, angle-of-view categories: normal, wide-angle (wider-than-normal), and long (longer-than-normal). There are other important factors involved in selecting a lens for a view camera that should be carefully considered before you buy a lens.

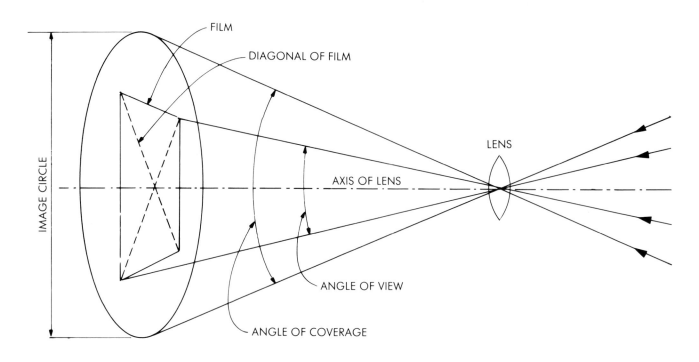

The angle of view is the amount of a scene covered by the lens, as described by two imaginary lines running from the lens to the diagonal corners of the film area. The image circle projected by the lens must be larger than the film area in order for the entire surface of the film to be exposed.

Their designs and purposes

KEEPING THE SAME ANGLE OF VIEW ACROSS DIFFERENT FORMATS

	35mm	2¼ × 3¼	4 × 5	8 × 10	ANGLE OF VIEW
Wide-Angle Lenses				125mm	92°
	20mm	47mm	65mm		81–84°
	24mm	58mm	75mm	165mm	74–79°
	28mm	65mm	90mm	180mm	65–68°
			105mm	210mm/8″	61–62°
	35mm	75mm	125mm	250mm/10″	53–55°
Normal Lenses			135mm		48–51°
	50mm	90mm	150mm/6″	300mm/12″	40–44°
		100mm	180mm/7″	375mm/15″	37–38°
Long Lenses		135mm	210mm/8″	450mm/18″	31–35°
	85mm	150mm	240mm/9″	480mm/19″	24–29°
	105mm	210mm/8″	300mm/12″	600mm/24″	19–22°
			375mm/15″	750mm/30″	18°
	135mm	250mm/10″	450mm/18″		15°

This chart compares lenses with similar angles of view across different camera formats. The angle of view determines how much of a scene is recorded on film. These comparisons cannot be exact due to the different proportions of the film formats; for instance, the 35mm and the 2¼″ × 3¼″ negatives are 50-percent longer than they are wide, whereas the 4 × 5, and the 8 × 10 negatives are only 25-percent longer than they are wide. However, the comparisons are useful as a place to begin thinking about how to find appropriate lenses for the kind of work you do.

Size of the Image Circle. Before you buy a lens, you'll first need to know the size of the image circle of good definition that is projected by that lens onto the film plane when the camera bellows is extended to focus that lens at infinity. If you are using a 150mm/6″ lens on a 4 × 5 camera, focusing at infinity will mean there is a 6-inch distance between the optical center of the lens (usually located at the point of the diaphragm) and the plane of the film. An object is considered to be at an infinity position when its distance from the camera is 200 times the focal length of the lens. For a 150mm/6″ lens, this distance is 100 feet.

In order to use a lens on a view camera, the lens must project an image circle that is at least as large as the diagonal measurement of the film. For example, the diagonal measurement of a piece of 4 × 5 film is 6.4 inches or 162mm. Consequently, any lens used on a 4 × 5 camera for general outdoor work must project an image circle with a diameter of at least 6.4 inches or 162mm. When the bellows is extended for closer-than-infinity work, there will be more distance between the

optical center of the lens and the plane of the film, and the image circle will expand. A piece of film that is 8 × 10 requires an image circle of at least 13 inches or 325mm. A 2¼ × 2¾ negative requires an image circle of 3 inches or 80mm, and a 2¼ × 3¼ negative requires an image circle of 4 inches or 100mm.

The size of the image circle depends on the angle of coverage, which is formed by two imaginary lines running from the lens out to opposite sides of the image circle. The angle of coverage is determined by the design of a lens. Lenses that are shorter-than-normal for a given format are designed to have a wider angle of coverage because the shorter lens requires less distance to project the image circle back to the film plane. Lenses that are long don't need such a wide angle of coverage because they have a greater lens-to-film-plane distance. Consequently, normal and slightly long lenses are less expensive to produce and purchase.

In reality, the size of the image circle should be considerably larger than the size of the film area. Many

When the film area is perfectly centered on a larger image circle, as when the camera's adjustments are in neutral, all of the film will be exposed. However, when the film area is shifted, for example, by using the back-fall movement shown here, some of the film may fall outside of the image circle and not be exposed. This is called vignetting.

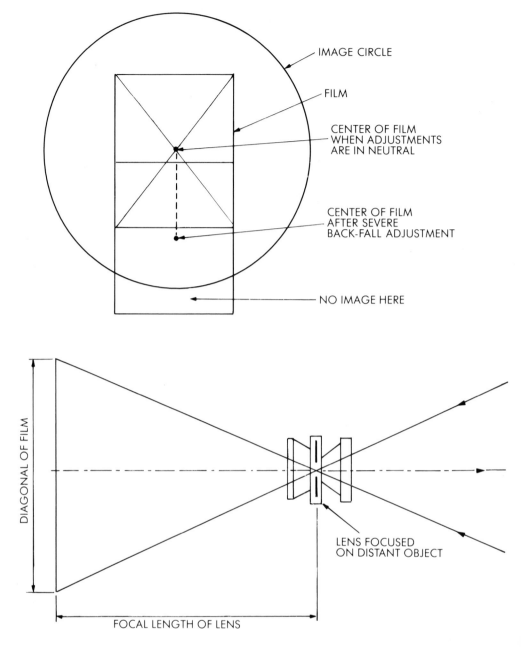

IMAGE CIRCLE

FILM

CENTER OF FILM WHEN ADJUSTMENTS ARE IN NEUTRAL

CENTER OF FILM AFTER SEVERE BACK-FALL ADJUSTMENT

NO IMAGE HERE

This diagram of a normal lens shows that its focal length is approximately equal to the diagonal of the film area.

DIAGONAL OF FILM

LENS FOCUSED ON DISTANT OBJECT

FOCAL LENGTH OF LENS

of the adjustments permitted by the view camera move the center of the projected image away from the center of the film area. If you move the film area outside the image circle, one or more of the image's corners will be cut off, leaving a dark area on the groundglass. This is called vignetting, and it happens when part of the film doesn't receive any exposure at all. An image circle that is larger than the minimum size required lets the lens and film plane move around independently of each other, so you can make adjustments in the depth of field, the shape of the image, and what is actually seen by the camera.

For example, a 90mm F/8 lens for a 4 × 5 camera may have an angle of coverage of 100 degrees, which results in an image circle of 216mm when the lens is focused at infinity. A 90mm F/5.6 lens has an angle of coverage of 105 degrees, which will produce an image circle of 236mm. A 150mm F/5.6 lens has an angle of coverage of only 76 degrees, but its greater lens-to-film-plane distance (6 inches, as opposed to 3¾ inches for the 90mm lenses) will produce an image circle of 224mm. A 210mm F/5.6 lens has an angle of coverage of 71 degrees, but its 8¼-inch projection distance will produce an image circle of 300mm. Because all of these image circles exceed the 4 × 5 film's diagonal measurement of 162mm, all of these lenses will permit full use of the view camera's adjustment capabilities. None of these lenses could be used on an 8 × 10 camera, because it requires an image circle with a diameter of at least 325mm. However, a 240mm lens

with a 70-degree angle of coverage and an image circle of 336mm could function as a longer-than-normal lens on a 4 × 5 camera, as well as being a wider-than-normal lens on an 8 × 10 camera.

Image-circle measurements are generally taken at an aperture of f/22. At wider apertures the image circle is slightly smaller, and at smaller apertures the image circle is slightly larger. The size of the image circle expands when the lens-to-film-plane distance is increased by focusing on objects at closer-than-infinity distances.

The newer lenses will generally produce sharp, clean images that extend to the limits of their projected circles. These lenses have been designed to cut off their image circles before any chromatic aberration (a failure to focus at least two of the primary colors at the same point) occurs, which can be a problem at the outer limits. The older lenses often don't have this built-in cut-off point, making their images soft and fuzzy around the edges of their image circles.

Lens manufacturers all publish information sheets that give image-circle sizes for their new lenses, and this information should be available from any store selling view-camera equipment. If you buy a used lens, try it on your camera first, and use the camera's movements to determine if the lens has enough coverage.

THE NORMAL LENS

The definition of a normal lens is one in which the focal length of the lens is equal to the diagonal measurement of the film area. The normal lens has an angle of view that places objects in a scene in approximately the same near-to-far size relationships and proportions as those perceived by the naked eye.

Remember that the larger your film format is, the longer your lens has to be to maintain a normal view. The normal lens for a 35mm camera is 50mm, whereas a 2¼ × 3¼ view camera requires an 80mm to 100mm lens, a 4 × 5 camera requires a 150mm/6″ lens, and an 8 × 10 camera requires a 300mm/12″ lens. If you stood in precisely the same spot and took a photograph with each of these cameras and its normal lens, the size, shape, and placement of the objects in the image would look very similar. Actually, there is some variation in what is considered a normal lens with each camera size. A normal lens for a 2¼ × 3¼ view camera can be anything between 80mm and 105mm. For a 4 × 5 camera a normal lens will range between 135mm and 180mm, and for an 8 × 10 camera, anything between 270mm and 360mm could be considered normal.

The 150mm focal-length lens is considered to be the normal lens for a 4 × 5 camera, although in practice any lens between 135mm and 180mm can be used as a normal lens. The 150mm lens on a 4 × 5 camera is comparable to a 50mm lens on a 35mm camera.

The Fujinon 150mm F5.6 lens pictured at the bottom is a good normal lens. It has an adequate angle of coverage for all the various camera movements. Lenses of this focal length are also available from Schneider, Rodenstock, Nikkor, and Caltar.

The Fujinon 180mm F5.6 lens at the top is on the long side of normal but can work nicely in a well-designed and carefully planned group of lenses. I have a 125mm and a 240mm lens, so the 180mm normal lens was a better choice for me than a 150mm lens.

The Schneider 180mm lens included on the left can be converted to a 315mm lens by unscrewing the front lens element from the shutter and just using the rear elements. There is a second f-stop scale in green letters to indicate the f-stops for the longer configuration. Typically, the optical quality of this type of lens suffers noticeably when converted; the high-value separation in the image deteriorates considerably. However, when completely assembled, these lenses can be quite good.

On the right is a Tele-Xenar 180mm lens. Although its focal length falls into the normal-lens category, this lens' covering power is very limited, and the lens won't function as a normal lens on a 4 × 5 camera. Its primary distinction is that it is a true "telephoto" lens. Consequently, it uses only 5- to 7-inches of bellows rather than the 7- to 10-inches usually required by a 180mm lens. This lens can function as a longer lens for a 2¼ × 2¼ view camera.

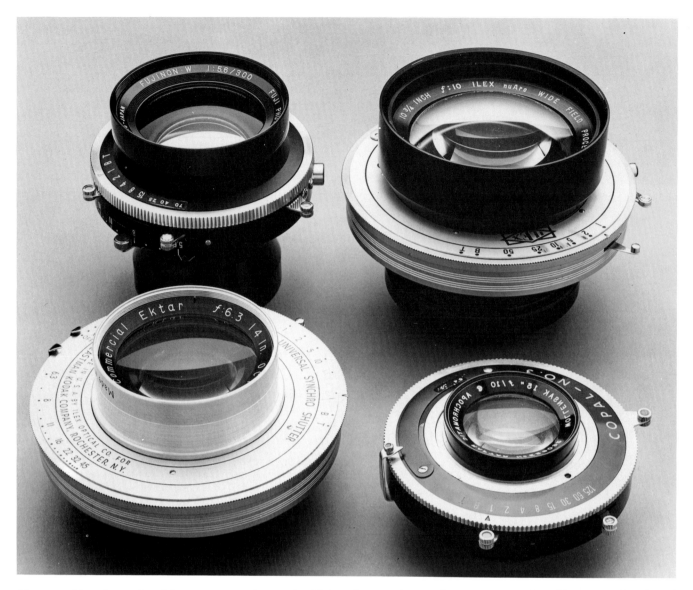

The normal lens for an 8 × 10 camera is anything in the 10¾- to 15-inch (270- to 375mm) range. In addition to the 300mm lenses used as long lenses for a 4 × 5 camera, there is a good variety of new and used lenses available in the normal focal-length range for the 8 × 10 view camera.

The larger lens pictured in this group is a Process 270mm/10¾" lens made by Ilex for the graphic arts industry. This lens, pictured top right, was purchased in a barrel and then mounted into a No. 5 shutter. It is an unusual lens—very few of these lenses were made—but it functions beautifully on the 8 × 10 camera. Its f-stop range is from f/5.6 to f/45, and its angle of coverage allows for a great deal of front and rear adjustments. A similar focal-length lens was made under the name of Goerz Dagor, and it has an f-stop range from f/6.8 to f/64.

The top left lens is a 300mm/12" F5.6 model made by Fujinon. Similar lenses are made by Nikkor, Schneider, Rodenstock, and Caltar. These lenses permit considerable front and rear adjustments on an 8 × 10 camera. Good used 300mm lenses include any lens called "Dagor" and the Voitlander Apo-Skopar.

The lens on the bottom left is a Kodak 360mm-14" Commercial Ektar lens made several years ago. This focal length is used as a normal lens by many 8 × 10 photographers. As a used lens, the Commercial Ektar is well respected. Its f-stop range is f/6.8 to f/45. New 360mm lenses are made by Nikkor, Rodenstock, Caltar, Fujinon, and Schneider. Other good used lenses are the Goerz Dagor 14" lens and any lens called an "Artar"; the latter are Dagor-type lenses with apochromatic corrections.

The fourth lens in this group is a Wollensak Apo-Raptar 375mm/15" F10 lens that was purchased in a barrel and then mounted into a shutter. This lens was also originally made for the graphic arts industry, but it has functioned for several years as a normal lens on my 8 × 10 camera and occasionally as a long lens on my 4 × 5 monorail camera.

THE WIDE-ANGLE LENS

The definition of a wide-angle lens is one that has a focal length shorter than the diagonal measurement of the film area, so the wide-angle lens has a greater-than-normal angle of view. Wide-angle lenses come in a variety of styles with different angles of view, but they all exaggerate the size of a scene's foreground objects while minimizing the size of the objects in the background. When used creatively, a wide-angle lens produces some very interesting effects.

Wide-angle lenses are frequently used to photograph architectural subjects. These lenses are also used in landscape photography and occasionally in portraiture when some of the subject's environment needs to be included in the image. In certain situations, wide-angle lenses are good for table-top or small-product illustration work, and they may be helpful in industrial photography where a large production area needs to be shown.

The moderate, wide-angle category is the place to start when buying a wide-angle lens. For example, the 90mm lens for a 4 × 5 camera is a very popular and useful lens, and it is the favorite of many architectural photographers. It can also be applied in landscape work, and possibly in some environmental portraiture and industrial photography.

Severe wide-angle lenses, such as the 75mm, 65mm, and 58mm lenses on 4 × 5 cameras, are special-application lenses that aren't used by most view-camera photographers. The 65mm and 58mm lenses will allow for only minimal movements—less than the 75mm focal length—on 4 × 5 cameras but their extremely wide view can be useful. Photographers who specialize in working with architects and interior designers frequently use the 75mm lens because it is the widest lens that doesn't produce an image with a distorted, semi-fish-eye appearance. With the moderate-to-severe wide-angle lenses, consider using the recessed lensboard described in chapter 1, if one is available for your camera.

The widest lenses that can be used at infinity with the 8 × 10 format are the Nikon 120mm lens and the new version of the Schneider 121 Super Angulon with a 110-degree angle of coverage. Both lenses will cover the 8 × 10 film area at an infinity-focus position. Using these superwide lenses for 8 × 10 formats is comparable to using a 15mm lens on a 35mm camera.

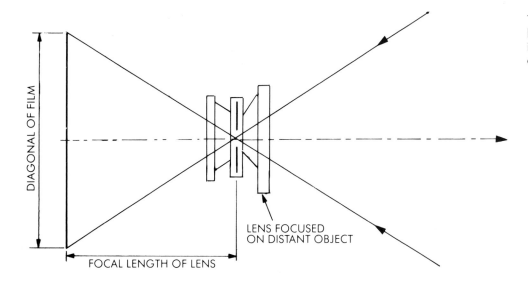

This diagram of a wide-angle lens shows that its focal length is not as long as the diagonal of the film area.

DIAGONAL OF FILM

LENS FOCUSED ON DISTANT OBJECT

FOCAL LENGTH OF LENS

WIDE-ANGLE LENSES FOR VARIOUS FORMATS

	35mm	2¼ × 3¼	4 × 5	8 × 10
gentle lenses	35mm	75mm	125mm	240–250mm
moderate lenses	28mm	65mm	90mm	210mm
extreme lenses	20–24mm	47–58mm	65–75mm	125–160mm

Some wide-angle lenses provide a greater angle of view than other, more gentle, wide-angle focal lengths. The most extreme wide-angle lenses produce the greatest degree of distortion, which is most noticeable with objects closest to the camera.

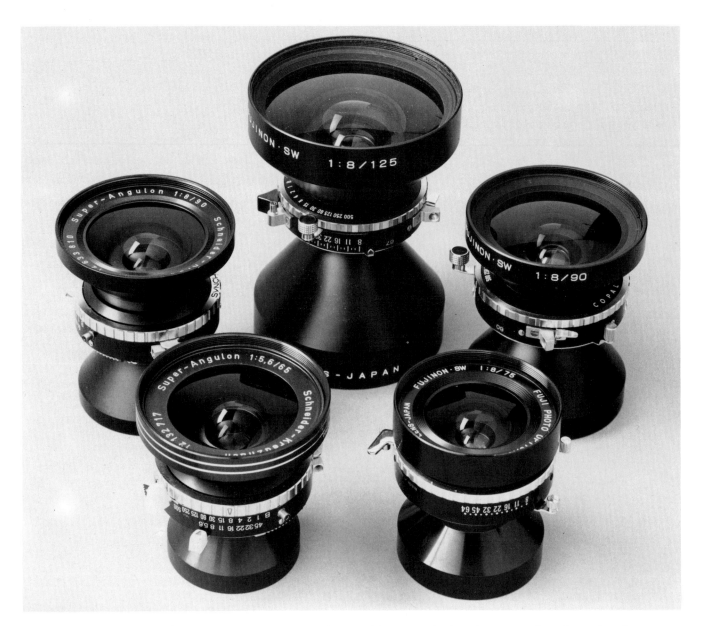

Illustrated here are some wide-angle lenses frequently used on 4 × 5 cameras. The top left Schneider Super Angulon 90mm lens was the standard wide-angle lens for many many years. This focal length is comparable to a 28mm lens on a 35mm camera. Over the last few years several new and very good brand name 90mm lenses have appeared; these new lenses are made by Fujinon (one is shown top right), Rodenstock, Nikkor, and Caltar. The 90mm lens generally comes in two styles: an F8 model with an image circle of approximately 216mm, and models with maximum apertures between f4.5 and f5.6 that produce slightly larger image circles. The latter models also produce slightly brighter images on the groundglass and allow for a little more camera adjustment, but they are approximately 75-percent more expensive than an F8 model.

The Super Angulon 65mm lens on the bottom left is very wide for a 4 × 5 camera. It is about the equivalent of a 20mm lens on a 35mm camera. The image circle is just large enough to cover the 4 × 5 negative and allows only minimal camera adjustments. The primary use for a 65mm lens on a 4 × 5 camera is in interior photography and studio and table-top work when the near-to-far relationships between various objects need to be greatly exaggerated. Using a recessed lensboard is essential with this focal-length lens.

The Fujinon 75mm F8 lens on the bottom right is no longer available new, but it is a very good lens. This focal length is comparable to a 24mm lens on a 35mm camera. The new Fujinon 75mm lens is an f5.6 model with slightly more covering power. Lenses of this focal length with maximum apertures of f8 and f5.6 are available from Schneider, Nikkor, Rodenstock, and Caltar. All these 75mm lenses enable some adjustments on a 4 × 5 camera. The 75mm lens also requires the use of a recessed lensboard.

The Fujinon 125mm F8 lens at the top is a gentle, wide-angle lens for the 4 × 5 camera and is comparable to a 35mm lens on a 35mm camera. A similar wide-angle lens for 4 × 5 is available from Schneider. These lenses have tremendous covering power and will work on 8 × 10 cameras if used without any adjustments. Smaller 125mm lenses are also available from Fujinon and Nikkor, but they have only minimal covering power and are more suitable for a field camera or a 2¼ × 3¼ camera.

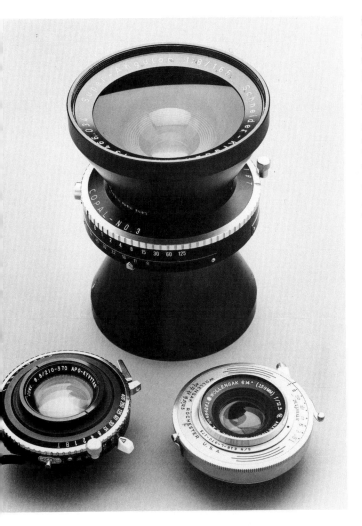

Good, functional wide-angle lenses for an 8 × 10 camera are somewhat difficult to find. It takes a very large angle of coverage to facilitate any camera adjustments, and the optics must be able to produce a clean, crisp image on the film plane.

A lens in the 150mm to 165mm range is comparable to a 24mm lens on a 35mm camera. The Schneider Super Angulon 165mm lens, shown on top, and the Wollensak 159mm/6¼" F12.5 Yellow-Dot lens, shown on the right, are both in this category. The Wollensak is only available as a used lens, but the Super Angulon can be purchased new or used. Their difference in size is due to the difference between f8 and f12.5 in light-gathering power and in their angles of coverage. The Super Angulon allows for more camera adjustments. Other lenses in this category are the Cooke 165mm lens, the Wide-Angle Dagor 6¼" lens, and the Rodenstock Grandagon 155mm lens.

The bottom left lens shown in this photograph is an Apo-Kyvytar 210mm F6.8 lens, which is comparable to a 28mm lens on a 35mm camera. This is a new, relatively unknown lens that functions very well as a wide-angle lens on an 8 × 10 camera. It allows ample adjustments and is quite sharp. It converts to 370mm by removing the front element, but the results in its ability to produce a sharp, flare-free image are somewhat marginal. Another 210mm lens available new and used is the Schneider Super Angulon. Rodenstock makes a Grandagon 200mm lens with an image circle of 498mm, and this lens functions quite well on an 8 × 10 camera.

Although not included in this photograph, there are several other good wide-angle lenses for 8 × 10 cameras. Good new lenses include the Apo-Fujinon 240mm, the 250mm F5.6 lenses made by Schneider, Nikkor, Caltar and Rodenstock, and the Fujinon 250mm F6.7 lens. Good used lenses include anything with the name 'Dagor' in the 240–250mm/9½–10 inch range.

THE LONG LENS

The definition of a long lens is one that has a focal length longer than the diagonal measurement of the film area. The long lens has a narrower-than-normal angle of view, and will minimize the size of objects near the camera while exaggerating the size of more distant objects. Portraiture often utilizes a longer lens because its shortened perspective enhances facial features.

A longer-than-normal lens will shorten, and sometimes eliminate, the foreground space in an image. Depending on the camera position, this shortened perspective can make distant objects appear relatively larger in relation to closer objects, which is opposite to the effect of a wide-angle lens.

A popular long lens for the 4 × 5 camera is the 210mm. Its slightly longer-than-normal length works well for such various applications as portraiture, table-top work, some landscape photography, and displaying a piece of architecture within its environment.

The 4 × 5 field camera cannot practically use a lens longer than 240mm. These cameras have a maximum bellows draw of 12 to 13 inches, which means that a 300mm lens could only be used to focus on objects at infinity (200 feet away from the camera). An alternative to the 300mm lens is the 270mm Tele-Xenar, which is a true telephoto lens and only requires 7 inches of bellows when focused on objects at infinity distance. This still leaves plenty of bellows for focusing on objects closer to the camera.

Another telephoto lens for a 4 × 5 field camera would be the Fujinon T 400mm F8 lens with a bellows draw of 10.4 inches at an infinity focus. A 400mm lens on a 4 × 5 camera is approximately comparable to a 135mm lens on a 35mm camera. This lens is significantly longer than a 240 lens, and it might be worthwhile to have both of them if your need for a long lens is great enough to warrant the expense. The primary use is in scenic and landscape work.

It is important to know the maximum bellows extension of any view camera before deciding to purchase a long lens. Some 4 × 5 field cameras have only 12 inches of bellows, which means that the longest lens that can be used for general purposes is a 250mm/10″ lens. This would allow only 2 inches of bellows for focusing objects that are at closer-than-infinity distances, but it would still require that the object be 15-to-20 feet away from the camera. Monorail 4 × 5 cameras generally have 16 to 20 inches of bellows which will accommodate lenses with focal lengths between 300mm/12″ and 360mm/14″. The 2¼ × 3¼ view camera usually has at least 9 inches of bellows, and some will have as much as 14 inches. The 8 × 10 view camera has anywhere from 24 to 36 inches of bellows.

This diagram of a normal lens shows that its focal length is greater than the diagonal of the film area.

DIAGONAL OF FILM

FOCAL LENGTH OF LENS

LENS FOCUSED ON DISTANT OBJECT

Long lenses for the 8 × 10 camera include anything longer than 375mm/15″. These lenses range as long as 1300mm/52″ although in most cases the longest lens used in general photography applications is 24 inches (600mm). The three older lenses pictured in this group are currently functioning very well on 8 × 10 cameras. The shortest lens here, shown on the bottom, is a Goerz Apochromatic Artar 420mm/16½″ lens that has been mounted in a Copal No. 3 shutter. The middle lens is a Wollensak Apo-Raptar 530mm/21¼″ lens mounted in a No. 4 Ilex shutter. The top lens is an Artar Apochromatic 600mm/24″ lens mounted in a No. 5 Universal shutter manufactured by Ilex.

The Artar lenses (also available in 480mm/19″ and 760mm/30″ lengths) are among the best used lenses available on the market. They have a large following and are therefore a little more expensive than other used lenses of the same respective focal lengths. The Apo-Raptar is also a very good lens. The disadvantage with all these lenses is that they are somewhat large, and the Wollensack and Artar lenses have to be mounted in the older No. 4 and 5 shutters.

There are a variety of other long lenses available for the 8 × 10 camera. Fujinon makes its CS series lenses in 450mm and 600mm focal lengths, 480mm/19″ lenses are made by Schneider and Rodenstock, and a 450mm/18″ lens is made by Nikkor.

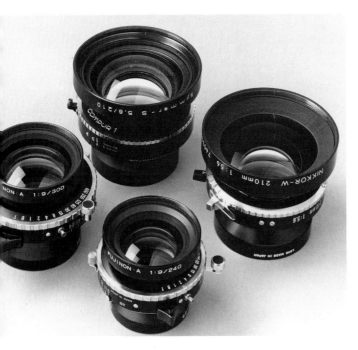

Probably the most popular long lens for the 4 × 5 camera is the 210mm focal-length lens. Many photographers actually use this as their "normal" lens and don't have anything in the mid-range category. The 210-mm lens works well for table-top photography, some portraiture, and some landscape photography.

The 210mm F5.6 lenses pictured here on the top and on the right are made by Nikkor and Schneider and are typical in design and size of lenses in this focal length. They have image circles of approximately 300mm, which facilitates a great deal of movement on a 4 × 5 camera. Similar lenses are made by Rodenstock, Caltar, and Fujinon.

The bottom lens in this group is a Fujinon Apochromatic 240mm F9 lens. It is comparable to an 85mm lens on a 35mm camera and is designed for closeup work, but it also functions very well as a long lens for a 4 × 5 camera. With care it can also be used as a wide-angle lens on an 8 × 10 camera, although its angle of coverage limits the adjustments possible on the larger camera. Because of its focal length and apochromatic corrections, it works well as a copy lens for photographing flat artwork and other documents and for doing closeups of jewelry and other finely detailed subjects.

The lens on the left is a Fujinon Apochromatic 300mm F9 lens that is twice the normal focal length for a 4 × 5 camera. It is comparable to a 100mm lens on a 35mm camera. Most 300mm view-camera lenses can also be normal lenses on 8 × 10 cameras. Lenses in the 240- to 300mm category make good portrait lenses when there is enough room to back away from the subject and are good for some nature and landscape photography.

LENS DESIGN

Long before photography was invented, the appearance of the first optics, telescopes, and magnifying glasses set lens design in motion. Before the computer revolution, it was an arduous procedure to work out the many mathematical computations necessary to design a lens. Now, with the use of computers, developing a new design or improving on an old one is a much easier task.

For a lens to produce crisp, clean images on film, several corrections must be made in its basic design. Over the years, manufacturers have developed a number of solutions to the following lens problems: *chromatic aberration*, the failure of a lens to focus blue and red light to the same point; *spherical aberration*, the failure of a lens to focus rays at the center and at the edge of a lens to the same point; *curvature of field*, the failure of a lens to focus its image onto a flat plane; *astigmatism*, failure of a lens to equally focus horizontal and vertical lines; and *coma*, the failure of a lens to sharply focus a point source of light that is off the center of the image circle.

All of these designs involve using multiple cells, which are concave or convex pieces of glass within the lens barrel, positioned in front of and behind the diaphragm. Each individual cell, as well as each set of cells, is shaped and configured to correct as many problems as possible. It is a fact, however, that not all problems can be corrected equally and compromises must be made. Because of this, some lenses are designed for flat field or copy work, some lenses are designated apochromatic, and so on.

Lens speed is an especially important design factor to consider when buying a lens. Most view-camera lenses have maximum *f*-stops that range between *f*/5.6 and *f*/8. You'll rarely find or need lenses that are as fast as the ones you may have for a smaller camera. At the other end of the scale *f*/45 and *f*/64 (remember the group *f*/64 made up of Ansel Adams, Edward Weston, and others in the 1920s who wanted absolute sharpness throughout the image?), and sometimes even settings of *f*/90 and *f*/128 are available to provide the necessary depth of field on longer view-camera lenses.

Camera lenses are generally designed to focus two of the primary colors, blue and green, onto the film plane. The third primary color, red, is focused onto the film plane by the depth of field. This amount of correction is quite good and is sufficient for all but the most exacting scientific and close-up applications. Depth of field is a function of the *f*-stop and the reproduction ratio (see chapter 4 about depth of field).

The Apochromatic Lens. When a lens is designated as being "apochromatic," it has been corrected to focus all three of the primary colors onto the film plane. These lenses are sometimes corrected for subject-to-image-size ratios of 1:1 through 1:4, which means they are suitable for close-up and copy work. However, when stopped down, they can also be very good, general-purpose lenses. The apochromatic lenses frequently have a smaller angle of coverage than lenses of equivalent focal lengths, so if you want to use an apochromatic lens, consider one with a normal or longer-than-normal focal length for your film size.

The Convertible Lens. Some lenses are called "convertible," which means that they have more than one focal length. When assembled as a whole, a convertible lens has one length, and when the front element is removed, it will have another focal length that is about 75-percent longer. Some older lenses are called "triple convertible," which means that they have three focal lengths. The first, and shortest, length occurs when the front and rear elements are in their proper places. The middle length is usually achieved by removing the front element, and the longest length is obtained by placing the rear element in front of the shutter. When convertible lenses are properly assembled, they range from adequate to good in terms of their ability to produce a sharp, crisp image on film. In their converted state, sharpness suffers, and they may cause some flare in bright areas of the image.

The Telephoto Lens. Don't confuse telephoto lenses with long lenses; they aren't the same thing. The telephoto lens is unique in that its optical center is out in front of the lens rather than being at the point of the diaphragm, as is common for most lenses. The telephoto lens was designed for use on cameras with short bellows when a long lens was required in relation to a given film size. The telephoto lens will have a bellows draw of approximately two-thirds of its focal length. Because of its design it has a limited covering power that necessitates back movements rather than front swings and tilts. A telephoto lens also limits the use of the rise and fall and the shift adjustments. These lenses were originally designed for use on press cameras that had a limited amount of bellows. Today, telephoto lenses are still employed with some field cameras for the same reason. Telephoto lenses are usually distinguished by having the word 'tele' in their name, such as the Tele Xenar and the Tele Arton made by Schneider in a variety of focal lengths including 180mm, 240mm, 270mm, 360mm, and 580mm. More modern telephoto lenses are the Fujinon TS and Nikkor T series lenses.

BUILDING A LENS SYSTEM FOR A 4 × 5 CAMERA

	FIRST PURCHASE	SECOND PURCHASE	THIRD PURCHASE
general-purpose work	180–210mm	90–125mm	depends on interest
architectural work	90mm	150–180mm	75mm
table-top work in the studio	210mm	90mm	300mm
industrial and corporate work	180–210mm	90mm	125mm or 300mm, depending on interest
studio portraiture	210mm	300mm	
environmental portraiture	210mm	105–125mm	

The chart above suggests a plan for buying the lenses that will be most useful for your own photographic purposes. If you are using a view camera other than a 4 × 5, refer to the chart on page 31 to find equivalent lenses for a larger or smaller format.

A good way to find equivalent lenses for your new large-format camera is to take your favorite 35mm lenses and multiply their focal lengths by 3 for 4 × 5 and by 6 for 8 × 10. When moving up from medium format, multiply your favorite focal lengths by 2 for 4 × 5 and 4 for 8 × 10.

The Soft-Focus Lens. The primary application of the soft-focus lens is in fashion and portrait photography. The soft-focus effect is controlled by inserting disks with cut-out holes into the diaphragm area of the lens. The effect can range from a sharp image, like a regular lens, to a very diffused image that minimizes or eliminates skin blemishes and reduces the amount of retouching that might otherwise be needed.

PLANNING A LENS KIT

The first lens you purchase should probably correspond to the angle of view provided by your favorite lens on your current camera. Maintaining a familiar perspective will help ease your transition from shooting with a smaller camera to working with a view camera. Some camera manufacturers and stores specializing in large-format equipment offer package deals that include a camera and a lens. This kind of arrangement could save you some money over the cost of buying individual pieces of equipment.

If you eventually plan to own more than one lens, try to anticipate the work you'll be doing. Landscape work is best done with a gentle wide-angle lens and some longer-than-normal lenses. Portraiture benefits from longer-than-normal lenses, architectural photography from wide-angle lenses, and tabletop work can be done with either a wide-angle lens or a long lens. Look at the chart on page 40 for ideas on how to build up the lens system that best fits your own purposes. The following guidelines should also help.

1. Use a newer, more modern lens when doing studio commercial work. An older lens, as well as any uncoated lens, will not produce the quality of image expected by your clients.

2. Use a lens specifically designed for a particular task when doing work that involves a magnification ratio greater than 1:1. A lens designed for distant work does not work well in extreme closeup situations. Most lenses designed for this purpose are apochromatic, even if the name does not explicitly state such is the case.

3. When shooting architectural photography with wide-angle lenses, excess coverage is the prime consideration. You will need lenses with angles of coverage of at least 100 degrees. This eliminates using apochromatic lenses, but don't worry about this lack of correction. Any modern wide-angle lens will be sharp enough for the task.

4. With an older, uncoated lens, black-and-white works better than color film because the lens' lack of edge definition, sharpness, and contrast can be partially overcome with increased development time available in black and white. Color portraiture, which often encourages softness, might be an exception.

5. Landscape work and general outdoor photography involve several considerations: size and bulk of the lens, its covering power, maximum aperture, and sharpness. Large, 100+ degree angle-of-coverage lenses are probably not necessary because the subject does not require extreme movements, and carrying or backpacking the weight and size can be a problem. An apochromatic lens will produce nice results; you have to decide if this lens is worth the extra expense when a normal design lens will produce a more-than-adequate image.

BUYING USED LENSES

Buying used equipment can be a good way to set up a view-camera system at a substantial savings if you are careful about what you purchase. When looking at a used lens, ask yourself these questions:

1. Is the glass free of knicks or smudges that don't wipe off easily with lens tissue?

2. Is the lens clear, not fogged? Sometimes the cement between the elements begins to look cloudy, which will create a slightly fuzzy image and possibly some flare on film. Older lens' coatings were not well-applied and may begin to discolor.

3. Is the lens coated? There should be a smooth and transparent color to the glass if it is coated. If the glass is completely clear, then it probably isn't coated. An uncoated lens will produce an image that is lower in contrast than one projected by a coated lens. Also, an uncoated lens will have more problems with flare if a light source is included in or near the frame.

4. Does the shutter appear to operate smoothly? The 1 sec. setting is a good place to check. It should run with an evenly pitched hum (no stops and starts), and it should open the diaphragm for one second. If the shutter does not operate smoothly, then it needs to be cleaned and calibrated.

5. Does it have enough coverage for your film size? The best test is to put the lens on a camera and move the front through the swings, tilts, rise, fall, and shift. If it is an older lens, check to see if it will produce an image that is sharp all the way to the edge of the image circle. A lens can only be moved in relation to the film area up to the point where the lens stops producing a sharp image.

6. If you'll be working with strobe lighting, does the shutter have a flash-sync connection that is compatible with modern sync cords? If not, then you'll need to find a repairman to add this connection.

7. And last, but not least, will it produce a sharp image on the film? The best way to find out is to use the lens on your camera, process the film, and then check the results.

Any lens that passes the above tests would be a good investment, providing it is competitively priced. Sources of used lenses are large photo stores in major metropolitan areas and a nationally circulated newsletter called the *Shutterbug Ads* that is available by writing to P.O. Box F, Titusville, Florida.

SHUTTERS

Lenses for view cameras are almost always sold properly mounted into a shutter, the device that controls the length of the exposure as light passes through the lens. The view-camera shutter has a leaf design comprising blades that open and close like the iris of the eye. This is the same type of shutter found on many of the 120 roll-film cameras. This shutter must first open completely before it can close. All the film is exposed at one time rather than in sections as happens with the focal-plane shutter on 35mm cameras. The film receives most of its exposure while the shutter is wide open.

The advantage of this type of shutter is that strobe light can by synced to the camera's exposure at any shutter speed. The flash is triggered by the sync chord, which is attached to the shutter, so it will fire at the moment the shutter is wide open. This can be perfectly synchronized because the duration of the strobe flash is shorter than even the faster shutter speeds. The only time this might not be the case is when larger strobe units are set at maximum power, which may limit your shutter speed to something slower than 1/250 sec. The usual practice is to use the shutter speed to control the amount of ambient light from the scene (for example, window light) that is recorded onto the film, to set the *f*-stop to obtain the necessary depth of field, and to use the power setting on the strobe unit to provide the primary light on the subject.

The most commonly used shutter for new view-camera lenses is made by Copal. They come in three sizes, depending on the focal length of the lens and its maximum aperture. The sizes are designated #0, #1, and #3. The older and longer lenses for 8 × 10

cameras frequently require larger shutters, such as a #4 or #5. These large shutters were manufactured by Ilex and Acme.

Shutter-speed designations on the newer shutters are usually T, B, 1, 2, 4, 8, 15, 30, 60, 125, 250, and 400. The T designation means that the shutter will open when the cable release is first pressed, and the shutter will close when the cable release is pressed a second time. The B designation means that the shutter will remain open as long as the cable release is depressed. The others, of course, correspond to fractions of a second.

Some variations in shutter design are available. Self-cocking shutters don't have to be re-cocked each time, but they generally have a top speed of 1/125 sec. Electronic shutters are also available.

Many of the older lenses for the 4 × 5 and the 8 × 10 cameras are mounted into shutters manufactured by Compur, Ilex, and Acme. These shutters have speed designations of T, B, 1, 2, 5, 10, 25, and 50. They are all mechanically operated, and they run by a system of gears and springs. Although they may need to be cleaned and calibrated, some are very good shutters and will operate satisfactorily for many years if properly maintained.

Another kind of shutter used on some older lenses is known as a compound shutter; it operates by forcing air pressure against a diaphragm in a small tube at the top of the shutter. The compound shutter needs a lot of care and attention, and it may not be as reliable as a mechanically operated shutter.

MOUNTING LENSES INTO SHUTTERS

If you are looking for used lenses with longer focal lengths for an 8 × 10 camera, you will periodically see advertisements for a lens described as "barrel mounted" or "in a barrel." This means that the lens has an aperture diaphragm but no shutter. These lenses were used for graphic-arts purposes that didn't require shutters. They can be very good lenses for general outdoor work, but if you buy one, you'll need to mount it in a shutter, which will require the skills of a good machinist. It is possible to use a barrel-mounted lens on a camera by working out an arrangement so that the lens is "turned on and off" by putting a black hat over the front element, but this is a cumbersome process that results in some film being overexposed and some images not being sharp because the camera is inevitably jarred in the process.

The mounting task is not difficult, but it requires some precision work. The following measurements of

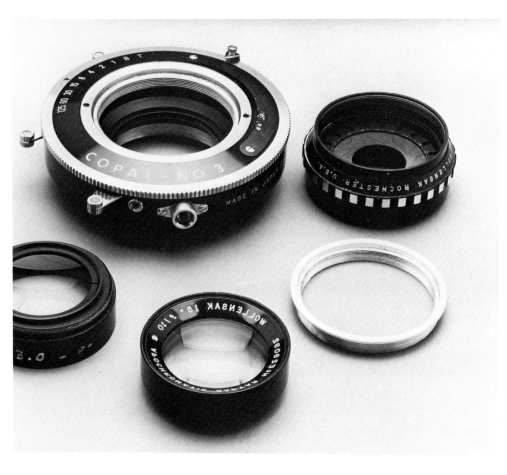

The Wollensak Apo-Raptar 375mm/15" F10 lens shown here illustrates the elements in the lens that are mounted into the shutter. The barrel contained a diaphragm but lacked a shutter. The front and rear elements unscrewed easily from the barrel. The rear element screwed directly into the Copal No. 3 shutter and neatly positioned itself the proper distance from the diaphragm.

Positioning the front element wasn't so easy. The front opening in the shutter was too big for the lens, so an aluminum adapter ring was machined on a lathe to fit in between the lens and the shutter; it was carefully designed to place the front element the correct distance from the rear element in order for the lens to function properly and produce sharp, crisp negatives. The number 373 on the bottom of the rear element indicates that the lens was tested and found to have an exact focal length of 373mm.

the original lens must be recorded: the length of the lens from front to rear, the distance from the diaphragm to the rear elements, and the diameter of the threaded area of the barrel that holds the elements. When the elements are reassembled in the new shutter, the overall length of the lens must be *exactly* the same as the original length, and the distance from the new diaphragm to the rear element should also be the same. In most cases, the machinist will have to make adapters for the front and rear elements to allow them to be screwed into the shutter. The diameter of the threaded area of the barrel that houses the elements will determine the size of the requisite shutter.

Whenever a lens is mounted into a new shutter, the f-stop markings must be changed or added to accommodate the lens. The size of the opening in the diaphragm for any given f-stop varies with the focal length of the lens. The longer the lens, the wider the opening.

The easiest way to mark the new f-stop positions is to take a lens that is already calibrated and put it on the camera. Position the front and rear standards so that the lens can be focused at infinity, and then aim the camera at an evenly lit surface. Open the lens, place your exposure meter at the center of the groundglass, and take a reading. Now close that lens down one stop, and take another reading. Your meter now indicates one-stop-less light is hitting the groundglass. Write down the f-stop and the meter reading. Now put on the new lens, position the front and rear standards for an infinity focus, and aim the camera at the same evenly lit surface. Place your exposure meter in the center of the groundglass, and move the diaphragm lever until the meter gives you the same reading obtained with the other lens. You have now found a comparable f-stop on your new lens. By moving the f-stop lever and marking each place where the meter indicates a one-stop change in the light hitting the groundglass, you can calibrate your new lens.

Chapter Four

OPTICAL PRINCIPLES

Light travels in a straight line unless it is bent while traveling through a clear or translucent object. In photography, this object is the lens, and it must bend the light rays reflected by the subject until they form a sharp, clean image on the film plane.

The point of infinity is generally considered to be a distance 200 times the focal length of the lens out into the scene (for example, the point of infinity for a 6-inch lens is 100 feet). As the camera moves closer to the object, the distance between the optical center of the lens and the film plane must increase in order for the lens to sharply focus the image. The angle at which the light rays enter the lens varies according to the lens-to-object distance. The closer the lens is to the object, the greater the angle of entry, which means a greater lens-to-film-plane distance is required in order for the light rays to meet and focus on the film plane. This increased lens-to-film-plane distance makes the subject larger on the groundglass and film plane. As the camera moves closer to the subject and it appears larger, some of it may disappear from the film plane.

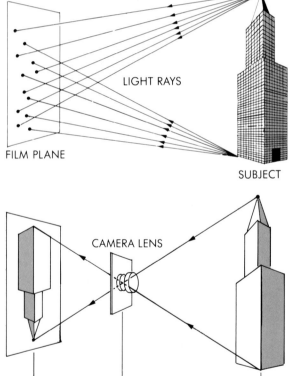

LIGHT RAYS

FILM PLANE

SUBJECT

CAMERA LENS

FOCAL LENGTH INFINITE DISTANCE

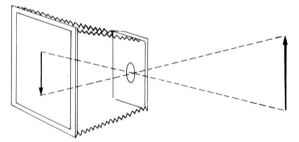

CAMERA AT A MODERATE DISTANCE FROM THE SUBJECT

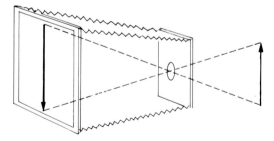

CAMERA AT A SHORTER DISTANCE FROM THE SUBJECT

On top, the light rays bouncing off the building randomly hit the film plane on the left without forming an image. The lens in the bottom diagram focuses the same light rays and projects an inverted image of the building onto the film plane.

The subject—the arrow on the right—leaves a smaller image on the film plane in the top diagram because the camera is at a moderate distance from the subject. The bottom camera is closer to the subject, so the projected image on the film plane is larger and the lens-to-film-plane distance is greater.

DEPTH OF FIELD

Depth of field is the area between the nearest and farthest points from the camera that appear in sharp focus on the film plane. Objects in front of the nearest point and behind the farthest point won't be sharply focused on the film plane.

The depth of field in a photograph depends on two factors: 1) The f-stop. The smaller the aperture, the greater the distance between the near and far boundaries of the area in focus. 2) The reproduction ratio. This compares the size of the object on the film to the size of the object in reality. A reproduction ratio of 1:1 means that the image on the groundglass is the same size as the actual object (closeup work). A reproduction ratio of 1:1,000 would mean that a 3-inch object in a 4 × 5 groundglass would be 250 feet tall (3,000 inches) in reality. The smaller the reproduction ratio is, the more equal are the two numbers on each side of the colon, and the smaller the depth of field is for any given f-stop. Photographers who do tightly-controlled studio work should pay close attention to reproduction ratios.

The aperture you use changes the depth of field which increases as the aperture decreases in size. Note that the depth of field is generally greater behind the point of focus in the scene.

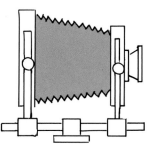

f/45

f/32

f/22

f/16

PLANE OF FOCUS

There is one important aspect to remember: It is a mistake to think that greater depth of field can be obtained by putting a shorter lens on your camera and moving it closer to the subject so the subject fills the groundglass. The shorter lens will produce greater depth of field only if the camera position remains the same. This is because the subject will become smaller on the groundglass, thereby creating a larger reproduction ratio that in turn creates a greater depth of field. If you move in closer with the shorter lens in order to fill the frame, the reproduction ratio will begin to equal that obtained with the longer lens, creating the same depth-of-field problems and necessitating the same *f*-stop and camera-adjustment solutions.

The three elements tying together critical focus, depth of field, and perspective are the lens-to-subject distance, the "projection distance" between the lens and the film plane, and the projection path of the rays as they pass through and are altered by the lens. These elements determine the image sharpness on the film, the object size on the film, and the size relationships between various objects in the scene.

The image of an object in the scene is focused on the film when the distance between the lens and the plane of the film is precisely correct for the focal length of the lens and the lens-to-subject distance, or when the projection path of the rays as they pass through the lens is correct for the lens-to-film-plane distance.

With a non-adjustable camera, you can only control the lens-to-subject distance and the lens-to-film-plane distance. With a view camera, you can also alter the projection path of the rays from the lens to the film (front swing/tilt) and the projection distance between the lens and different parts of the film (back swing/tilt). These two additional controls are what make the view camera so valuable.

The multiple light rays from any point in the scene pass through the lens and form a cone as they are projected back toward the film. If the point of the cone intersects the film plane, then that part of the image appears sharp. If the point of the cone is either in front of or behind the film plane, then the image will appear unsharp because the rays are spread apart and form a circle rather than a tight point at the place they cross the film plane.

With a view camera, you can adjust the lens-to-film-plane distance and the projection path of the rays with the rear and front swing-and-tilt movements. If the lens-to-film-plane distance is too great or too small, or if the projection path is inadequate to bring the rays to a point on the film plane, simply use the front and rear swings and tilts to bring the image into sharp focus.

In reality, only one plane in the scene can be critically focused on the film (with a non-adjustable camera, this subject plane must be parallel to the film plane). Objects in front of and behind the plane of focus cannot be as critically sharp, although for normal viewing these closer and more distant objects may be perceived as being in focus, depending on the depth of fie

THE SCHEIMPFLUG RULE

The view camera allows you actually to rotate the plane of focus and the depth-of-field lines until they align themselves more closely with the subject plane if it is not parallel with the film plane. The Scheimpflug Rule states that a subject plane will be rendered with greatest sharpness when the planes of the film, subject, and lensboard are extended and meet at a common line above, below, or to the side of the camera (see diagrams on page 47).

You can rotate the plane of focus and simultaneously the depth-of-field lines, by using the front and rear swing-and-tilt movements. Using the swing-and-tilt movements has the effect of rotating either the film plane, the lensboard plane, or both, so that their extended planes meet the extended plane of the subject at a common line below, above, or to the side of the camera. These camera movements alter the projection distance between the lens and the different sections of the film plane (rear swings and tilts), or the path of the rays as they are projected from the lens to the film (front swing and tilts). Therefore, you can critically focus a subject plane that is not parallel to the film plane with a view camera. The swing-and-tilt movements, and the resulting Scheimpflug relationship among the three planes, allow objects at varying distances from the camera to be brought into focus at the same time as long as they are aligned along a single subject plane.

If you encounter a scene where the objects are not aligned along a single plane, then you must solve this problem with smaller *f*-stops to increase the depth-of-field area, just as you would with a non-adjustable camera. For objects that are not aligned along a single plane, the best placement for the plane of focus for any camera (including a view camera) is where both the object closest to the camera and the object farthest from the camera that both need to be included in the depth-of-field area are equally out of focus when the lens is wide open. Then, by closing the lens down to smaller *f*-stops, these near-and-far points will be brought into the depth-of-field area at the same rate.

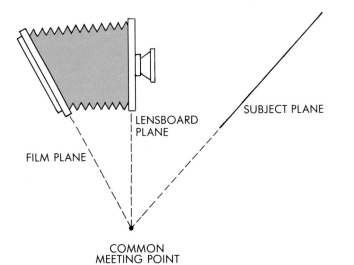

SUBJECT PLANE

LENSBOARD PLANE

FILM PLANE

COMMON MEETING POINT

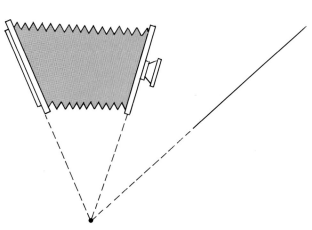

The Scheimpflug Rule has four applications as shown on this page. Above, the common meeting line for extensions of the film, the lensboard, and the subject planes is directly below the lensboard. The purpose of the movement shown here is to adjust the projection distance between the lens and the film plane so that it becomes the proper distance to sharply focus the different points along the subject plane, which is at differing distances from the camera.

Here, both the film plane and the lensboard are tilted (from a side view) or swung (from a top view). The back movement alters the projection distances while the front movement alters the projection path of the rays between the lens and the plane of the film. In this situation, combining the movements created the Scheimpflug relationship.

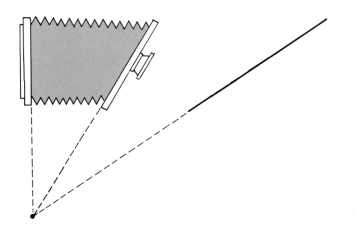

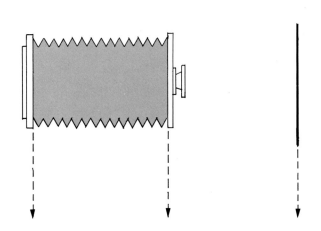

Here, moving the lensboard creates the Scheimpflug relationship. The tilt (from a side view) or the swing (from a top view) alters the path of the rays as they travel through the lens to reach the film plane. By making this adjustment, all points along the subject plane are sharply focused on the film plane.

The Scheimpflug Rule can also be utilized when the film plane, subject plane, and lensboard are parallel to each other. Their common meeting point lies at infinity. In this configuration, all points along the subject plane are the appropriate distance from the lens for the lens-to-film-plane projection distance. Consequently, the subject plane will be sharply focused along the film plane.

These four photographs of the California State Capital were made with a 4 × 5 camera. The top left photograph was taken with a 180mm lens, creating a 37-degree angle of view on the 4 × 5 format. Here the building fills the frame. In order to have everything in sharp focus— that is, included in the depth-of-field area—I had to use f/22.

The top right photograph was taken from the same spot with a 90mm lens, creating a 68-degree angle of view with the 4 × 5 format. This combination produced a larger reproduction ratio, so the building looks considerably smaller relative to its actual size. Consequently, I was able to use f/16 and still achieve sharp focus throughout the image.

The bottom left photograph was taken with the same 90mm lens but from a spot considerably closer to the building. Once again the building fills the frame, so I had to use f/22 because of the smaller reproduction ratio. The change in the shape of the building is due to the closer camera position, not the use of the shorter lens.

The bottom right photograph is my favorite. I moved back from the camera position used in the bottom left photograph and used a 120mm lens. This gentler perspective, caused by the more-distant camera position, is very flattering to the building. The 120mm lens included the elements I wanted in the scene and excluded those I did not want.

FOCAL LENGTH AND PROJECTION DISTANCE

A lens' focal length has some influence on the shape of an object and the size relationships between objects in an image. Consider the various lens-to-film-plane projection distances that a single wide-angle lens has: for example, a 90mm lens on a 4 × 5 camera. Assuming all camera adjustments are neutral, the distances between the center of the lens and the center of the film area and between the center of the lens and the edge of the film area are not the same. From center to center the distance is 90mm (3.54 inches). However, from the center of the lens to the edge of the 5″ end of the film, the distance is 110mm (4.33 inches). The ratio of these projection distances is 110/90, which equals 1.22. Viewed with wide-angle lenses, objects near the edge of the frame thus appear somewhat distorted when compared to objects in the center of the scene.

With a slightly longer-than-normal lens—for example, a 210mm (8.25 inches) lens on a 4 × 5 camera—the ratio will be closer to 1 (actually 220/210, which equals 1.0476). The longer the lens, the closer to the perfect ratio of 1. Hence, viewed with longer-than-normal lenses, objects in the center and on the edges of the frame appear to assume more realistic size relationships.

PERSPECTIVE CONTROL

The only perspective control available with a nonadjustable camera is camera position. Moving the camera closer to and farther from the subject, and to the right and left, influences the size and position relationships of the various objects in the scene. After the camera position is selected, choose a lens: a wider-than-normal lens to include more of the scene, and a longer-than-normal lens to include a smaller section of the scene.

With a view camera, the projection distances between the lens and various sections of the film can be altered. The best rule of thumb is to use the swings and tilts on the film plane to alter perspective and the swings and tilts on the lensboard for focus control. This is basically correct because swings and tilts on the back of the camera have the greatest effect on projection distances, while those on the front have relatively minimal effect on the projection distance between the lens and the film plane. There are, however, minor changes in perspective when the front swings and tilts are used, but they are minimal and only apparent in careful side-by-side comparisons of finished photographs. Perspective changes due to back swings and tilts are more dramatic and can be seen on the groundglass as the film plane is moved.

Chapter Five

CAMERA MOVEMENTS

The view camera generally has four basic movements or adjustments: the rise and fall, the shift, the tilt, and the swing. These adjustments allow the lensboard and the groundglass to be realigned independently of each other. They can be moved up and down, and from side to side; the vertical movement is called a rise and fall, and the horizontal movement is called a shift. When the lens is pivoted around its optical center, it is said to either tilt (up and down on the horizontal axis) or swing (from side to side on the vertical axis). The rear tilt and swing of the groundglass is identical. Not all view cameras are capable of all four movements; some flat-bed cameras do not offer rise and fall for the lensboard and very few of the bed cameras have rise and fall on the rear standard. Most monorail cameras have all of the movements. However, there are ways to compensate for these limitations by using the tilt and swing.

The rise and fall and the shift adjustments move the optical center of the lens and the center of the image circle away from the center of the film; consequently, they change the part of the image circle that is recorded on film. Tilting the front of the camera moves the center of the image circle above or below the center of the film, and swinging it moves the center of the image circle to the left or the right of the center of the film. However, the tilt and the swing don't change what section of the image circle is recorded on film since the optical center of the lens and the center of the film stay aligned.

Both the rear tilt and the rear swing adjustments keep the center of the film, the center of the image circle, and the optical center of the film in alignment, so there is no change in what part of the image circle is recorded on film. Instead, with these movements the shapes and sizes of the objects in the scene are altered on the groundglass as parts of it move closer to the lens and parts of it move farther away from the lens.

The rear tilt and swing adjustments are primarily used to alter perspective by manipulating shapes and sizes. Although they don't change the depth of field, these movements can also be employed to bring more of a scene into sharp focus by taking advantage of the Scheimpflug Rule. This secondary function is especially useful when working with a lens of limited covering power, as long as the resulting change in perspective is not objectionable.

The primary purpose of the front tilt and swing adjustments is to aid in focusing and to make use of the Scheimpflug Rule (discussed in chapter 4) without distorting the shape of the objects in the scene. The shapes and sizes of these objects don't change with the front tilt and swing because the distance from the center of the lens to the various sections of the film area remains the same. Instead, these tilt and swing adjustments are used to change the plane of focus so it becomes more aligned with the principal plane of the subject. The tilt and swing of the front are also used to return the image to sharp focus if alterations in the perspective have been made by tilt- and swing-adjustments on the back of the camera.

When all camera adjustments are in a neutral position, the center of the image circle, the optical center of the lens, and the center of the film area all line up together. The film area should fit completely inside the image circle; therefore, the size of the image circle projected by the lens must exceed the diagonal measurements of the film. If the image circle is barely large enough to cover the film area, only the rear tilt and swing movements will be useful. Always begin by positioning the camera's adjustments in neutral, and be sure that you're using a lens with an adequate angle of coverage.

Adjusting the camera's shape

 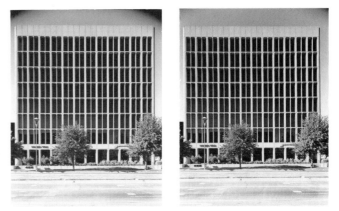

These photographs illustrate the use of the rise, fall, and tilt adjustments. The subject is a tall vertical building. The first photograph includes all of the building, but its shape is distorted because the camera is aimed upwards, and the film plane is no longer parallel to the plane of the building.

In the second photograph, the shape of the building has been corrected because the camera is now aimed squarely at the building, so the film plane and subject plane are now parallel. But the top of the subject has been cut off as a result.

In the third photograph, the front of the camera has been raised so that the top of the building is included in the groundglass and on the final image. This photograph is much more successful than the two previous attempts. But there is another problem. The darkened corners at the top of the picture reveal that the film area has been moved to the outer edges of the image circle. Since the lens is a new, wide-angle model, the image remains sharp to the edge of the circle. If it were an older lens, the image might become soft before the fall-off of light rays occurred. This vignetting reveals that parts of the film haven't received any exposure. Vignetting is visible on the groundglass and can be avoided if the photographer pays careful attention to the edges of the frame.

There are five possible solutions to the vignetting problem in the third photograph: 1) Move the camera away from the building. This will make it decrease in size and fit more easily into the groundglass. This solution couldn't be used here because I was directly underneath a tree that would have obscured the top of the building if I'd moved backwards. 2) Use a wider lens. This will make the building smaller, but it

won't change the building's perspective as long as the camera position remains the same. I was using a 210mm lens, the widest lens I had for an 8 × 10 camera. The negative could be enlarged in the printing stage so that the building fills the frame. 3) Elevate the camera's position. This will change the perspective and make the building seem a little shorter, but this is preferable to having dark corners. Having a shooting platform on top of a car is useful for solving this type of problem because simply raising the camera a few inches with the tripod's center column may not be sufficient. However, in this situation the tree prevented me from elevating the camera. 4) Burn in the corners in the printing stage. This works if the subject doesn't come too close to the corners of the frame, which, unfortunately, wasn't the case here. 5) Use a little backwards tilt on the front of the camera. This will move the center of the image circle down towards the center of the film area and allow light to strike all areas of the film. This adjustment will cause the top and bottom of the image to go out of focus slightly. Stopping the lens down several stops will increase the depth of field and bring the building into sharp focus.

These maneuvers to eliminate or minimize vignetting can also be used when the horizontal shift adjustment causes the same problem. In the case of the shift, the front of the camera is swung just enough to move the darkened corners off the groundglass. The frame's left and right edges will become a little soft, but once again, stopping the lens down one or two stops more than usual should provide enough depth of field to bring everything into sharpness.

The Rise and Fall

The rise-and-fall movements on a view camera enable the photographer to select which part of the image circle is recorded on film. When all the camera adjustments are neutral, some portions of the scene that are within the image circle fall outside (above or below) the area covered by the film. Raising or lowering the front or rear standards moves the center of the film up or down in relation to the optical center of the lens, thus changing the part of the image circle that is captured on film.

The rise-and-fall movements on the front and back of the camera are not truly interchangeable. Raising or lowering the back changes the part of the image circle captured on film, but it won't affect shape in the image. However, the rise and fall of the front does make minor, if almost imperceptible, changes in the point of view because it changes the lens-to-subject alignment, thus changing the point of view. The effect on the image is practically the same regardless of which standard is adjusted. The difference is only noticeable with close camera-to-subject distances and wide-angle lenses.

Monorail view cameras usually incorporate rise-and-fall movements on both their front and back standards. However, field cameras with flat beds usually have rise-and-fall movements on only their front standards. Photographers wishing to pursue commercial photography seriously should obtain a monorail camera, although a field camera is quite functional for general landscape work, some portraiture, urban landscapes, and documenting historical buildings.

One obvious example of the need for the rise and fall occurs in architectural photography. When photographing a tall building from street level with a nonadjustable camera, it is frequently necessary to point the camera upward to include the top of the structure. This tilting of the camera means that the plane of the film and the plane of the building are no longer parallel, which will cause a keystone effect in the image—the top of the building will appear narrower than its base. Its shape, once square, becomes trapezoid. Unless this effect is intentionally made in an obvious manner, it can be disturbing because the building will appear to be falling backwards.

With a view camera this distortion in the image is easily corrected. You simply make the film plane parallel to the plane of the building, by employing either the rise-and-fall or the tilt movements. In either case the film plane needs to be made parallel to the

side of the building. Level the camera (see page 68) from front to rear and from left to right. This will cause the section of the building appearing in the groundglass to be parallel to the film plane (assuming the building is standing straight). The vertical lines in the building should be parallel to the sides of the groundglass. This leveling of the camera may result in too much foreground showing, so that the top of the building disappears. To decrease the foreground and include the top of the building, you can either raise the front standard, lower the rear standard, or do both.

The camera will still be closer to the bottom than to the top of the building. However, the shape of the building will be corrected because the distance from the center of the lens to the top of the film (which records the bottom of the building) will be less than the distance from the center of the lens to the bottom of the film (which records the top of the building). Since the size of an image on film increases as the lens-to-film-plane distance increases, the rise or fall causes the top of the building to spread out and match the size of the bottom of the building, so that its vertical lines become parallel to the edges of the image frame.

Rise-and-fall movements can also be used when you're looking down on such objects as boxes or wine bottles. In advertising photography, it is usually important to keep the correct shape of the product, rather than allow any distortion. When you're looking down at the subject, your solution with camera adjustments will be the opposite of the situation with the building—you'll want to use either a front fall, a back rise, or a combination of both to include all the necessary elements in the picture, while at the same time keeping the film plane parallel to the vertical planes of the objects in the setting.

A third, common application of the rise-and-fall movements occurs in landscape photography when a decision has to be made about the placement of the horizon line. Raising the front of the camera or lowering the back will put the horizon line lower in the frame and decrease the amount of foreground in the photograph. Lowering the front or raising the back standard will have the opposite effect.

It is important to note that maintaining perfectly correct, vertical lines in a photograph is not always appropriate. There will be times when you will want, for instance, to emphasize height or decrepitness, and allowing vertical lines to converge at one end of the photograph will help create the desired effect.

NEUTRAL

Here all the camera adjustments are neutral. The block and the orange are positioned directly along the axis of the lens. This image is a good reference point for the adjustments portrayed in the images to the right. To make these illustrations, I used a 90mm lens on a 4 × 5 camera. The wide-angle lens and the close camera-to-subject distance exaggerated the changes that occurred when the various adjustments illustrated in this chapter were used. With a longer lens or a greater camera-to-subject distance, the changes would be more difficult to see.

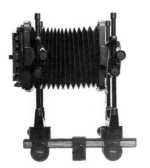

BACK-FALL

Lowering the back of the camera leaves the subject-to-lens alignment intact, so the block and the orange remain in the same relative positions. The subject appears lower in the frame because the film area has been moved onto a different section of the image circle.

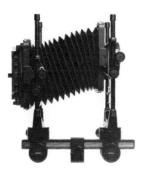

FRONT-RISE

Raising the front of the camera changes the subject-to-lens alignment. The lens is now looking at the two objects from a slightly different position, so the block appears lower relative to the orange. Both objects are lower in the frame because a different section of the image circle has been recorded on film.

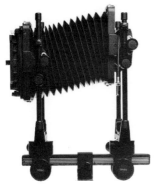

BACK-RISE

Like the back fall, this adjustment doesn't affect the subject-to-lens alignment, so the objects remain in the same relationship to each other. However, they are higher in the frame because of the change in the section of the image circle recorded on film.

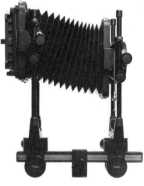

FRONT-FALL

Lowering the front of the camera affects the relationship between the two objects; the block now looks slightly higher than the orange. Once again, a different section of the image circle is recorded on film, and both objects appear higher in the frame.

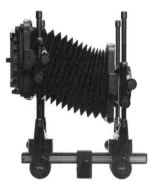

Most field cameras have limited front-rise-and-fall adjustment capabilities and no back-rise-and-fall adjustments at all (in fact, some older field cameras don't have any front-rise capabilities). However, it is possible to use the front and rear tilt adjustments to simulate the rise and fall adjustments. Simply aim the camera upward for front rise or downward for front fall, then tilt the front and back of the camera to bring the film plane and lensboard into vertical positions. This method works equally well on monorail cameras when the rise-and-fall requirements exceed the camera's capabilities.

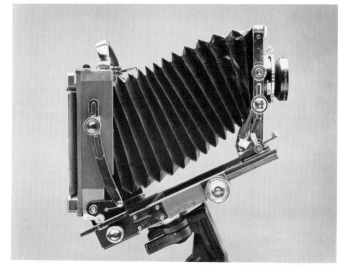

The Shift

The front and rear shift movements on a view camera are another way for the photographer to select which part of the image circle is recorded on film. The shift is used to include portions of the scene that are within the image circle but fall outside to the right or left of the film area. Sliding the front or the rear standard sideways, either to the right or the left of the camera's center axis, shifts the film area horizontally, moving the center of the negative in relation to the optical center of the lens.

The shift is just like the rise and fall, except the shift movements are horizontal, and the rise and fall are vertical. None of these movements change the angle between the film plane and the lens. The front shift, like the front rise and fall, does affect spatial relationships between the objects in a scene because it somewhat alters the lens-to-subject alignment. However, the actual difference between using the front or rear shift adjustments will only be visible at close camera-to-subject distances and with wider-than-normal lenses. Of course, you must have a lens that projects an image circle larger than the diagonal measurement of the film in order to use the shift.

When it is necessary to position the camera off to one side of your subject because of an obstruction or reflection, the shift movements are useful for restoring a more head-on point of view. This allows the film plane and the subject plane to remain parallel even when the camera can't be placed squarely in front of the subject. Photographing a mirror is a good example of a situation that necessitates standing to one side rather than directly in front of the subject. With the front or rear shift, the film can be moved over to record the area of the image circle that includes the mirror, making the image appear as if it were directly in front of the camera.

Another situation where the shift is useful occurs when a direct frontal view of a building is obscured by some unsightly object, such as a parked car, a trash container, or a telephone pole. This kind of obstruction will force you to move toward one end of the building, which will create some horizontal convergence as you look along the side of the structure. To eliminate this convergence and accurately record the shape of the building, the film plane and the front of the building must be made parallel to each other. Making this adjustment will cut off the far end of the building, and there will be too much space at the near end. The shift adjustments can then be used to recenter the building in the groundglass.

The camera will still be closer to one end of the building. However, the shape of the building will be corrected because the distance from the lens to the film edge recording the near end of the building is now less than the distance from the lens to the film edge recording the far end of the building. The size of the image on film increases as the lens-to-film distance increases. Therefore, the far end of the building will expand and become equal in size to the near end of the building when the camera back is shifted toward the near end or when the lens is shifted toward the far end.

Correcting the shape of the image may or may not be desirable. Horizontal convergence is usually more acceptable than vertical convergence. It is the photographer's task to interpret the subject in the most pleasing manner. There are times when the feeling of distance provided by some horizontal convergence creates a better interpretation.

Monorail cameras usually have shift adjustments on both the front and rear standards. Field cameras sometimes have only front-shift adjustments, and sometimes they don't permit any shift movements at all. If shift adjustments aren't available, it is possible to use the front and rear swing adjustments to achieve the same effect. Simply aim the camera in the desired direction so that the groundglass includes the important parts of the scene, and then swing the front and rear standards so they are once again parallel to the subject.

NEUTRAL

Here all the camera adjustments are neutral, and the block and the orange are positioned directly in front of the lens.

FRONT-SHIFT LEFT

Moving the lens to the left changes the subject-to-lens alignment; the lens is now looking slightly to the left of the block. The film area now records the right side of the image circle showing more of the left side of the scene.

BACK-SHIFT RIGHT

Shifting the back of the camera (and hence the film plane) to the right doesn't affect the subject-to-lens alignment, so the objects don't move in relation to each other. The film area has shifted to the right part of the image circle, moving both objects to the right side of the frame.

FRONT-SHIFT RIGHT

A rightward movement of the lens puts the left side of the image circle on the film area, so more of the right side of the scene is recorded on the film.

BACK-SHIFT LEFT

Moving the camera back to the left doesn't change the lens-to-subject alignment, so the relative positions of the objects remain the same.

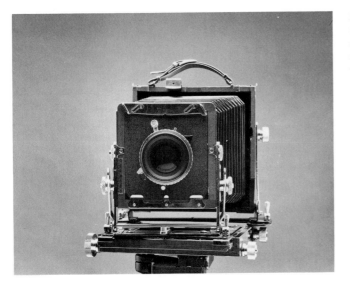

Some current and older field cameras don't have any front- or rear-shift adjustment capabilities. However, by using the front and rear swing adjustments, it is possible to create a sideways displacement of the lens and film plane. Simply aim the camera in the desired direction, then swing the front and back of the camera until the film plane and the lensboard are parallel to the subject plane.

The Tilt

Unlike the rise and fall and the shift, tilting the lensboard or the groundglass forward and backward on a horizontal axis changes the angular relationship between the lensboard, the film plane, and the subject plane. Tilting the groundglass changes the projection distances between the lens and the different sections of the groundglass causing a very noticeable change in the shape of the object on the groundglass and a slight change in its focus.

You can use the front and back tilts to simulate the rise-and-fall movements. Some situations demand this substitution, particularly if you are working with a field camera that lacks a rise-and-fall capability. Basically, you aim your camera either up or down at your subject, and then tilt the front and back either forwards or backwards until the focal plane is parallel to the subject plane, eliminating linear distortion.

THE FRONT TILT

The front tilt is generally used to rotate the depth-of-field area until it is more closely aligned with the subject plane. To more closely align the lensboard and the subject plane, you can tilt the lensboard toward the subject plane, angling the lensboard approximately midway between the film plane and the subject plane. As a result of this movement, more of the horizontal plane of the scene will be sharply focused within the depth of field.

Some care must be taken in using the front-tilt adjustment. If there are tall vertical objects in the foreground, you shouldn't tilt the lens so much that the tops of these objects extend up through and out of the area of sharp focus. It is also possible to use the front tilt to minimize the depth of field for any given *f*-stop and reproduction ratio. This can be done by tilting the lensboard away from the subject plane.

THE BACK TILT

When a back-tilt adjustment is made, the distance between the center of the lens and the top and bottom of the film area changes. However, the center of the film area remains the same distance from the center of the lens, regardless of the back tilt.

The size of the image (or the size of its various sections) on film is related to the distance between the center of the lens and the film plane. With the back tilt, the change in the distance between the top and the bottom of the film area is relative.

With a forward tilt of the groundglass, the top of the film area (which is the foreground area in the scene—remember that the projected image is upside down) moves closer to the center of the lens, and the bottom of the film area (which is the background or the more elevated section in the scene) moves farther away from the center of the lens. Consequently, when the groundglass tilts forward, the foreground becomes smaller, and the background becomes larger. With a backward tilt the foreground becomes larger, and the background becomes smaller. Whether or not these changes are desirable or objectionable is primarily an aesthetic decision depending on the subject matter and its interpretation.

You can use the back tilt to augment the front tilt and also take advantage of the Scheimpflug Rule (described in chapter 4). When faced with a horizontal plane receding from the camera, tilt the back until the image appears sharp on the groundglass. At this point, the imaginary lines projected from the film plane, the lensboard, and the horizontal subject plane will all meet at a common point below the camera. The resulting change in the shape of the subject or in the size relationships between the objects in the scene will have to be tolerated if you want it all to appear in sharp focus.

NEUTRAL

These images illustrate a subject plane moving away from the camera in a horizontal direction. In this image the camera is leveled, and all camera adjustments are neutral. An aperture of *f*/11 is not sufficient to keep the subject plane in sharp focus from the near to the far edge. Only the center area is sharp.

A SMALLER *f*-STOP

One solution is to stop the lens down until the depth-of-field area expands enough to include all of the subject plane. In this case, that occurred at *f*/22. However, this required two stops more exposure.

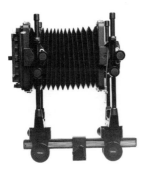

FRONT-TILT FORWARD

Another solution is to tilt the lensboard toward the subject plane (forward in this case). This adjustment rotates the depth-of-field area so that it aligns with the subject plane. This adjustment permits the use of *f*/11, which will shorten the exposure. The subject's shape remains the same because the top and bottom of the film area remain the same distance from the center of the lens.

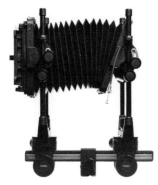

BACK-TILT BACKWARD

A third solution is to tilt the film plane away from the subject plane (backward in this case). This adjustment will also enable an f-stop of 11 to bring the scene into sharp focus. However, since the back tilt adjustment changes the relative distances between the center of the lens and the top and bottom of the film area, there is a change in the shape of the subject.

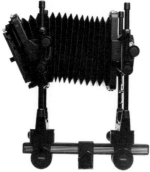

FRONT-TILT FORWARD, BACK-TILT FORWARD

Another way to interpret the scene is to tilt the film plane toward the subject plane (forward in this case). This changes the relative distances between the top and bottom of the film area and the center of the lens, which therefore changes the shape of the subject plane. This adjustment will initially throw the near and far sections of the plane badly out of focus. However, by tilting the lensboard toward the subject plane (forward in this case), a sharp focus can be achieved from front to rear with f/11.

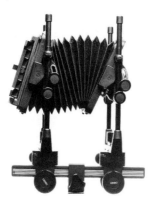

AXIS-TILT VERSUS BASE-TILT ADJUSTMENTS

View-camera adjustments all function in the same manner except for the tilt. There are two varieties of tilts, and although they ultimately have the same result, they function in slightly different ways. As a general rule, monorail cameras have axis-tilt adjustments and field cameras have base-tilt adjustments. (However, that rule is not absolute, and there are exceptions.) These pictures illustrate the front and back axis tilts on a monorail camera, shown left, and on a field camera, shown right.

Axis tilts keep the lens and the film plane in virtually the same place regardless of how much adjustment is used. The design of a typical monorail camera is such that its front and back rotate on an imaginary line through their centers or axes. The lens-to-film-plane distance doesn't change for either the front or rear tilt. Consequently, very little refocusing is required after using an axis-tilt adjustment.

The pivot point for a base-tilt adjustment is located below the center of the lens or the film plane along the bed of the camera. Consequently, the lens or film plane moves forward or backwards depending on the direction of the tilt, and the lens-to-film-plane distance changes. Therefore, some refocusing is required after using the base-tilt adjustment.

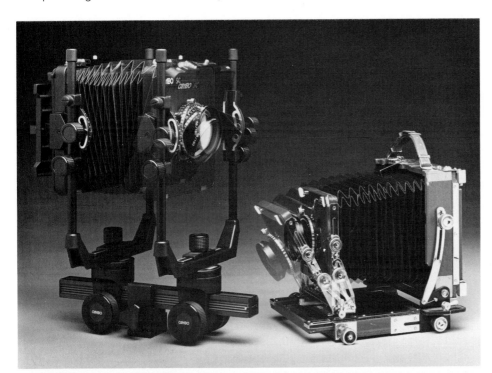

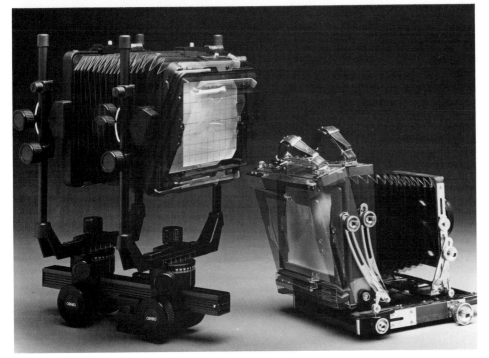

The Swing

The swing is analogous to the tilt in that both movements pivot the groundglass and the lensboard around an axis. The swing twists them sideways, either right or left, around a vertical axis. Like the tilt, it has different effects depending on whether the lensboard or the groundglass is being moved.

THE FRONT SWING

Using the front swing swivels the lens, which changes the angle of the lensboard in relation to the film plane. Since it is the lens that is being swung, and not the groundglass, the subject's shape doesn't change; instead, it creates a well-defined area of focus that travels on an angle across the scene or subject.

The front swing is generally employed to align the lensboard with a vertical plane in the scene by swinging the front of the camera toward the vertical plane. This also swings the imaginary lines governing the boundaries of the depth of field in the same direction. As a result, more of the scene's vertical plane will be included in the depth-of-field area and will be rendered in sharp focus. If desired, the front swing can also be used to minimize the depth of field along a vertical plane. This is accomplished by swinging the front of the camera away from the subject plane.

The front swing gives the photographer a wonderful selectivity of focus. You can use it to fine-tune your compositions by sharpening some objects and throwing others out of focus.

THE BACK SWING

When the back-swing adjustment is used, the distance from the center of the lens to the right and left edges of the film area changes, but the center of the film area remains the same distance from the center of the lens, and the film area stays in the center of the image circle. Although the focus in the image doesn't change much, pivoting the camera back always elongates the objects in a scene. The back tilt stretches objects vertically, and the back swing affects them horizontally.

When the left edge of the film is moved closer to the lens, the right edge moves farther away from the lens, and objects along the left edge (the right side of the scene) become smaller. Objects along the right edge (the left side of the scene) become larger because the light rays projecting them from the lens to the film plane must travel a greater distance. When the back swings in the opposite direction, the size relationships are reversed. Basically, if the subject is square, it will become trapezoid in shape, and both ends of the trapezoid will be slightly less sharp.

The Scheimpflug Rule also works with the back swing. The film plane can be swung to the right for alignment with a vertical plane along the left edge of a scene, or it can be swung to the left for alignment with a vertical plane along the right edge of the scene; in either case, the imaginary lines extending from the subject plane, the lensboard, and film plane will meet either to the right or left of the camera. This will cause some change in the shape of the scene.

NEUTRAL

These images illustrate a vertical subject plane moving from the far left to the near right of the frame. The camera is leveled and all adjustments in the image above are neutral. An aperture of *f*/11 is not sufficient to include all of the subject plane in the depth of field area. The near and far end are out of focus.

A SMALLER *f*-STOP

One solution is to close the lens down so that the depth-of-field area will expand to include all of the subject plane. This situation required closing down two stops to 22. This smaller *f*-stop required an exposure time four times as long or four times the flash power in the studio.

FRONT-SWING RIGHT

A second solution is to swing the lensboard toward the subject plane. This rotates the depth-of-field area so that it now includes the entire subject plane at *f*/11. The shape of the plane remains the same because the front swing adjustment doesn't change the relative distances between the center of the lens and the right and left edges of the film area. The front swing adjustment requires a lens with a large angle of coverage.

BACK-SWING LEFT

A third solution, which may be used for interpretive reasons or because the lens has limited covering power, is to swing the back away from the subject plane (left in this case). This adjustment changes the relative distances from the center of the lens and the right and left edges of the film area, and changes the shape of the subject plane. The back swing leaves the film area in the center of the image circle, so this adjustment can be used with a lens of limited covering power.

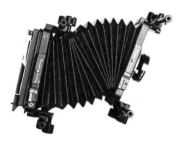

BACK-SWING RIGHT, FRONT-SWING RIGHT

Another interpretation is to swing the film area towards the plane of the subject. This adjustment changes the shape of the subject plane but, if used alone, will throw the left and right edges of the scene badly out of focus. However, by swinging the lensboard toward the subject plane (swinging it right in this case) the subject plane can be brought back into focus at $f/11$.

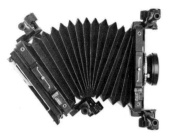

YAW

Yaw is one of the terms often used when discussing the advantages and disadvantages of one monorail camera over another. Yaw occurs when the tilt pivot point is located above the swing pivot point and both adjustments are used on the same standard. The front or rear standard then rocks left and right when it is swung because the platform on which it rotates is no longer level. If you have lined up vertical lines with the edges of the frame or with a grid pattern on the groundglass, and then swing the groundglass, you will have to relevel the camera from left to right to realign vertical lines in the scene with the edges of the frame. This can have the effect of slightly undoing the swing adjustment. Adding more swing means having to relevel the camera—and you can begin chasing your tail very quickly.

Yaw also interferes with the formation of a perfect Scheimpflug relationship between the planes of the lensboard, film plane, and subject. When the lensboard and/or film plane is rocked by yaw, then the three planes cannot be extended to meet at a common line. The extension of the plane rocked by yaw may intersect the other two planes, but it will not be aligned with them. This will affect your ability to achieve the necessary depth of field but, in most cases, the effect will not be noticeable.

Yaw-free cameras are designed so that their tilt pivot point is located below the pivot point for the swing adjustment. This means that the platform for the swing adjustment is always level and the left-to-right rocking motion of the front and/or rear standard cannot occur. Flat-bed-camera photographers, all of whose cameras have yaw, don't seem too concerned about this problem and are still able to produce wonderful photographs despite their cameras' affliction with this calamity.

If you level your camera front to rear and left to right, you will never have a problem with yaw. This is generally easy to do when working with architectural, landscape, and portrait subjects. The only time it is really necessary to aim the camera up or down is in the studio when working with a tabletop subject.

The rocking motion illustrated here is the result of yaw. Yaw would not occur if the camera bed/monorail was in a horizontal position instead of being aimed upward, as in this situation, or downward.

Chapter Six

OPERATING THE CAMERA

At first, using a view camera may seem overwhelming. When to tilt, how to swing, which film and lens to use, whether or not to use a filter, and where to place the camera are some of the questions you'll face every time you shoot with a view camera.

There is a lot to learn. But with the consistent use, the view camera becomes easy to operate. Much of what seems mind boggling in the beginning simply becomes an extension of your hands and imagination after a few months' practice.

The secret is to go out and work with the camera. Manipulate it, and watch the image change on the groundglass. If you own more than one lens, put each one on the camera and observe what happens when the angle of view changes. Move the camera around and watch how the perspective changes. When you have exposed and processed some film, you'll begin to develop an understanding of how the image on the groundglass is transformed into an image on the negative or transparency. Compare your results with what you expected or wanted from the scene. Look at magazines, books and exhibits to see what is being done in your field of interest, whether it be landscape, food, interiors, product and table-top illustrations, architecture, industrial, or corporate work.

There is a natural order of activity that photographers who are accustomed to working with a view camera follow almost instinctively. In the beginning it can be helpful to make a check list of these procedures in their appropriate order, which will help organize your work. It won't be long before this list becomes almost intuitive if you are an ardent photographer. Once you have selected a subject or scene to photograph, I suggest that you proceed with the following order of activity.

LOADING SHEET FILM

Sheet film is packaged differently from roll film. Sheet film is generally put into a foil or plastic pouch that is put into a box that is then put into another box. The outer box should only be opened in a completely dark room. To get to the film, tear off one end of the foil pouch (very carefully so that static flare doesn't expose the film) and pull out the stack of film. There will usually be pieces of cardboard on the top and bottom of the stack. Set these aside before you load any film into your holders. Ilford films are packaged with a paper interleaving between each sheet of film. The paper is much thinner than the film, and it feels quite different, so you won't have any trouble distinguishing between the two. You'll discover that each type of sheet film has its own identifying notch pattern cut into one corner on each sheet. Feeling this notch will help you locate the emulsion side of the film.

To load sheet film into a film holder, you'll want to begin by laying your holders on a clean, dry surface. Dust in a film holder is a real problem because it causes clear, unexposed spots on the negative, which will show up as black specks on a print or transparency. It is a common belief among view-camera users that dust in a holder automatically seeks out the sky areas in an image, areas where black specks are clearly visible and difficult to retouch. To prevent this, you need to blow or brush the dust out of each holder every time it is loaded.

Film holders have dark slides that protect the film from exposure until the holder is loaded in the camera. Then the slide is pulled out, readying the film for exposure. Afterwards, the slide is reinserted into the holder to prevent further exposure. The handle on the dark slide of a film holder is silver on one side and black on the other. The silver side is inserted face-out to indicate unexposed film in the holder; conversely, the black side indicates that exposed film is inside. A freshly loaded holder should display the handle's silver side. After exposing the film, insert the slide so that the black side shows.

To load your film holders, do the following:

1. First lay out your holders and carefully clean them. Then choose the type of film to be loaded. In the

beginning, before you become familiar with the notch patterns that identify each film, load only one type of film at a time. Partially insert your dark slides into the film holders so that their silver sides show.

2. Turn off all the lights, and open the box of film. Carefully remove the film from the pouch and take the cardboard off the top of the stack. Locate the notch pattern so that you'll know which is the emulsion side of the film (the notch should be along the top edge in the right-hand corner).

3. Lift off one sheet of film, and put it in your right hand so that your index finger is resting on the notch pattern. Open the end flap on the holder. With the holder in your left hand, slip the film underneath the guide rails that run along the inside of the holder. When the film has been inserted properly, you can almost feel it snap in place. Then close the flap, and push the dark slide into the holder. Turn the holder over, and load the other side in the same manner.

4. After loading all the holders, put the rest of the film back into the pouch and back into its box. Now you can turn on the lights.

5. With a pencil, write the name of the film being used on the label area of each holder. Often you'll be using several types of film, making it important to know which film is in which holder.

POSITIONING THE CAMERA AND SELECTING THE RIGHT LENS

The first task is to determine where you want to place the camera. The best tack is to move around and look at the scene from different vantage points. Move to the right of the subject and to the left, higher and lower, closer to it and farther away before making a final decision. Some scenes offer a lot of subtle choices wherein a slightly different camera position creates an entirely different image. In other scenes, moving the camera a few feet one way or the other won't make a

great deal of difference. Once you've determined the camera's placement, set up the tripod and the camera, and make sure all the adjustments are in a neutral position.

The next task is to select a lens that will include all the important elements in the scene. Remember, a wide-angle lens includes more and a long lens includes less of a scene.

Depending on your choice of lenses, it may be necessary to change the camera position once the best available lens has been placed in the front standard. You may discover that the lens you've chosen is slightly too wide or a little too long for your original vantage point. If you don't own the ideal lens for a given situation, one alternative that sometimes works is to

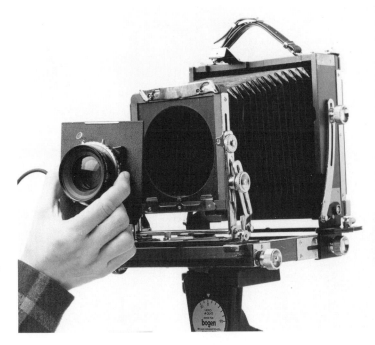

Changing lenses on a view camera means changing both the lens and the lensboard. The lensboard fits into the front standard of the camera and is generally held in place by a spring or a sliding clamp device. On this camera the silver bar along the top of the front standard slides down and holds the lensboard in place.

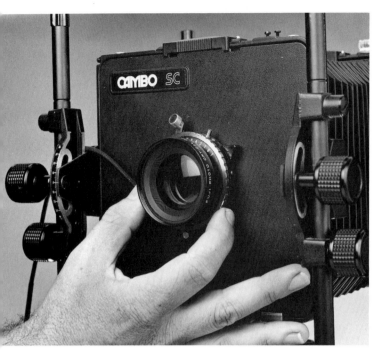

Most modern shutters for view-camera lenses look very similar to the one in this picture. In order to look through the groundglass, the diaphragm must be opened by using the preview lever (the triangular black knob above my index finger), and the aperture should be set to its widest opening. (Some older shutters don't have a preview lever, making it necessary to use the "T" setting on the shutter-speed ring. The "T" setting means that the shutter opens the first time the cable release is pushed and closes the second time it is pushed. The "T" setting is generally used for very long exposures.

After the scene is composed and the various adjustments have been utilized, the preview lever is closed and the f-stop lever (below and to the left of my index finger) is set to the desired opening. The shutter speed is set by adjusting the silver ring around the outside of the shutter. The shutter is cocked with the large round lever at the top of the lens.

When the bubbles in the two bubble levels shown here are centered between the black lines on the levels, then the camera is perfectly horizontal, which is the best position for starting to set up a shot.

use a slightly wide lens and then enlarge the image in the printing or reproduction stage to crop out the unwanted elements.

LEVELING THE CAMERA

This is an optional procedure that a great many photographers do instinctively. Leveling the camera makes the orientation of its monorail or bed perfectly horizontal, which is the optimal starting position. If your camera incorporates bubble levels, the tripod head should be adjusted so that the film plane is leveled both left to right and front to rear. When doing architectural work, the verticals usually *must* be vertical, so this leveling process is essential. In most landscape work the horizon line should be level, although in some situations it won't make any difference. If you have a field camera without bubble levels, the tripod head can be adjusted until the vertical sides of the groundglass line up with vertical lines in the scene.

CAMERA ADJUSTMENTS

Always set the camera's adjustments at the neutral position when you begin to photograph any scene. Your first look through the groundglass should be as unbiased by the camera as possible, so that you have a clean opportunity to manipulate the camera to achieve the final image you want.

The first adjustments you'll want to utilize are the shift and the rise and fall because these select the section of the image circle that will be recorded on the film. Two simple rules to remember for these movements are: (1) To get more of something, move the camera front toward the area of interest. For example, to get more sky, raise the front; to get more foreground, lower the front; to get more of the left side of the image, move the front to the left; to get more of the right side of the image, move the front to the right. To get less of something, move the front away from it. (2) Or to get more of something, move the camera back away from it. For example, to get more sky, lower the back; to get more foreground, raise the back; to get more of the right side of the image, move the back to the left; to get more of the left side of the image, move the back to the right. To get less of something, move the back towards it.

Your second adjustment will be tilting and/or swinging the back. Similar rules can be applied when working with these adjustments: To make an object in the image larger, pull its area of the film plane away

from the lens. To make an object smaller, push its area of the film plane towards the lens.

The final adjustments to make are the tilt and swing on the front. A simple rule to guide front adjustments is: To bring something into sharper focus, tilt or swing the lensboard toward the subject plane. To make something less sharp, tilt or swing the lensboard front away from it.

Your choice of camera position and lens and how you use the view camera's adjustments are all part of the creative process behind every photograph. The more familiar you become with your camera's capabilities, the easier this process will be. Try to remember that good images don't always require complicated adjustments or a multitude of lenses.

CHOOSING A FILTER

Next you'll want to think about using a filter. Questions you can ask yourself include: 1) Is there blue sky in the scene? If you're using black-and-white film, a filter will help darken the blue and make any clouds or light-colored buildings stand out. Consider using a #8, #12, #16, #21, #23A, or a #25 filter in the yellow-to-medium-red range. With color film, a polarizer may be desirable to darken the blue. 2) Is there green foliage in the scene? With black-and-white film, one of the yellow-green filters, such as a #11 or a #13, will lighten foliage while slightly darkening a blue sky. A #44A filter will have a stronger effect on the foliage, but the #44A will also lighten any blue sky in the scene. With color film a polarizer may help saturate the colors, and with transparency film you may find it appropriate to use one of the #81-series filters to warm the sometimes bluish tone of the Ektachrome film.

Filters can also be employed in highly specialized ways, such as to correct a variety of unusual light sources frequently found when photographing architectural subjects. This sort of application is beyond the scope of this book. The interested reader will find an abundance of informative books on the subject in most major libraries and book stores.

CALCULATING THE RIGHT EXPOSURE

The next step is to take light readings from various parts of the scene to determine the general light level and the range of contrast. Your readings should proceed from the darkest to the lightest areas in which you want to show detail and texture. These readings will help determine your ƒ-stop and shutter-speed

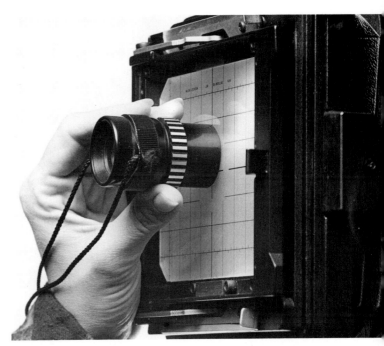

For closeup images, working in a dark interior or studio, or when the lens is closed down to check the depth of field, a magnifier placed on the groundglass can be a helpful focusing aid.

settings, as well as the development time for the negative or transparency. If you're using color film, the readings will tell you whether the film needs any pre- or post-exposure to soften the contrast by building up the shadow areas. When working with black-and-white film, remember to take light readings through the filter you intend to use on the lens, and don't forget to apply the Hutchings Filter Factor described in chapter 2.

You'll also need to take into account how the bellows extension affects the exposure. When a lens is set at a given ƒ-stop it projects a certain amount of light onto the film plane. Calculating the exposure according to the ƒ-stop setting is only accurate when the bellows is extended for an infinity focus. As the camera is moved closer to the subject, the bellows extension increases, and less light reaches the film plane. Therefore, it is necessary to allow more light through the lens when working at closer-than-infinity camera-to-subject distances, in order to obtain an equivalent exposure.

The increased bellows extension only becomes a problem when working with a camera-to-subject distance that is less than ten times the focal length of the lens. If you are using a 210mm/8¼" lens, and the camera-to-subject distance is less than 7 feet (84 inches), more exposure will be necessary to make up for the additional bellows extension. The increased bellows extension changes the effective aperature of the lens as less light reaches the film plane. There is a

As the distance increases between the light source and the subject, the light level rapidly decreases. The inverse-square law states that the intensity of illumination is inversely proportional to the square of the distance between the light and the subject; moving an object twice a given distance from the light means the object will only receive one-fourth the light, so the light must be correspondingly increased.

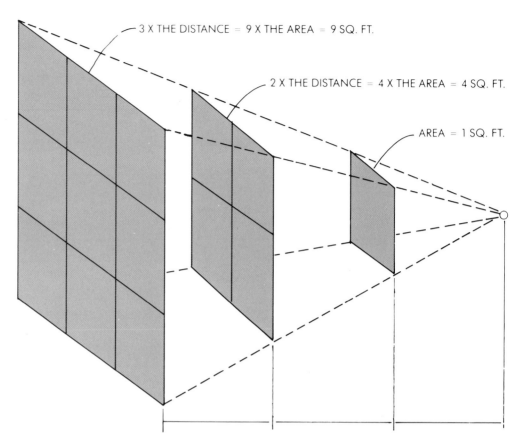

3 X THE DISTANCE = 9 X THE AREA = 9 SQ. FT.

2 X THE DISTANCE = 4 X THE AREA = 4 SQ. FT.

AREA = 1 SQ. FT.

mathematical formula for finding the increase in exposure time when doing closeup work. First, square the lens-to-film-plane distance and then divide that figure by the square of lens' focal length. Take this factor and multiply it by the indicated exposure time on the meter. For example, if you have an 8-inch lens and 12 inches of bellows extension, you will have a factor of 2.25 ($8^2 = 64$, $12^2 = 144$, $144/64 = 2.25$). A good rule of thumb for most landscape work, architectural photograph, large-product studio work, and portraiture is that for every 25-percent increase in the length of the bellows, add one-half stop of exposure (either by adjusting the *f*-stop or the shutter speed). In other words, if you are using a 210mm/8″ lens, and the bellows is extended to 10 inches, add one-half stop of exposure to what the meter indicates. For a 50-percent increase in the bellows extension (12 inches), add one stop of exposure. If you double the bellows extension to do a 1:1 reproduction, add two stops (four times as much light) of exposure.

After you've decided the exposure and the film development, take careful notes so that you'll remember how to process the film. Don't get in the habit of second guessing yourself several hours after

exposing film. Instead, you should refine your judgment and develop enough self-confidence to depend on your notes. When the film is processed, examine it to see if you have obtained the results you expected.

INSERTING FILM INTO THE CAMERA

Once everything is set up, the next step is to expose the film. Insert the film holder into the back of the camera. Be gentle and don't move the camera during this procedure, or else you'll have to reset the camera's position.

When you're working outdoors in direct sunlight, it is a good idea to leave the dark cloth draped over the back of the camera to cover the film holder after it is inserted into the camera. The film holder fits so snugly into the camera back that light rarely leaks in, but there is always that slim possibility. The older, larger holders seem to have the most problems.

You should pull out the dark slide slowly and directly. Yanking it out quickly can move the camera and may also create a static charge that will attract any dust inside the camera to the surface of the film.

EXPOSING THE FILM

Making a photograph sometimes involves finding fortuitous weather conditions, allotting several hours for set-up time, or even traveling a long distance to the scene. With all the work it takes to make a photograph, it doesn't make sense to expose only one sheet of film.

I'm not suggesting that you bracket several exposures and then pray that one of them turns out all right. However, it is simply good practice to make one or more back-up exposures. This will guard against processing errors, allow for slight variations in the exposure and development to compensate for quickly changing light, or perhaps insure that you've captured the right expression on the subject's face.

A common procedure is to process the first sheet and then judge it before the rest of the back-up sheets are developed. After the film is processed, you can refer to your notes to see if your recommendations for development were appropriate. The results with the first sheet may suggest changes for processing the rest of the film.

PROTECTING YOUR EQUIPMENT

After you've made the photograph, everything goes back under protective covering. Lens caps are replaced, gel filters are returned to their folders, meters go back into their pouches, and the camera goes back into its case. You've invested a lot of money in your equipment—now take good care of it. Many photographers are still using the same equipment they used twenty years ago, not because they feel it is the best, but because they are comfortable with it and know how it performs. This productive familiarity only occurs when the tools of the trade are well tended.

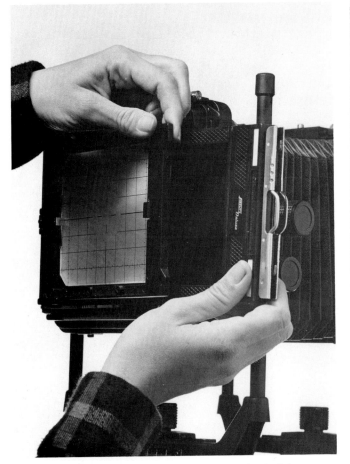

The film holder is inserted into the back standard of the camera. The metal frame holding the groundglass is pulled away from the camera (it is spring loaded) and the holder is slipped into the opening.

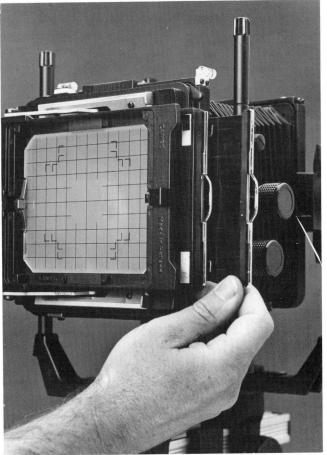

Once the holder is inserted into the camera, the dark slide must be pulled out so the film can be exposed. Unexposed film in a holder is indicated by the silver handle on the dark slide. The slide should be pulled out in a slow, even motion so the camera isn't jarred. After the film is exposed, the dark slide is re-inserted into the holder with the black side out to indicate exposed film.

Chapter Seven

FILM CHARACTERISTICS

When you begin using a view camera, you quickly learn that your choice of films is a little different from the wide range of films available for smaller-format cameras. The slow, fine-grain, black-and-white films, such as Kodak's Panatomic-X and Ilford's Pan F, aren't available in sheet-film sizes, and neither are Kodak's Kodachrome slide films. The high-speed color films aren't made in sheet-film sizes, either.

However, there are many good films available, including some that aren't made for the smaller roll-film cameras, so you won't have any trouble finding a good selection. The charts in this chapter list common films currently available in black-and-white negative, color negative, and color-transparency materials. The suggested exposure index included for each film is the recommended setting for your exposure meter. Using it should provide enough density in the thin (shadow) areas of the film to render the proper shadow tones in the print. Most film manufacturers tend to be a little optimistic about their film-speed ratings. The notch patterns pictured in these charts can be used to identify different types and brands of film when you are working in the dark.

BLACK-AND-WHITE FILMS

Panchromatic film is sensitive to the color spectrum in a way that approximates the sensitivity of the human eye. Orthochromatic film is less sensitive to red and more sensitive to blue and green than regular panchromatic film. Orthochromatic film is sometimes used for male portraits and in some industrial, commercial, and landscape photography. Its effects can almost be duplicated by using regular panchromatic film with a Kodak Wratten #44 (minus red) gel filter.

Infrared film is sensitive to infrared light not visible to the human eye and is used in some scientific, medical, and aerial-survey work. It is also employed to create special effects in landscape and architectural photography. Normally, it is used with a #25 (deep red) filter. Its effects can be softened by using #12, #15, #16, and #21 filters.

All of the films described on the chart have different characteristics that make each one attractive for certain applications. The slow- and medium-speed films tend to be sharper, and they have greater potential for increased contrast when their development time is lengthened (see page 90). However, their slower speed makes then potentially more difficult to use in situations with low-light levels because they require longer exposure times.

The higher-speed films are slightly grainier and a little less sharp, but they are easier to use in situations where the light level is low or when there is a slight movement, perhaps due to wind, in part of the scene. The higher-speed films are also better when you want to reduce the contrast in the scene by cutting back on the development time (see page 90).

Since there is no "perfect" film, the best solution is to pick one and use it consistently for several months. Your film and developer constitute a team—use them together to learn how they interact.

The black-and-white film data chart opposite and on page 74 and the color film data chart on pages 76–7 contain the most pertinent information about the films generally used with view-camera formats.

BLACK-AND-WHITE FILM DATA

	Film Size	Manufacturer's ISO	Suggested EI	Notch Pattern
SLOW-SPEED, EXTREMELY FINE-GRAIN FILMS				
Agfapan 25	4 × 5, 8 × 10, 120	25	12-16	
Ilford Pan F	120	50	32-40	
Kodak Panatomic-X	120	32	25-32	
Kodak Technical Pan	4 × 5 120	25	16-20	
MEDIUM-SPEED, FINE-GRAIN FILMS				
Agfapan 100	4 × 5, *8 × 10, 120	100	50	
Ilford FP4	4 × 5, 8 × 10, 120	125	80-100	
Kodak Ektapan	4 × 5, 8 × 10	100	50	
Kodak Plus-X	4 × 5, 8 × 10, 120	125	64-80	
Kodak T-Max 100	4 × 5, 8 × 10, 120	100	64-80	

	Film Size	Manufacturer's ISO	Suggested EI	Notch Pattern
HIGH-SPEED, MODERATE-GRAIN FILMS				
Agfapan 200*	4 × 5, 8 × 10, 120	200	100	not available
Agfapan 400	4 × 5, *8 × 10, 120	400	160-200	
Ilford HP5+	4 × 5, 8 × 10, 120	320	250-320	
Kodak Tri-X	4 × 5, 8 × 10, 120	320	160-200	
Kodak T-Max 400	4 × 5, 8 × 10, 120	400	200-250	
HIGH-SPEED, COARSE-GRAIN FILMS				
Kodak Super-XX	4 × 5, 8 × 10	200	160-200	
SPECIAL PURPOSE FILMS				
Kodak Tri-X Ortho	4 × 5, 8 × 10	320	testing required	
Kodak High-Speed Infrared	4 × 5	50 with a #25 Wratten filter	testing required	
INSTANT PRINT FILMS				
Polaroid Type 52	4 × 5	400	600 daylight 400 strobe and tungsten	
Polaroid Type 54	4 × 5	100	100	
Polaroid Type 55	4 × 5	50	80 for print 40 for negative	

*This film is not available in the United States.

RECIPROCITY FAILURE

One problem often encountered with larger-format cameras is the need for exposure times that are longer than one second. This is because the depth-of-field requirements can't always be met by using the camera movements, so it becomes necessary to use smaller *f*-stops, (between *f*/22 and *f*/64) than you are accustomed to with a smaller camera. Smaller *f*-stops mean longer exposures, and this may result in meter-indicated exposure times of one second and longer. Exposure times that are longer than one second will result in reciprocity failure affecting the film.

Reciprocity failure is a slowing of the film's reaction to light—a decrease in the film speed. This loss of film speed occurs mainly in the shadow areas, and it can be corrected by increasing the exposure time. The high values in black-and-white film are relatively less affected by reciprocity failure, and thus the increase in the exposure time must be accompanied by a decrease in the development time in order to obtain the same level of contrast in the negative. The table below gives the necessary exposure and development time adjustments for Kodak, Ilford, and Agfa black-and-white films.

RECIPROCITY CORRECTIONS FOR BLACK-AND-WHITE FILMS

	metered time in seconds	2	4	8	12	16	24	32	45	60	90	120
KODAK Tri-X, Super-XX, Plus-X	actual time necessary	5	13	37	70	108	216	316	534	832	1,550	2,400
T–Max 400	actual time necessary	3	7	18	32	54	90	140	206	300	550	800
T–Max 100	actual time necessary		10	26	45	80	124	190	280	400	720	1,050
	development time adjusted		–5%	–8%	–10%	–12%	–17%	–22%	–24%	–26%	–28%	–32%
AGFA	actual time necessary	4	10	26	45	68	124	175	278	413	719	1,060
	development time adjusted		–10%	–18%	22%	26%	–30%	–32%	–35%	–38%	–45%	–50%
ILFORD	actual time necessary	3	7	19	33	50	93	145	250	378	853	1,670
	development time adjusted			–5%	–8%	–10%	–12%	–14%	–16%	–18%	–20%	–24%
POLAROID Type 52, 54, or 55	actual time necessary	3	6	15	25	36	65	90	140	204	350	504

(no development changes)

In some cases, the exposure times indicated above are longer than those recommended by the film manufacturer. However, the exposure times in this chart have worked well for me and are a good place to start until individual experience indicates otherwise. It is far better to err slightly on the overexposure side with negative film.

As you can see, Kodak's films have the most severe rate of reciprocity failure, while Ilford's films have the least rate in terms of the necessary adjustment in the exposure time. Agfa's films fall between the other two brands. However, in looking at the necessary adjustments for development time, Agfa's films require the greatest percentage decrease, while Ilford's require the least percentage decrease in development.

You can use reciprocity failure to create an intentional increase in contrast without having to lengthen the film's development time. This can be done by using your standard or "normal" development time (see page 89) rather than the recommended decrease. A 20-percent increase in contrast—about the same as using a +1 development or one higher-contrast grade of paper or printing filter—can be obtained by using your normal time instead of following the recommendation for a 20-percent decrease. A 40-percent increase in contrast—about the same as a +2 development or using two higher-contrast grades of paper or printing filters—can be obtained by not following the recommendation for a 40-percent decrease in the development time. Contrast increases of +3 and +4 (most modern thin-emulsion films aren't capable of increasing contrast this much simply by increasing the development time alone) are possible when you combine reciprocity failure with an increase in development time. The information in this chart should be kept in a notebook that is part of the equipment you carry every time you go on a shoot.

COLOR FILM

Daylight-balanced color films are designed to be shot outdoors or with strobe and flash equipment. They are balanced for 5000- to 5500-degrees Kelvin, which is the approximate color temperature of daylight at noon on a sunny day. Tungsten-balanced color films are designed to be shot indoors with tungsten, quartz, or incandescent lights. Tungsten films are balanced for 3200K.

With color photography you also have a choice of negative or transparency film. Whether you should choose negative or transparency film depends on how you plan to use the image. If the photograph is to be reproduced in a book, magazine, brochure, or newspaper, then transparency film is the best choice. If the final result will be rendered as a color print, then

COLOR FILM DATA

	Film Size	Manufacturer's ISO	Suggested EI	Notch Pattern
COLOR NEGATIVE FILMS				
Daylight-Balanced				
Kodak Vericolor III S	4×5, 8×10, 120	160	100	
Kodak Vericolor II S	4×5, 8×10, 120	100	80	
Agfacolor 100	4×5, 120	100	80–100	not available
Fujicolor 160 S	4×5, 120	160	100–125	
Tungsten-Balanced				
Kodak Vericolor II L	4×5, 8×10, 120	100	50	
Fujicolor 160 L	4×5, 120	160	125	

	Film Size	Manufacturer's ISO	Suggested EI	Notch Pattern
COLOR TRANSPARENCY FILMS				
Daylight-Balanced				
Kodachrome 64	120	64–80	as per Kodak's data sheet	
Ektachrome 64 EPR	4 × 5, 8 × 10, 120	50–80	as per Kodak's data sheet	
Ektachrome 100 EPN	4 × 5, 8 × 10, 120	80–100	as per Kodak's data sheet	
Ektachrome 100 + EPP	4 × 5, 8 × 10	100	100	
Ektachrome 100Z	4 × 5, 8 × 10	100	100	
Ektachrome 200 EPD	4 × 5, 8 × 10, 120	160-200	as per Kodak's data sheet	
Agfachrome 100	4 × 5, 120	100	80-100	
Fujichrome 50	4 × 5, 120	50	50	
Fujichrome 100	4 × 5, 120	100	80-100	
Fujichrome Velvia	4 × 5, 8 × 10	50	50	
Tungsten-Balanced				
Ektachrome 64T	4 × 5, 8 × 10, 120	50-64	as per Kodak's data sheet	
Ektachrome 160 EPT	120	125–160	as per Kodak's data sheet	
Fujichrome 64	4 × 5, 120	50–64	50	
INSTANT PRINT FILMS				
Polacolor Type 59	4 × 5, 8 × 10	80	80	

use negative film. Actually, it is best to use both whenever possible. A transparency can be used by the color printer as a guide for getting the correct color balance in the print.

Reciprocity failure also occurs with color film when the meter-indicated exposure time is longer than one second. Although some film manufacturers don't recommend exposures longer than 10 seconds for some of their films, it is possible in some cases to obtain good results with exposures that are as long as an hour.

You don't need to alter the development time for color film when the exposures are longer than one second. Color film doesn't experience the contrast increase with long exposures that affects black-and-white film.

Every box of tungsten color-transparency film includes an information sheet that gives recommendations for the color corrections. These are necessary due to the color shifts that happen during long exposures. Sometimes a shift of five-to-ten units occurs. If absolutely perfect color rendition is required as, for instance, when photographing an interior, these color shifts can be corrected by using color-correction filters on the lens. These filters are distinct from color-compensating filters (see page 28).

RECIPROCITY CORRECTIONS FOR COLOR-NEGATIVE FILMS

metered time in seconds	2	4	8	12	16	24	32	45	60	90	120
Kodak Vericolor III S and Kodak Vericolor II S actual time necessary	3	7	18	32	48	85	128	206	308		
Kodak Vericolor II L actual time necessary	3	7	17	28	42	72	107	170	251	434	640

Knowing the actual exposure-time corrections is more useful information than the simple statement "3 Stops More" indicated on many reciprocity-correction charts. Opening the shutter 3 stops may mean going from f 32 to f 11, which could destroy the depth of field necessary to keep everything sharp in the image.

RECIPROCITY CORRECTIONS FOR COLOR-TRANSPARENCY FILMS

metered time in seconds	2	4	8	12	16	24	32	45	60	90	120
Ektachrome 64, 100, 200	3	6	15	25	36	62	90	140	204	347	504
Ektachrome 64T (Tungsten)					use meter-indicated time						
Fujichrome 50, 100, Velvia	2	5	11	17	24	38	53	80	110	176	246
Fujichrome (Tungsten)	2	5	10	15	21	34	46	68	94	147	203
Agfachrome 100	3	7	17	28	42	72	107	170	251	434	640

With some transparency films, a long exposure time causes a color shift. Information about color shifts is included along with the technical data enclosed in each box of film. If a color shift is inevitable, it becomes necessary to use color-correction filters on the lens during exposure.

Chapter Eight

FILM PROCESSING

If you will be working with color film, you should find a good, professional-quality color lab to process your color sheet film. Trying to do it at home is impractical unless you process it in large quantities, in which case buying the necessary equipment will be very expensive. Processing black-and-white sheet film in a home or small darkroom can be done easily with a little practice and a minimal investment in new equipment.

There are three ways to process black-and-white sheet film: in daylight tanks or drums, in open tanks with hangers, or in open trays. Each method has advantages and disadvantages.

DAYLIGHT TANKS AND DRUMS

Daylight tanks and drums are light-tight containers that operate much like the tanks used for processing 35mm and 120 roll film. Some tanks are made specifically for processing sheet film; these have racks that hold individual sheets of film. It is also possible to process black-and-white film in the drums designed to process color prints. Most tanks and drums can handle four-to-six sheets of $2\frac{1}{4} \times 3\frac{1}{4}$ or 4×5 film. The larger 8×10 film can be processed only in drum containers, usually one sheet at a time.

The beauty of working with these light-tight containers is that once the film is loaded and the lid put into place, the lights can be turned on, and you can see what you're doing. Then you can pour the chemicals into the tank or drum through an opening on its top or side. After the film is fixed, the lid can be removed, and the film can be inspected.

If you opt for using this film-development method, all your sheets of film must be processed for the same length of time. This is practical for studio work where you can control the lighting and contrast in a scene or if you are printing on variable-contrast paper and can change the paper's tonal range to match each negative.

However, if you are working under varied lighting conditions, you may eventually want to vary the development time for each sheet of film in order to control the contrast of each negative. This opportunity to individually tailor the exposure and development of each black-and-white negative is one of the great advantages of working with sheet film—it is the best way to obtain really good-quality black-and-white prints.

OPEN TANKS AND HANGERS

This method of film development must be done in complete darkness, which may intimidate some people, but once it is tried a few times, it becomes relatively easy. It also has the advantage of allowing different development times for each sheet of film even if a batch of four-to-six sheets are being processed simultaneously.

This technique involves placing each sheet of film in a separate hanger that is then placed into the chemical-filled tank. A standard tank for 4×5 and $2\frac{1}{4} \times 3\frac{1}{4}$ film will hold one-half gallon of chemicals and six film hangers. Tanks for 8×10 film come in three sizes: one gallon, three gallons, and five gallons. The one-gallon size will hold up to six film hangers, and the larger sizes are for doing a lot of film.

The procedure for developing film on hangers in open tanks is as follows:

1. Lay four tanks out across your sink or some other smooth surface. The first tank is for a presoak in pure water. This presoak softens the emulsion of the film so it will accept the developer more readily and evenly when the film is put into the developer tank. The second tank is for the developer, the third tank is for the stop bath, and the fourth tank is for the hypo/fixer.

2. Turn out the lights. Unload the film holders, put each sheet of film into a hanger, and then place each hanger into the presoak tank. The development time for each negative should have been written in pencil on every film holder. The negative receiving the shortest development time should be placed in the front of the presoak tank, and the negative receiving the longest development time should be placed at the back of the tank. After you put a hanger into any of the tanks, it

should be jostled to dislodge the air bubbles that may form on the film's surface. The water in the presoak tank should be the same temperature as the developer in the next tank. The presoak should last for approximately sixty seconds.

3. Set your timer (which must have a luminous dial that can be seen in the dark) for the longest development time required by the negatives in this batch of film. Move the negatives requiring the longest development into the tank of developer. Be sure to jostle the film hangers to prevent any air bubbles from adhering to the film surface. The remaining film can be left in the presoak tank until the time comes to move it into the tank of developer. When your timer counts down to the start time for the negatives needing the next longest development time, move these hangers from the presoak tank into the developer tank. Keep careful

track of your time in order to move the remaining hangers into the development tank at the appropriate times.

4. Agitation is very important to all types of film-development because exhausted chemicals must be removed from the film's surface and be replaced by fresh developer. The agitation procedure for film on hangers is as follows: Lift all the hangers out of the tank and tilt them to the left so that the developer runs off the surface of the film. Place the hangers back inside the tank. Lift the hangers straight up and out of the developer, and then put them back inside the tank. Lift the hangers up out of the solution, tilt them to the right, and put them back inside the tank.

This procedure should last only about ten seconds and should be done every thirty seconds while the film is in each of the tanks. This lifting and dunking is a

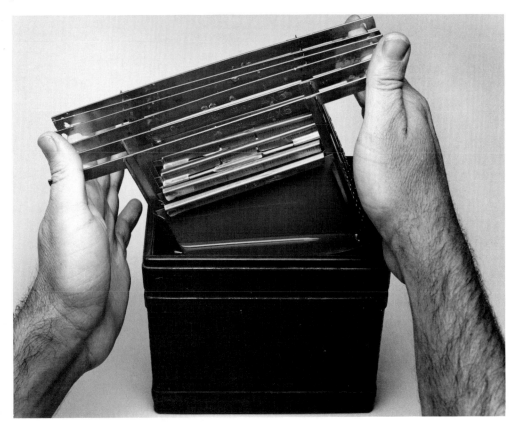

Developing sheet film with hangers and tanks is one of the recommended ways to process sheet film. Shown above is the standard film hanger for 4 × 5 film, a Kodak No. 4A. The tank is a hard rubber container that holds 64 oz. (2000 cc) of solution. Similar hangers are available for 8 × 10 film; tanks for 8 × 10 film come in different sizes depending on the number of hangers used.

It is relatively easy to develop six sheets of 4 × 5 film at one time. The film is agitated periodically, usually every 30 seconds, by lifting the hanger up and out of the tank and then slowly placing the hanger back down into the solution. Sheet film developed by this method must be handled in complete darkness until after the film is fixed.

slow and gentle procedure. If it is done too vigorously, uneven development will occur around the edges of the film as the developer surges through the holes around the edges of the hanger.

5. When the timer turns off, move all the film hangers into the tank of stop bath, and agitate the film for sixty to ninety seconds.

6. Move the film into the tank of hypo/fixer. Agitate the film throughout the normal fixing time, which should last between five and six minutes for regular fixers or shorter for quick-fix solutions.

7. Turn on the light, and inspect your film. Except for the fact that the negatives are bigger, they will look just like the 35mm or 120 negatives you have processed in the past.

8. Wash the film in running water for thirty to forty-five minutes. This can be done in one of your regular tanks, providing you empty the tank every five to ten minutes to allow for a fresh refill. Agitate the film periodically. The film can be washed while you are cleaning the other tanks and putting things away.

9. Give the film a final rinse in Photo-Flo or some other wetting agent, and hang the negatives to dry in a clean, dust-free place. The film can be dried in the hangers.

If you are developing a lot of film, it might make sense to find lids for your tanks. Putting lids over the solutions will preserve them in their tanks when not in use by preventing the chemicals from evaporating. If you rely carefully on the proper replenishment procedures for your developer, several batches of film can be run through one tank of solution. If you are processing smaller amounts of film, it is generally better to dump the developer after one use and start with a fresh solution for each batch of film.

OPEN TRAYS

Perhaps the easiest way to begin processing sheet film is in open trays since you might already have the necessary equipment. With a little practice it is quite possible to process six to eight sheets of 4 × 5 film or four to six sheets of 8 × 10 film at a time. The open tray procedure also permits individual development times for each sheet of film.

Open-tray development must also be done in complete darkness, and it involves putting your hands directly into the trays of the solution to agitate the film. If you are allergic to any of the chemicals, you should wear rubber surgeons' gloves available from most drug stores. These gloves are very snug fitting and don't hinder dexterity.

Many photographers develop their sheet film in trays. The film is placed in the tray emulsion side *down*, and the bottom sheet is pulled free from the pile and placed on top. Every minute or so the stack should be rotated 90 degrees so that the film is pulled in a different direction. With this development method, use a tray that is slightly larger than the film size. The tray should have ribs or grooves along the bottom making it easy to slip your fingers underneath the pile of film. After some practice, you should find it fairly easy to develop six sheets of 4 × 5 film or four sheets of 8 × 10 film at one time.

The procedure for developing film in open trays is as follows:

1. Lay out three trays across a flat surface. One is for your developer, one is for the stop bath, and one is for the hypo/fixer. All of the solutions should be the same temperature. If you are processing 4 × 5 film, use 8-×-10-inch trays. If you have 8 × 10 film, use 11-×-14-inch trays. You'll also need one presoak tray for each sheet of film, so lay out the presoak trays and fill them with water. Make sure that each tray has enough solution to completely cover the negatives. An 8-×-10-inch tray should be filled with one-half gallon of solution, and an 11-×-14-inch tray with one gallon of solution.

2. After all the trays are filled, lay out your film holders and turn off the lights. The negative that needs the longest development should go in the first tray. The second tray is for the second-longest development time, and so forth. Unload your film holders. Make sure each piece of film is completely submerged in its presoak tray. Put the emulsion side of the film up in the presoak tray to make sure that there aren't any bubbles on the film's surface.

3. Set your timer for the longest development time required, and move the first sheet of film into the developer tray putting the emulsion side *down*. This is to avoid scratching the emulsion side of the film during the agitation procedure. As you put each sheet in a tray of new developer, it should be gently swished back and forth to release any air bubbles that might be caught underneath its surface. When the clock counts down to the start time for the next piece of film, move it from its presoak tray into the developer tray. Place the second negative emulsion side down, and gently swish it back and forth.

4. Agitation is very important in tray development. The procedure is as follows: Take the piece of film on the bottom of the stack and free it from the pile. Lift it up and place it on top of the stack. This is a slow and continuous process that should turn over the entire stack of film four times every minute. You should rotate the stack 90 degrees every two minutes in order to pull the film in a different direction and eliminate the possibility of streaks occurring on the image.

5. When the timer clicks off, begin moving the film, one sheet at a time, into the tray of stop bath. As each negative goes into the stop bath, swish it gently to make sure its entire emulsion quickly comes into contact with the acetic acid so that the negative stops developing quickly and evenly across its emulsion. After all the film has been transferred to the tray of stop bath, serially agitate the stack of film for one minute the same way you did during development.

6. Move the film, one sheet at a time, to the tray of hypo/fixer. After all the film is in the hypo/fixer, set the timer for your standard fixing time, and begin the agitation process already described.

7. When you are finished fixing your film, you can turn on the lights and look at the results.

8. You can wash the film in a tray of running water. Make sure that the negatives stay separate and float around freely in the tray. If you are washing 8 × 10 film, you could also use an 8-×-10-inch or 11-×-14-inch print washer to wash the film.

9. Give your negatives a final rinse in a very weak dilution of Photo-Flo or some other wetting agent, and hang the negatives to dry in a dust-free place.

With tray development the developer and stop bath are usually dumped after one use. The hypo/fixer can be put back into a bottle and used again. A gallon of hypo/fixer will fix only a certain amount of film. This amount is usually described in square inches. One 4 × 5 sheet of film measures twenty square inches, and an 8 × 10 sheet of film measures eight square inches (the same as one roll of 35mm film with thirty-six exposures). Check the information packaged with your fixer to see how much film it will handle.

Chapter Nine

THE ZONE SYSTEM

The Zone System of exposure and development for black-and-white photography has been around for over forty years. It was formulated by Ansel Adams and Fred Archer while they were teaching at the Art Center in Los Angeles, California. Ansel Adams, Minor White, Fred Picker, and many others have written numerous books and magazine articles describing the Zone System. It is a simple, straightforward method for arriving at predictable, predetermined densities on the negative that translate into the desired tonal values on the print.

The Zone System is particularly useful for working with sheet film because the Zone System affords you the opportunity to tailor the exposure and development of each negative according to the requirements of the scene and the tonal range of the paper grade you are using to make your prints. This is particularly important when you are working with available light, which causes the tonal range in a scene to vary a great deal. Even if you are working in a controlled studio environment, you should run tests to find the right exposure index, or film speed, for the film you are using. A film manufacturer's ISO ratings are, at best, guidelines that need personal refinement.

One of the keys to using the Zone System is understanding what an exposure meter can, and more importantly, cannot do for you. The exposure meter is designed to translate anything it reads into 18-percent gray (see example). Whether you are taking a reading from sunlit snow or from a door deeply shaded by an overhanging roof, the meter wants everything to look this middle-gray tone.

The 18-percent gray card is used as a standard, artificial tone for meter readings, and it matches Zone V on the zone scale. Pure black printing paper is Zone 0, and pure white paper is Zone IX. If you are metering sunlit snow, you don't want it to be a medium gray in your print. It would be preferable if it were between Zones VII and VIII. Zone VIII is a very light gray tone that is just barely darker than the pure white

This middle-gray tone is Zone V on the zone scale. Most exposure meters are calibrated to give exposure readings that will result in this tone regardless of the actual value of the subject. If you want an area in a scene to be darker than this middle-gray tone, you must give it less exposure than indicated by the meter. If you want an area to be lighter than this middle gray, you must give these lighter areas more exposure than indicated by the meter.

printing paper. Zone VII is a slightly darker gray and is the lightest tone that will display detail and texture in the image.

You probably would prefer that the deeply shadowed door be darker than a medium gray, but not so dark that it loses the texture and detail that make it readable as a door. Deeply shadowed objects that must retain enough information in the print to be recognizable are frequently placed on Zone III.

ESTABLISHING A PERSONAL EXPOSURE INDEX

The first task in developing a working knowledge of the Zone System is to run tests to find the proper exposure index (E.I.) for your film and film developer. The E.I. will vary depending upon the type of light source you are using, but in most cases it will be less than the manufacturer's recommended ISO. The daylight E.I. will probably be slightly higher than the one obtained working indoors with tungsten or strobe lights. Panchromatic black-and-white film is most sensitive to the blue part of the color spectrum prevalent outdoors. Tungsten lights have less blue than daylight, so your E.I. will be about one-half stop less. Although strobe lights are the same color temperature as daylight, they flash so quickly that the film doesn't have time to react normally. Therefore, the E.I. for strobe flash in a studio will also be slightly lower than the outdoor E.I.

The second key to using the Zone System is understanding that the density in the negative's shadow areas (Zones I, II, and III) is determined by the amount of exposure given the film. Increasing or decreasing the development time has relatively little effect on the shadow areas of the negative and the resulting tones in the print.

To test for your E.I., find or set up a scene that has bright, well-lit areas as well as shadow areas that contain the detail and texture you want to retain in the print. If you generally work outdoors, find a sunlit scene with sun-drenched areas and deep shadows. If you work in a studio, set up a table top or a large illustration scene including brightly lit areas and shadow areas.

After you've established your test scene, begin taking meter readings of the different areas. Find the darkest area that includes the detail and texture you want to retain in the final print. Place this area in Zone III by setting the ISO guide on your meter at the number recommended by the film's manufacturer and then closing down your lens two stops more than your meter indicates. For example, if you are using a 1-degree spot meter with an ISO of 320 and you get a reading of 10, the meter would suggest an exposure setting of $\frac{1}{15}$ sec. at $f/11\ \frac{2}{3}$. This setting will give the scene's deep shadows a tonal value of Zone V, which is medium gray. Setting the lens for one stop less exposure, or $\frac{1}{15}$ sec. at $f/16\ \frac{2}{3}$, will give deep shadows a tonal value of Zone IV. Closing the lens down one more stop for an exposure of $\frac{1}{15}$ sec. at $f/22\ \frac{2}{3}$ will give the area a tonal value of Zone III. To run a test for your personal E.I., follow these steps:

1. Shoot one sheet of film exposing the darkest area for Zone III at the manufacturer's suggested ISO (in this example, the original is 320).

2. Shoot a second sheet of film with one-third stop more exposure (in this example, the new setting would be $\frac{1}{15}$ sec. at $f/22\ \frac{1}{3}$, which would give you an E.I. of 250). Most view-camera shutters are marked in one-third stop increments.

3. Shoot a third sheet of film with an additional one-third more stop exposure (in this example, the third exposure would be $\frac{1}{15}$ sec. at $f/22$, which would give you an E.I. of 200).

4. Shoot a fourth sheet adding another one-third stop of exposure (in this example, the fourth exposure would be $\frac{1}{15}$ sec. at $f/16\ \frac{2}{3}$, which would give you an E.I. of 160).

COMPACTIONS

EXPANSIONS

N – 2	N – 1	Result of Altered Development	N + 1	N + 2

Zone X

Zone IX → Zone IX

Zone IX
pure paper white

Zone VIII — Zone VIII

Zone VIII
a light tone just
darker than paper white

Zone VII — Zone VII

Zone VII
light gray with
good texture and detail

Zone VII

Zone VI — Zone VI

Zone VI
light gray
(light skin)

Zone VI

Zone VI

Zone V — Zone V

Zone V
medium gray
(dark skin)

Zone V

Zone V

Zone IV — Zone IV

Zone IV
dark gray but
with good detail

Zone IV

Zone IV

Zone III — Zone III

Zone III
dark gray, darkest tone
with good detail

Zone III

Zone III

Zone II — Zone II

Zone II
dark gray, just a
hint of detail

Zone II

Zone II

Zone I — Zone I

Zone I
almost black

Zone I

Zone I

Zone 0 → Zone 0

Zone 0
darkest black produced
by printing paper

Zone 0 ← Zone 0

Compacting or expanding a normal development time, which means reducing or increasing it, will change the placement of tonal values across the zone scale. This chart shows what the new zone values will be after the development has been altered. Sometimes the new values fall halfway between the standard zones as the arrows indicate.

If you are using strobe lights in a studio with an incident-flash meter, use the *f*-stop and shutter speed setting recommended by the meter for the first sheet, but shoot the three additional sheets of film with the one-third-stop increases in exposure.

Process the film according to the time recommended by the film manufacturer. Add one sheet of unexposed film to the development process, so that you get four sheets of exposed film and one clear piece of film. Now do the following:

1. Take the clear piece of film and put it in your enlarger, or contact print the clear piece of 8 × 10 film (see page 93). Set the enlarger head's height for an 8 × 10 print, and adjust the lens to the place where an image, if there were one, would be in focus.

2. Set your enlarger timer for 2 sec., and close the lens down three stops from its maximum aperture. Place a sheet of printing paper directly under the lens so that the paper is completely inside the 8 × 10 area of light projected by the enlarger.

3. Expose the paper in 1-inch increments all across the sheet. Cover most of the paper for the first 2 sec. exposure, and then slowly uncover 1-inch sections and do the additional 2 sec. exposures. When you're

finished, you'll have exposed sections for 2, 4, 6, 8, 10, 12, 14, and 16 sec.

4. Process the print as you normally do. After it is fixed, turn on the light, and look at the results.

5. You will see a succession of gray bands that get darker across the paper. At some point you'll see two adjoining bands that can't be distinguished from one another. They are the maximum black that your paper and print developer can produce. The black band that received the shorter exposure received the minimum amount of exposure to produce the maximum black tone. If you don't have two bands with the same tone, then repeat the procedure using 3 sec. increments. If the bands with the same tone appear early in the sequence, then repeat the procedure using 1 sec. increments.

6. Record the exposure time and *f*-stop for the maximum for later use. This is now your proofing time for all subsequent tests with this combination of film, film developer, and printing paper.

7. Place each of your test negatives in the enlarger and expose a piece of paper using the same *f*-stop and time just established. Process each print as you

This is an example of the results from a proof test. I exposed a piece of print paper through a clear piece of film (unexposed but completely processed) and made a series of 2-sec. exposures across the paper. The exposure times on the successively darkening strips are 2, 4, 6, 8, 10, 12, 14, 16 and 18 sec. with the enlarger lens set at *f*/16. The tonal difference between the strips is evident until you reach the 16 and 18 sec. portions. Since 16 sec. is the least amount of exposure time needed to make the maximum black tone for this combination of film, paper, and paper developer, I know how to proof my negatives for all of my film tests and subsequent photographs. If I decide to use a different film, print paper, print developer, or developer dilution, I will need to redo this test.

These four photographs were made as one of my exposure and development tests. The first picture was printed from a negative exposed according to the manufacturer's exposure index of ISO 320.

The windows along the right side of the building registered as 10 in my 1-degree spot meter. Placing them in Zone III (where important shadow areas are generally placed) meant giving the film two-stops less exposure than indicated by the meter (remember, the meter wants to place everything in Zone V). In this case with ISO 320, my exposure was 1/30 sec. at f/16⅔.

The sun-struck stucco area of the building registered a 15 on my meter, which meant a five-zone spread from Zone III to Zone VIII. Zone VIII is just a little darker than pure paper-white, which is how I wanted the sun-drenched walls to look. Zone VIII doesn't show much texture and detail, but the building material was smooth and displayed very little texture. Finding a five-zone spread meant I had located a "normal" scene to record on film. I exposed this first test and developed the negative for eight minutes.

I knew as soon as I turned on the lights that the film was underexposed. The shadow areas of the negative were very thin; however, I printed the negative for my proof time and obtained the top left picture. Not only are the shadow areas much too dark and empty, but the stucco walls are also too dark. They are about a Zone V-½ (medium gray) and I wanted a Zone VIII.

From this proof I knew that both the exposure index and the development time were wrong for this particular film. Trying a harder grade of paper or a contrast filter would have elevated the stucco on the zone scale, perhaps to Zone VII or VIII, but the shadow areas would have still been too dark and empty.

The top right picture was made from a negative given the same exposure as the first, but developed for twelve minutes (50 percent longer than the first). The sun-drenched stucco is now too light, and the line between the top of the building and the sky disappears. Although the stucco in the shaded area is brighter, the windows are still too dark and empty. A softer grade of paper or a printing filter could be used to soften the overall contrast of the scene, but the windows would still be empty.

The bottom left photograph was made from a negative given twice the exposure recommended by the manufacturer and developed for nine minutes. The shadow areas in the windows along the right side and the trees on the left are lighter and show more detail and texture. The additional exposure for this negative did what the extended development for the second picture could not do—it gave more depth and life to the important shadow areas placed in Zone III.

The sun-drenched stucco is also brighter. It now falls in about Zone VII and separates nicely from the sky. This is a definite improvement over the previous two examples. With some print development manipulation and possibly a harder grade of paper or a printing filter, it would be possible to raise the Zone VII stucco to Stone VIII and create a pretty good print.

The bottom right picture was given the same exposure as the third, but it was developed for ten minutes. The shadow values remain the same, but the stucco is a little brighter in this photograph and achieves the Zone VIII placement that I wanted. I now know that with this combination of film and film developer I need an exposure index of 160 and a development time of ten minutes whenever I photograph a sunlight scene with a five-stop spread between the important shadow and high-value areas.

normally do. After they are fixed, turn on the lights, and inspect the results.

8. Look at the shadow area placed in Zone III, and compare its differences between the prints. Select the one with the best detail and texture—it should have a good, deep, dark gray tone. The negative used for this print is the one exposed at the proper E.I. for your film, film developer, and printing paper.

You have now established your personal E.I. for the tested film under the tested exposure situation, whether you used daylight, studio strobe, or an incandescent light source. If you are content to alter the contrast of the print by changing paper grades or printing filters, then further testing is not really necessary. You've determined how much exposure is required to obtain the desired shadow densities; the high-value placements can be manipulated during the printing process. However, if you want to work with just one or two paper grades and keep your print manipulations to a minimum, then you'll need to do more testing.

DETERMINING NORMAL DEVELOPMENT

The third and final key to using the Zone System is understanding that the negative densities creating high values (Zones VI, VII, and VIII) on the print are more influenced by the development time than by the exposure. If your high values are too dark, then the development time was too short. If your high values are washed out and appear blank and paper white, then the development time was too long. Now that you have your own E.I., the next step is to determine your "normal" development time, or how long you should develop your film to make a Zone VIII value in a scene into a Zone VIII value on your chosen paper grade.

Go back to your test scene. If you were working outdoors, meter the brightest area where you want to retain detail and texture in the print. Let's assume your meter gives you a reading of 15. This is five stops brighter than the 10 reading you obtained for the shadow area. Set your meter for your personal E.I., and expose four to six sheets of film, placing the shadow area in Zone III. The bright area where you want to hold a very light tone will now fall in Zone VIII. Process the film for various development times: for example 7, 8, 9, 10, and 11 minutes.

Place one of these developed sheets in your enlarger, keeping the enlarger head in the same position as in your E.I. test, and expose a print for your proof time. Process the print as you would

normally. After it is fixed, turn on the lights and look at the Zone III and Zone VIII areas. The Zone III area should be a deep gray and have good detail and texture. The Zone VIII area, if properly developed, will be a light gray that is barely darker than pure paper white. If so, that negative was developed for the correct length of time. If the Zone VIII area is too dark, try a negative developed for a longer time. If it is too light, try a negative developed for a shorter time.

Once you have found the negative that produces the desired tone on the print, you'll know what your normal development should be. This will be your development time for test film whenever you photograph a scene that has a five-stop spread between the important shadow areas and the important high-value areas. Each time you decide to try a new film or film developer, it will be necessary to repeat this test procedure to establish your personal E.I. and normal development time.

The process whereby normal development is increased, or expanded, so that a brightness value in a scene moves into a higher zone, is called normal-plus. When brightness values and contrast are decreased, or contracted, by reducing development time, this is termed normal-minus. The common abbreviation for normal development is N. N + 1 (normal-plus-one) indicates an increased development; a Zone VII value would increase one zone to Zone VIII. N − 2 (normal-minus-two) means a decreased development; a Zone X value would decrease two zones to Zone VIII.

Try to keep your normal development time between 8 and 11 minutes. You can adjust your developer's dilution to increase or decrease your normal development time. If your normal time is less than 8 minutes, then your N − 1 and N − 2 may drop below 5 minutes, which is generally considered the minimum time for tray or hanger development. If your normal time is longer than 11 minutes, then your N + 1 and N + 2 development times will be too long.

If you are working in a studio with consistent lighting ratios or are on location using supplemental lighting to adjust the light ratios for color transparency or negative film, then your normal processing time for black-and-white film will be that which renders the high values as you desire them on the print. Once you have established this development time, you may not have to do any further testing. However, if you are working under varied lighting conditions, such as with landscape or outdoor architectural subjects, then you may want to do some further testing to learn how to increase and decrease the tonal range of the negative to match that of your paper grade.

Zone-System exposure and development manipulations can be used on roll film as well as sheet film. If you are a roll-film user, you'll want more than one roll-film back for your camera. If you have two roll-film backs, use them in calculated-development combinations of N and N − 1, N and N + 1, or whatever makes sense according to the situations you are photographing. If you have three backs, you can do N − 1, N, and N + 1 development.

DECREASING THE CONTRAST RANGE OF A SCENE

Your normal development should be used when there is a five-stop range between the meter readings for the important shadow areas and the important high value areas. If there is a six-or-more-stop range, then you will either have to use a softer paper grade or printing filter, or you will need to make some adjustments in the E.I. of your film and its development time.

When you find a scene where there is a six-stop spread between the important shadow areas and the important high-value areas (for example, a spread from Zone III to Zone IX), then you've encountered a situation that calls for an N − 1 treatment of your film's exposure and development. Try to find a scene with this six-stop spread in the meter's reading. Shoot four negatives according to the following guidelines:

1. Use your normal E.I. and place the shadow area in Zone III. (Remember this means two stops less exposure than indicated by the meter that wants to make everything a medium gray, or Zone V). Develop this negative at 85 percent of your normal time.

2. Expose a second negative with one-third stop more exposure. Develop this negative for 80 percent of your normal time.

3. Expose a third negative with one-half stop more exposure than the first negative. Develop the third negative at 75 percent of your normal time.

Now process these negatives (along with enough extra film to make a regular size batch) and let them dry.

After they are dry, proof them as you did the negatives for the normal test. The negative that gives you the desired print tones is the one that was correctly exposed and developed. Even if you don't get the exact tonal range with any of these negatives, you should be close enough with one to extrapolate the correct E.I. and development time for an N − 1 situation.

When you come across a scene with a seven-stop spread between the important shadow and high value areas (for instance, Zones III to X), then you have an N − 2 situation. If you want to test for N − 2, find an appropriate scene and do the following:

1. Set your meter for two-thirds the E.I. for an N − 1 scene, and place the important shadow detail in Zone III. Develop this negative at 85 percent of your N − 1 development time.

2. Expose a second sheet of film with the same E.I. as the first, but give the second 15 percent less development.

3. Expose a third sheet of film with one-third stop more exposure than the first, and give the third 15 percent less development than the second negative.

Proof these negatives as described for the other tests. The negative that gives you the desired tonal range or comes the closest to it in the print is the negative that received the proper exposure and development for an N − 2 scene.

On occasion it may be necessary to treat your black-and-white film to an N − 3 or an N − 4 process. N − 3 situations can generally be handled by cutting your N − 2 E.I. in half and using 75 percent of the N − 2 development time. N − 4 situations can be handled by using one-half the N − 3 E.I. and by processing your film for 60 percent of the N − 2 development time. Not all films and film developers respond well to severely shortened development. Local contrast can be flattened to a point where the whole print looks dull and lifeless. If you think that N − 3 and N − 4 situations are something you may encounter, then it would be wise to do some testing beforehand.

INCREASING THE CONTRAST RANGE OF A SCENE

There will be times when you photograph scenes that have less than the five-stop range between the shadow and high-value areas. For esthetic reasons you may decide to leave this short tonal range as is, but you will also want to know how to increase it when the need arises.

When you find a scene with a four-stop range between the shadow and high-value areas (for example, between Zones III and VII) that you want to increase to a five-stop range, you have encountered an N + 1 situation. This expansion of the scene's contrast can be accomplished by using a harder grade of printing paper or a higher number printing paper or by

increasing the development time of your film.

To test for your N + 1 E.I. and development time, find a scene with a four-stop range between the important shadow areas and the important high-value areas. Once you've located the scene, do the following:

1. Expose one negative at your normal E.I., and place the shadows in Zone III. Develop this negative 20 percent longer than your normal development time if you are using a slow- or medium-speed film, and 25 percent longer if you are using a high-speed film.

2. Expose a second negative with one-third stop less exposure than your normal E.I. Develop this negative 30 percent longer than your normal time if you are using a slow- or medium-speed film, and 40 percent longer if you are using a high-speed film.

3. Expose a third sheet of film but give it one-half stop less exposure than your normal E.I. Develop this negative 25 percent longer than your normal development time if it is a slow- or medium-speed film, and 35 percent longer if it is a high-speed film.

4. Expose a fourth sheet of film in the same manner, but give it 35 percent longer-than-normal development if it is a slow- or medium-speed film, and 45 percent longer if it is a high-speed film.

Once the negatives are processed and dry, proof them the way you proofed all the other test negatives—with the enlarger head in the same place, with the same f-stop on the enlarging lens, and making prints with the same exposure time. Look at the shadow areas of the four test prints. They should be about the same, although the shadow areas in the prints from the first two negatives might be a little brighter. Decide which print has the detail and textural information that matches your normal print from the earlier testing. Now look at the high-value areas. Which negative best raised the Zone VII area to a Zone VIII tone? After evaluating the prints you should be able to determine your N + 1 E.I. and development time.

N + 2 situations occur when you want to expand the contrast of a scene with only a three-stop range into a print that has a five-stop range between the shadow areas and the brighter areas. N + 2 expansions are more difficult than an N + 1 expansion, and some film-and-developer combinations won't go past N + 1 or N + 1½. Consequently, it may be necessary to use harder grades of paper or printing filters in addition to lengthening the development time

for the film. With higher-speed 120 and 4 × 5 films, grain can become a problem if the development time becomes too long. Grain size is rarely a problem with the 8 × 10 negative. The slow- and medium-speed films generally respond better to contrast expansion because they are inherently more contrasty to begin with and have a finer and tighter grain pattern.

To test for an N + 2 E.I. and development time, find a scene with a three-stop range between the important low and high values and do the following:

1. Using an E.I. that is the same as that obtained from your N + 1 tests, place the low value in Zone III. Develop this negative 25 percent longer than your N + 1 development time for slow- and medium-speed films, and 30 percent longer for high-speed films.

2. Expose a second negative the same way, but develop it 30 percent longer than your N + 1 development time for slow- and medium-speed films, and 40 percent longer for high-speed films.

3. Expose a third sheet of film with one-third stop less exposure and process it 30 percent longer than your N + 1 time for slow- and medium-speed films, and 40 percent longer for high-speed films.

4. Expose a fourth sheet of film with the same exposure as the third negative. Develop it 40 percent longer than your N + 1 time for slow- and medium-speed films, and 50 percent longer than your N + 1 time for high-speed films.

After these sheets of film are processed proof them as usual. Compare the test prints for the tones in the shadow and high-value areas and also for visible grain. If the low values are similar in tone to those obtained on your other test prints, then you have determined your N + 2 E.I. If they are too bright, then give the next set of N + 2 test negatives a little less exposure. It is doubtful that the low values will be too dark, but if they are, then give the next set of tests a little more exposure.

Now look at the high values. Have they been raised to Zone VIII as desired? One of the negatives should be very close. If one of the negatives has the desired Zone VIII tone, then you have determined your N + 2 development time. If all the print tones are too dark, then do another set of tests with a longer series of development times and the appropriate adjustments to the E.I.

You should also check the grain on the test prints. If you are getting visible grain on your 8 × 10 test

prints, then there might be a problem with an 11 × 14 or a 16 × 20 print. If grain is becoming a problem, then use your N + 1 E.I. and development time along with a harder grade of paper to obtain an N + 2 expansion, or switch to a slower and finer grain film.

N + 3 and N + 4 expansions are sometimes possible with the slow- and medium-speed black-and-white films and some developers. Their development times can be quite long, but interesting results can be obtained with careful testing.

THE ZONE SYSTEM FOR COLOR PHOTOGRAPHY

Although the Zone System was originally developed with black-and-white film, it does have considerable value for working with color negative and transparency films. Having a good understanding of the black-and-white zone scale will help a great deal when learning to interpret the values in a color scene. The first step is to establish your personal E.I.s for the films you'll be using.

Color-Negative Film. Like black-and-white negative film, color negative film is more tolerant to overexposure than to underexposure in terms of yielding acceptable results. So it is important to determine how much exposure the negative needs to give it enough density to produce the desired detail in the shadow areas of the finished print.

The proper E.I. for color negative film can be determined in the same manner as that used for black-and-white negative film—find a scene with a four-stop range, and expose the important shadow area for Zone III½. Do this in one-third stop increments, starting with the recommended ISO and working down to an exposure that is twice that recommended by the film manufacturer. Have the color lab develop and proof the film, and ask them to help determine which negative has the best exposure.

A color print will display detail and texture through a range of four stops between the deepest shadows and the highest values (for example, between Zone III ½ and Zone VII ½). If the scene has a greater range, then you will either have to add supplemental lighting to open up the shadows, sacrifice the shadow or high values, or shoot under softer conditions. If you want to increase the contrast of the scene, Kodak Vericolor II commercial film has a range of three-and-a-half stops, which is approximately equal to a +1 development.

A good professional color-processing lab can "push" or "pull" color negative film. Pushing the film means increasing the contrast, while pulling the film means decreasing the contrast. If you want to increase the contrast, expose the film at your normal E.I. to protect the shadow values, and use push processing (slightly more time in the first developer) to raise the high values approximately one zone.

If you need to soften the contrast, give the negative a little extra exposure, again to protect the shadow values, and ask the lab to pull the film (a little less time in the first developer). This will pull down the overexposed high values. Pushing and pulling color negative film is a touchy procedure, and you should talk to your color lab and do some testing before trying this technique during an assignment.

Color Transparency Film. Color transparency film has a slightly longer zone scale than negative film because it is viewed by transmitted rather than reflected light. However, it is less tolerant of overexposure, so greater care must be taken when using this material. If properly exposed, transparency film displays good texture and detail from Zone III ½ to Zone VIII.

To determine the E.I. for color transparency film find a scene that has a four-stop contrast range. Expose the first sheet by using the manufacturer's recommended ISO, placing any white or light gray areas in Zone VIII and the important shadow areas in Zone III ½. Make two additional exposures of the same scene, giving one-third stop more and one-third stop less exposure. Have these sheets of film processed by the color lab, and look carefully at the results. All three may be acceptable, but one will have the best color saturation and the feeling of brightness that matches how you felt about the scene. With transparency film it is generally better to err slightly on the side of underexposure. Overexposure can lead to a loss of detail and texture in the high-value areas.

Some development manipulation is possible with transparency film. Many color labs can push or pull the film one or two stops. These manipulations can increase contrast or save a slightly underexposed film (push), or reduce contrast or save slightly overexposed film (pull). Consult with your local professional lab regarding their capabilities and recommendations.

Pre- and Post-Exposure. Another technique that works with color films is reducing contrast by pre- or post-exposure of the film. This procedure involves giving the negative or transparency an overall exposure between Zone II and III (depending on the amount of softening necessary). This technique will add

proportionally more exposure to the shadow areas of the film and will open them up.

This overall exposure can be made by placing a white card that is evenly illuminated by the correct light source (daylight or tungsten) in front of the lens and exposing for Zone II to III depending on the amount of softening needed. (Remember that the meter gives you the necessary exposure for Zone 5 and you want Zone II or III). It is essential for the card to cover the entire viewing area of the lens so that all of the film receives an equal amount of exposure. This second exposure can be done before or after the scene is recorded on the film.

Pre- and post-exposures are valuable resources for the view-camera photographer. You should do some testing and consulting with a good professional color lab in order to determine just how much pre- or post-exposure can be used before the transparency or print begins to look a little flat or fogged.

PRINTING LARGE NEGATIVES

Printing roll-film and sheet-film negatives is not any different than printing smaller negatives. You will need access to an enlarger capable of handling the larger film and to enlarging lenses that match the film size. It is becoming more practical to print color in a small commercial or home darkroom. Several new processes and printing methods have been developed that are relatively simple and not too expensive.

The length of your enlarging lens should match the length of the normal lens for your camera. Shorter lenses don't have adequate covering power, and longer lenses require more distance between the enlarger head and the printing easel; the latter makes 16×20 enlargements impossible because the enlarger's center support column usually isn't tall enough.

120mm and 4 × 5 Negatives. For people using 120 roll-film, an enlarging lens between 80 and 105mm long will do the job. Enlarging lenses in these focal lengths are relatively easy to find. If you use a 4×5 camera, select a 135 to 150mm enlarging lens. Some of the newer 4×5 enlargers have motorized heads that rise and fall at the push of a button. This is a nice feature but shouldn't be considered a necessity.

Light sources for an enlarger can vary considerably. Most enlargers are sold with a small incandescent bulb located in the top of the enlarger head; the light travels down to the negative through a set of condensors. These can be used for printing either black-and-white

or color work. If you plan on printing color, you'll need a set of color printing filters in order to fine tune the color of the print. If you will be printing black-and-white images on variable-contrast paper, you'll need a different set of printing filters that allow you to manipulate the contrast of the print. These filters are placed in a filter drawer that is generally located below the condensors but above the lens.

Another light source used for printing black-and-white work is called a cold light. This small fluorescent tube is wound back and forth inside the lamp housing. The cold-light head produces a soft, even illumination, and some people feel it produces prints with a smoother tonal scale and better separation between the high values than a condensor setup. The cold-light lamp cannot be used for printing color because the fluorescent tube emits green and blue-green light that cannot be corrected in color printing.

If you are serious about printing color, the best approach is to buy a color-printing head for your enlarger. This head contains a set of internal color filters allowing you to dial in the right amounts of yellow, magenta, and cyan correction. The color head can also be used to work with variable-contrast black-and-white paper because the yellow and magenta color-

Virgin River, Zion National Park. Fall, 1987.
By Gary Adams
This photograph was made with an 8 × 20 format. As with the 12 × 20 format, these cameras are sometimes referred to as "banquet cameras" because many years ago they were used to photograph banquets and large social gatherings. The long horizontal format demands a special eye for unique compositions, but when used carefully, these cameras produce wonderful images. Contact printing is the only way to work with this format.

correction filters can be used to simulate black-and-white printing filters. When all the filters are turned to the zero setting, you can use the color head to work with graded black-and-white paper.

8 × 10 Negatives. An 8 × 10 (or larger) negative presents a unique set of problems and opportunities. It is possible to enlarge an 8 × 10 negative, but a virtual impossibility with larger film sizes. You could buy or make an 8 × 10 enlarger, but they are very big and heavy, and will take up a great deal of space in the darkroom. Vertical models require 9 or 10 feet of floor-to-ceiling height. Horizontal models project the image against an opposite wall or movable easel.

Generally, the larger formats require contact printing. Many photographers choose these large cameras because they want large prints of contact-print quality. The contact print has a tactile feel and a textural clarity; the beauty and delicacy cannot be matched by any enlarged image.

To make a contact print, lay the negative directly on the paper, then place a sheet of glass on top of the film to keep it in close contact with the paper. Expose the paper through the film with an overhead light source, either an enlarger or a bare light bulb.

CREATIVE APPLICATIONS

After learning how the view camera works and how to process prints using the Zone System of exposure and development, it is easier to appreciate the technique and planning behind each of the following pictures. These photographs were made by a cross section of view-camera photographers and are evidence that there is no one style of view-camera photography. On the contrary, the view camera is the photographer's ultimate tool for achieving a highly personal style of photography.

© Nikki Pahl

RABBIT AT FAIRYTALE TOWN
by Nikki Pahl

This photograph was made with a Crown Graphic 4 × 5 camera and a 135mm lens. The film was Kodak Tri-X used with an E.I. of 250. It is easy to belittle the Crown and the Speed Graphic cameras because they are not fully functioning view cameras. They have a relatively short bellows (less than twice the length of the normal lens) and limited movements (generally only front tilt and rise and fall). Still, in the hands of a sensitive photographer they can produce wonderful results.

This photograph was taken through a chain-link fence. A small fence link was in front of the lens, but it was so badly out of focus it didn't register on the film. No camera adjustments were used. The aperture was *f*/22, and the exposure was ⅟₁₅ sec. The film development time was shortened to approximately N − 2 in order to give the fog a Zone VII–VII½ substance rather than the blankness of Zone IX. Because of the reduced development, Pahl set her exposure meter at 125, half her normal E.I. for this film.

THE TOY TRUCK

This photograph is a little satirical and was made for a group exhibit where each photographer had to include a red ball in his or her image. In order to enlarge the size of the toy truck in relation to the eighteen-story building, it was necessary to place a wide-angle camera as low as possible and then to position the camera very close to the truck. I accomplished this by pulling the center column out of my tripod and reversing it so that it projected down rather than upwards. The camera was then mounted onto the center column so that the front and rear standards actually rested on the ground. Had I used the tripod in the usual manner, I would have had the camera about 12 inches above the ground, which would have placed it above the center line of the truck and changed the size relationships considerably.

I purposely changed the size relationship of the truck and the building by moving quite close to the toy, about 18 inches away, and using a 90mm lens on the 4 × 5 camera.

I chose to make this photograph at dusk to just get a hint of the outline of the building and to include the street lights and the headlights of the passing cars as additional points of interest. All the lighting in the scene was available light with one exception: I did put a small, blue, daylight bulb in a reflector and aimed the light at the truck since it was the main subject. This small floodlight was powered by a portable generator.

I made my first exposure of 2 minutes at dusk to place the values of the top of the building and the sky in Zones III½ and IV respectively. The meter-indicated exposure was 30 seconds at *f*/32 for an E.I. of 80 with daylight-balanced Kodak Vericolor Type S film, but the reciprocity-failure correction called for an exposure of 120 sec. The lower section of the image was placed approximately in Zone III. After dark, a second exposure of 5 minutes was made to make the lights in and around the building record as Zone VIII and the general street area record as Zone III. This additional exposure on the bottom of the scene raised its total value to between Zone IV and IV½. Then I turned the floodlight on, aimed it at the truck, and made another exposure of 60 sec. This exposure had very little effect on any of the values of the rest of the scene, except it did record some headlights from passing cars.

CATHEDRAL OF THE BLESSED SACRAMENT, SACRAMENTO

Photographing the interiors of older churches can be a very rewarding adventure in color as well as black and white. This photograph was partly a personal assignment, but it was also made to document the upcoming one-hundredth birthday of the church. One hundred years may not seem like a long time in some parts of the world, but California is a relatively new place, and such buildings are rare.

The only adjustment used to make this photograph was considerable front rise. The camera was a 4×5 wide-angle model, and the lens was a 90mm F8. I would have preferred to back up a little more, but I was up against the back wall and couldn't retreat any farther. I rejected the idea of using a wider lens, because it would have caused greater distortion than that already apparent with the 90mm lens.

The problem of obtaining texture and detail throughout the image could not be solved by giving the negative additional exposure and minimal development because I was using color film. Some development manipulation can be carried out with color film but not enough to handle the extreme contrast range found in this situation. Adding supplemental lighting to any interior scene poses a challenge to do more than just flood the space with light to show what is there. Each interior has its own ambience that must be respected. When a photographer simply adds lights to brighten a space several sets of shadow lines often appear. These shadow lines telegraph the photographer's lack of feeling for the subject to the viewer.

One solution to lighting such a large space as this church is the old technique of painting with light. This simply means washing large areas of the interior with a constantly moving light source that fills in the shadow areas and gives a soft, luminous feeling to the space. It is a time consuming process, but it worked very well in this situation. Ultimately, I made nine exposures on the same piece of film. The first eight were done at night, and the last one was done after daybreak to show the colors in the stained-glass windows.

My first exposure was for a spotlight placed in the front of the church and used to illuminate the domed ceiling. The light was carefully hidden from the camera by one of the columns along the left side of the interior. Then a series of exposures was made by placing the same spotlight behind each of the four columns to the left of the camera and the one to the right of the camera. All of the other lights in the church were turned off, the shutter was opened, and I stood behind each column and "painted" the opposite wall and ceiling with light. At the end of each exposure, the light was turned off and the shutter closed (the "T" setting was used). This painting technique eliminated the shadows that would have appeared if single or multiple stationary lights had been used. A sixth exposure was made by aiming the spotlight in the balcony down onto the pews along the floor. I made the seventh exposure by walking up and down the aisle to the left of the camera position with a bare light bulb. This moving light source illuminated the left side of the scene without leaving any telltale shadows. The church lights were turned on for the eighth exposure. It was very brief and only served to show the lights as being on. If an

attempt had been made to illuminate the interior with these lights, the exposure would have been so long that the image of the lights would have burned out and appeared as huge flare balls. The final exposure was made after sunrise to

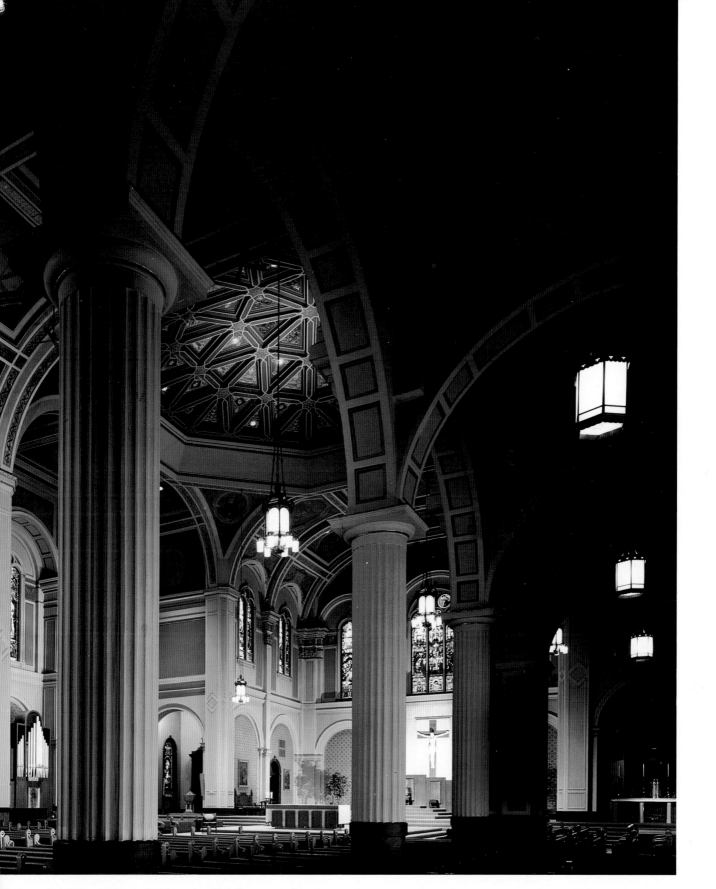

show the stained-glass windows. An 85B filter was placed over the lens. I used a tungsten-balanced negative film to make this photograph because all of the painting process was done with tungsten and incandescent lights. The 85B filter warmed up the bluish cast of the daylight and accurately recorded the colors in the windows. All the exposures used to make this image, including the Polaroid test shots, were several minutes long.

FRANK FAT'S RESTAURANT

Architecture and interior photography almost demand the large-format, adjustable camera. This specialty involves a slow, contemplative way of working, and the buyers of such photographs—architects and interior designers, magazines, and building-material associations, among others—have long expected the photographer to use a view camera. Very few photographers do much work with a nonadjustable roll-film camera. This photograph of a newly remodeled restaurant presented a variety of interesting problems and wonderful opportunities. The wild colors, the creative but fairly even incandescent lighting, and the exciting décor made this a marvelous environment to photograph.

I used a 4 × 5 wide-angle monorail camera with a 75mm f8 lens. This is a very wide lens for the 4 × 5 camera, and it must be carefully manipulated or the pronounced wide-angle look can be disturbing. You can see some stretching of the place settings in the lower corners. The camera position was chosen to give a good view of the central dining room and to show off the space-age chandelier. A considerable amount of front-rise adjustment, just short of the lens' limit, was used to include all the desired elements. Doing a symmetrical, or one-point, perspective is tricky with a wide-angle lens. Any minor misalignment is exaggerated, so it is important to check the groundglass carefully to make certain all the elements are square with the film plane. The camera must be perfectly horizontal left to right and front to rear.

All the lighting in the scene was available incandescent except for the neon that is a fluorescent light source. Sometimes it is important to correct the lights to match the 3200K temperature of the tungsten film, but in this situation I decided that letting the colors go would be more in keeping with the spirit of the place. The bar area through the central door required some additional exposure, so a second exposure was made with the dining room lights off. The balance between the two rooms was worked out with Polaroid film.

The resale possibilities of such an image are very good. This photograph was initially done for a local magazine, but I also sold it to a national design magazine, the architect, the construction company, and to a restaurant magazine.

RESIDENTIAL INTERIOR

I used some extreme shift movement in order to create the image I wanted of this home interior. My client on this job was the architect. I positioned a wide-angle, monorail camera with a 75mm lens so that it could record the fireplace down the hallway on the left side of the frame. In order to keep everything square and somewhat symmetrical, I kept the film plane parallel to the vertical walls and the counter in the kitchen area.

This camera placement and adjustment created an image on the groundglass that included a great deal of outdoor material I didn't want on the left side of the frame, and it excluded some detailing I wanted that fell outside the right edge of the frame. To correct this I shifted the rear standard to the left and the front standard to the right as much as possible without moving the groundglass outside the image circle projected by the lens. I had to watch the corners of the groundglass to make sure no vignetting occurred.

You can see some stretching on the right side of this image. The lines of the soffits could have been more equal if I had placed the camera in the center of the room. However, moving to the right would have meant losing the view down the hallway to the fireplace.

THE TABLE SETTING

This interior photograph is a good example of how to use the front-tilt adjustment and what its limits are. The subject plane extended from the near edges of the plates (I decided the backs of the chairs were not important) into the living room in the background. I used a 4 × 5 wide-angle camera with a 90mm *F*8 lens.

The front of the camera was tilted to bring both the plates and the small incandescent lights along the top of the frame into focus with the lens wide open. If I had tilted the lens any more, the lights would have gone out of focus, and it would have been difficult to make them sharp without going to *f*/45 or *f*/64. I wanted to use only an *f*/32 setting so my exposure would be short enough to allow me to make both a negative and a transparency before the dusk light outside the far windows completely disappeared.

Front-tilt dilemmas are commonly encountered in landscape and table-top photographs. In a landscape, trees would likely be the tall vertical objects, and in a table-top situation, a wine bottle is usually the problem. In both situations, as well as the one above, the front-tilt adjustment can only be made until the top of the vertical object just begins to go out of focus. Any objects behind the subject plane that extends from the foreground to the top of the vertical object, must be brought into sharp focus by using small *f*-stop settings.

© Dave Brooks

CHOCOLATE CAKE
by Dave Brooks

Dave Brooks made this photograph with a 4 × 5 camera and a 150mm lens for a magazine article. He used the front tilt adjustment to create a Scheimpflug relationship between the plane of the subject, the film plane, and the lensboard, and therefore aligned the plane of sharp focus with the plane of the film. He was then able to use an *f*-stop of *f*/16.5 rather than *f*/22 or smaller, an aperture that would have required either more light or a longer exposure.

Brooks also used some back rise to select the section of the image circle that was recorded on the film.

The lighting was a combination of available light from a window and two strobe heads, one bouncing off a white ceiling for general fill and one in a softbox adding to the strength and directional effect of the window light.

MODEL CINDY CRAWFORD
by Timothy Greenfield-Sanders

This straight-ahead shot of model Cindy Crawford was made by Timothy Greenfield-Sanders in a New York City studio. The 20 × 24 Polaroid camera is one of the largest cameras capable of using "instant" Polaroid film. There are five of these cameras in existence. (Believe it or not, this camera has actually been taken on location.) The "normal" lens for this camera is 600mm or 24″. The camera sits on a movable stand so that it can be repositioned for framing purposes. Oft-used *f*-stops are *f*/32 to *f*/64. The film speed of Polaroid color film is 80 to 100. Greenfield-Sanders used strobe lighting to match the daylight-color balance of the film. The use of this camera has become very stylish and the images are frequently left completely uncropped so that the uneven edges show.

© Timothy Greenfield-Sanders

UNITED STATES POST OFFICE
STOCKTON. CALIFORNIA 95213

THE POST OFFICE

Architectural photography is one of the specialties available to the photographer who can handle a view camera and likes working with both natural and artificial light in a variety of settings. Architects are very demanding clients—they expect a great deal of professionalism, perfectionism, and creative ability from a photographer. However, they are also very dependent on good photography so it is possible to build a long-term relationship with an architect client if you can handle the work.

This project was photographed both for the architect's portfolio and for an architectural awards program. I made this image on daylight color transparency film, an internegative was made in the lab for large display prints, and 35mm color slides were duplicated from the large transparency. Any good professional quality color lab can make 35mm slide "dupes" from either large transparencies or color negatives.

To make this photograph I used a 4 × 5 wide-angle camera with a 90mm lens. A slight amount of front tilt brought all the near and far points into sharp focus. The flag pole was far enough away that it didn't extend beyond the area of sharp focus even with the front tilt.

The key to this photograph is the interior and exterior lighting and the way the camera's placement emphasizes the building's lines.

The interior lighting was all fluorescent. Although this type of light source seems to produce a white light to the eye, it records very blue green on color film. Consequently, varying amounts of magenta, yellow, and red color-correction filters must be placed over the lens to neutralize the blue-green cast, from fluorescent light.

If the only light source was the fluorescent lights and the image was being made on negative material, the film could be exposed unfiltered and the color correcting could be done in the printing. However, with two different colored light

sources, fluorescent and daylight, each one must be corrected for the film being used, either daylight or tungsten, in order for the image to have the right color. Of course with transparency film, all light sources should be corrected for the color balance of the film. Color-correction charts for various light sources are available, but the best procedure is to make test exposures to check the actual amount of filtration to use for any given artificial light source.

This photograph began before sunrise when an exposure was made to place the interior lobby area in Zone VII. Because of the low-light level and the necessary color-correction filters, this resulted in an exposure of 9 minutes on the daylight transparency film. The dark sky prevented any of the exterior of the building from registering on the film during this first exposure. After this exposure was completed, I had to wait until 30 minutes or so after sunrise to make a second exposure with a polarizing filter to record the exterior of the building and the landscape on the film. During this waiting period, all the concrete and asphalt was wetted to make a cleaner-looking material, reduce the stains on the asphalt, and create a reflective surface in front of the building.

Because of the timing of the exposures, only one sheet of film could be exposed for this image. If a mistake had been made part way through the process, if the tripod was bumped while waiting for daylight, or an exposure miscalculation had been made, I would have had to redo the entire procedure the next day. However, this technique is used by architectural photographers throughout the country, and with care and attention to detail this type of photograph can be made without too many problems. This procedure is a great deal of work but gives the building a much more three-dimensional feeling than a single daylight photograph of the same subject.

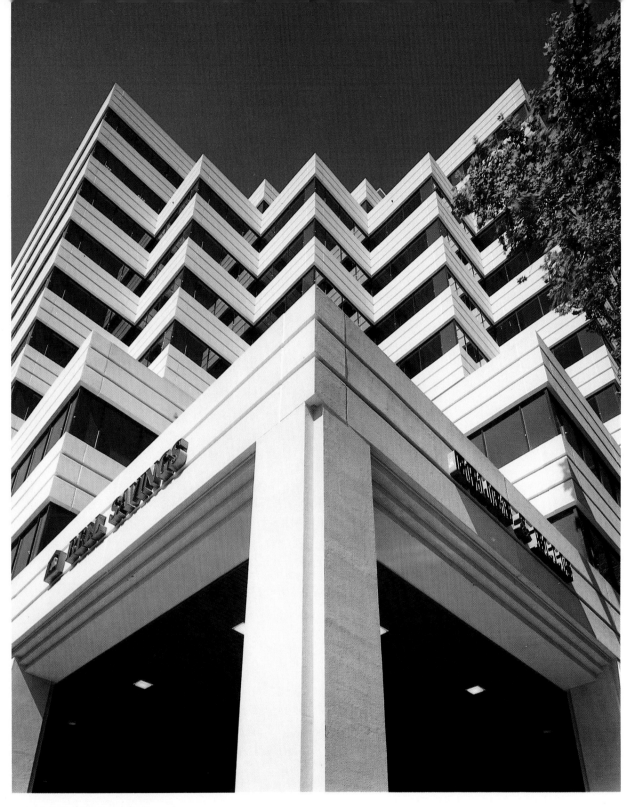

ARCHITECTURAL EXTERIOR

There are times when it is not always appropriate to correct for convergence on a tall building. In fact, some creative convergence can be very pleasing to the eye and create a feeling of real height and drama. It is important to make sure the viewer knows that a convergence effect was done intentionally and not by accident. If the convergence is subtle and the sides of the building are too close to the edge of the frame (the latter highlights any lack of parallelism), the result can look as though the photographer just missed and wasn't paying enough attention to the task at hand.

To make this photograph I placed myself on the sidewalk and aimed the camera severely upwards to emphasize the height and design of a fourteen-story building. The architect had created this sawtooth design to increase the number of corner offices that demand higher rent, and it was important to call attention to his work. I used a small amount of front tilt to ensure the entire building would be in focus. The camera was a 4 × 5 wide-angle model with a 90mm lens.

THE HAND, COUNTY CLARE, IRELAND
by Dick Arentz

This photograph is a platinum print contact printed from a 12 × 20 negative. Often referred to as "banquet format," this format is undergoing a resurgence in popularity. Many of these older cameras were used by commercial photographers who photographed business and social groups in a banquet setting, with two or three rows of people lined up at the end of a room. The proportions of 12 × 20 were very close to the proportions of the people in the room. The photographs from these cameras graced the walls of many companies and fraternal organizations. Prior to the mid 1930s, before enlargers were in common use, contact printing was the only way to make a print. Because of this, finished prints were the same size as the negative.

The platinum process—also a contact printing process—is an older process than the silver method used by most black-and-white photographers today. Each piece of paper is coated with a light-sensitive emulsion made from a mixture of platinum and palladium with several other chemicals. The negative is then laid on the paper and held tightly against the paper's surface while light is shown through the film. The light source can be anything with ultra-violet wavelengths, either the sun or an artificial source. Exposures typically take several minutes. (See the photograph by Frederick Evans on page 128, also printed with the platinum process.)

One of the appealing qualities of a platinum print is its very long, gentle tonal scale. Another characteristic is rich, warm tones, rather than the cooler tones of the silver print. The paper used with platinum printing is frequently a watercolor type of material with some texture.

When framing a platinum photograph, you can allow the brushmarks around the edges to show, as seen here, as an artistic statement. Otherwise, you can frame the photograph so that the brushmarks are hidden by the frame or overmat.

© Dick Arentz

© Frederick Charles

ATRIUM POOL AND WORLD TRADE CENTER, NEW YORK CITY
by Frederick Charles

One of the secrets to a good architectural photograph is to make it look easy and natural, hiding all of the work and thought that goes into it. For example, a great deal of thought about lighting, camera position, and manipulation went into making this natural looking scene.

The camera used was a 4 × 5 monorail style with a 65mm lens. The 65mm lens is very wide for the 4 × 5 format and because of the short projection distance between the lens and the film plane, it has very little coverage. Front-rise capability is only a millimeter or two before vignetting (dark corners) begins to occur, caused by the rise adjustment moving the image circle off of the film area. In extreme situations such as this, the coverage ability of the lens is frequently inadequate. Consequently, Charles used the technique on page 51, which describes how to utilize the desired front rise necessary, to make this photograph.

This technique of tilting the lensboard backward rotates the image circle back down to the film area and eliminates any vignetting in the upper areas of the scene. The back of the camera and the film plane must stay exactly perpendicular so that all vertical lines in the scene are recorded as being vertical on the film. The swing or (in this case) the tilt movement of the lensboard does not affect the shape of any objects in the scene.

Looking through a lens stopped down to *f*/45 is very difficult, even with a magnifier. One of the many uses of Polaroid film is as a proofing material prior to shooting with the actual film. In this case, Charles used Polaroid's Type 55 Positive/Negative material and processed the film on the spot. He then took a magnifier to the negative and checked the top and bottom of the film to make sure everything was in focus before exposing the transparency film.

LOBBY ATRIUM

Wide-angle lenses are commonly used in architectural photography to open up interior spaces and show more than what can be seen with a more typical focal length. In this case, I used an old Grandagon 58mm lens on a 4 × 5 camera. This is an extremely wide lens for the 4 × 5 format and is the shortest lens that will cover this format. This Grandagon was actually designed for an old 6 × 9 camera, but careful use allows it to be employed on a 4 × 5 camera. The optical center of the lens must be lined up precisely with the center of the film area, which means that no rise and fall or shift movements can be used on either the front or the rear standard. With a lens of this short focal length, swing and tilt movements for the Scheimpflug effect were not necessary as *f*/16 brought everything from two or three feet to infinity in focus.

To make this photograph, I carefully placed the camera in the exact position desired. I was not able to use any of the camera's movements to change the framing, so both the camera's left-to-right position and the vertical height had to be precisely correct.

As with most interior photographs, a great deal of cleaning and arranging had to be done to make this photograph. This medical office building is busy six days a week, from 7AM to 8PM. Consequently, I photographed this space early on a Sunday morning.

The exposure was timed so that the windows would have the same or just slightly less brightness as any white, light-washed interior walls. The camera was set up about an hour before dawn as the view is to the east. I made frequent careful meter readings as the outside light increased so that the film could be exposed at just the right moment to achieve the desired balance between the interior and exterior values.

CORPORATE BROCHURE

This photograph was made for a corporate brochure in which an eye-care insurance company wanted to emphasize its latest state-of-the-art equipment. The photograph was made with models in an optometrist's office. It would have been easier to do it in a studio, but it was not possible to move this piece of equipment. A lot of corporate and industrial photography must take place on location, which means that the camera and lighting equipment must be flexible enough for a variety of settings.

The 4 × 5 view camera was chosen because the client wanted the quality rendered by the larger piece of film. All the pictures in this brochure were done with 4 × 5 cameras to ensure a uniform look and quality reproduction throughout the brochure. I used a Cambo SCII monorail camera that has a complete set of movements.

My lens was a Fujinon Apochromatic 240mm F9 lens. This is a very sharp lens about 1.5 times the normal focal length for a 4 × 5 camera. By using a longer-than-normal lens I was able to back up from one subject and keep all the various elements in the scene in the correct size and shape relationships. If I had moved closer with a shorter lens, the doctor's left elbow would have increased in size more rapidly than the rest of the scene because it is the closest object to the camera. The camera position was slightly lower than the center of the subject, so a little front rise was used on the camera.

The strobe-lighting setup for this scene was relatively simple and consisted of just three lights. The main light was a 24 × 30 inch softbox suspended above and slightly behind the subjects. It was carefully aimed so that none of its light would fall on the background. The second light was flashed through a white umbrella to the left of the camera and aimed at the subjects. It provided enough light to fill any shadows from the softbox, making them open and easily readable. The third light was placed on the floor behind the subjects

and aimed up at the neutral-gray background. It was covered with an orange gel material.

The exposure was carefully worked out with Polaroid Type 52 film. The models were coached by showing them the Polaroid prints, which helped them position their hands and maintain the desired expressions on their faces. After everything was worked out, the lens was opened one-and-a-half stops, to account for the difference in film speed between the Type 52 film (ISO 400) and the daylight Ektachrome 200 (generally rated at ISO 160), and the exposure was made with one "pop" of the flash.

THE RED FERRARI
by Penina Meisels

The 4 × 5 camera may be the most frequently used view camera in studio and commercial photography, but the 8 × 10 is still well respected when large display prints or posters are the ultimate end product. This image, made to be an advertising poster for a ski-rack company, was photographed with an 8 × 10 monorail camera and a 240mm (slightly wide-angle) lens.

Because of the straight-ahead nature of the subject, it wasn't appropriate to use tilt and swing adjustments for the depth of field necessary. Instead, Meisels opted for an aperture of f/45. The wide-angle lens was chosen because the tight space in the studio included the car, extensive lighting equipment, and reflectors to produce an even red color across the car. The reflectors also prevented the studio from being reflected in the car's highly polished finish.

The test images checking for exposure, unwanted reflections, and composition were made on Polacolor ER 8 × 10 film. This is a very expensive material, but it was essential in this situation. Once the perfect Polaroid was obtained, the final image was made on daylight 100 transparency film.

CHEW KEY STORE
by Daniel D'Agostini

This photograph was taken inside an old Chinese pharmacy and herb store in Fiddletown in the gold country of California. The Chew Key Store is the last free-standing rammed-earth adobe building in California, and it has a great deal of historical significance. To make this image D'Agostini used a 4 × 5 field camera with 12 inches of bellows. The lens was a 210mm/8¼" F/5.6 lens used at f/22.

Making this photograph was comparable to copying flat artwork. The subject was an interior wall covered with several layers of weathered paper, an old calendar, and other decorative items. The subject is primarily two dimensional, so it was possible to set the camera up squarely in front of the wall. Although the true shape of the wall was not necessarily important in this case, it usually is when photographing paintings. Consequently, the usual practice is to set up the camera so that the film plane and the plane of the wall are parallel. By keeping the film plane, the plane of the lensboard, and the subject plane parallel, it is possible to use a relatively wide aperture on the lens and still keep the image sharp from corner to corner.

Because of the short camera-to-subject distance, the bellows was extended the full 12 inches in order to create a sharp image on the groundglass. This was 50-percent more than the infinity-focus extension for the 210mm/8¼" lens and necessitated one stop more exposure than usually required by this film.

The lighting for this photograph was a 2 × 3 foot softbox put on the left of the camera and a large white reflector board positioned to the right of the camera. The exposure was calculated with a flash meter so that all four corners received an equal amount of illumination. The meter was set at 25 to compensate for the bellows extension factor which was 2. The film was Fujichrome 50 balanced for daylight or strobe exposures.

© Daniel D'Agostini

© Janis Tracy

WINE AND CHEESE
by Janis Tracy

This Polacolor transfer print was made with an 8 × 10 camera, a 300mm lens, strobe lighting, and daylight-balanced film. The photographic materials used here have become quite popular in the last few years.

The Polacolor transfer process is a contact process in that the size of the film in the camera dictates the size of the final print. In this case, Polaroid color film is placed in a Polaroid holder, and the exposure is made onto this film. The film is removed from the holder and processed as normal except that instead of the normal 60-second processing time, the film package is opened after only 15 to 30 seconds. The still moist and processing print is then quickly pressed against a wet watercolor paper and left in contact with the paper for several minutes. The image transfers from the Polaroid material to the watercolor paper. The result is a somewhat muted and soft-focus looking photograph that works very well for some applications. The rough edges around this print are frequently left visible as an artistic statement.

FRESH VEGETABLES
by Dave Brooks

This table-top photograph is typical of the food photography done in studios across the country. This image was made for a magazine article, and the art director expected to receive a 4 × 5 transparency for the reproduction process. Brooks used a 4 × 5 monorail camera with a 90mm lens; the short lens allowed him to move in closer to the scene to fill the frame. This close camera position forced the perspective by slightly enlarging the size of the tomatoes in relation to the asparagus and the bell pepper. The bright color of the tomatoes also helped emphasize them. Brooks used a little front-tilt movement to ensure sharp focus across the subject plane.

The best approach to photographing either a natural or man-made scene is to select a camera position that places the objects in the desired relationship to each other—closer for a stronger, or slightly forced, perspective that emphasizes the near objects, or farther away for a more gentle perspective that equalizes the size of the objects in the scene. The question of perspective is a delicate one and must be worked out individually for each photograph.

The lighting in this scene was an overhead soft box containing a strobe light and several white reflector cards used around the edges of the set to bounce light into the shadowed areas. Once the exposure and composition was worked out with Polaroid Type 52 Film, the photograph was made on daylight-transparency film.

© Morley Baer

RANCHLAND, SAN LUIS OBISPO
by Morley Baer

Morley Baer made this photograph with an old wooden 8 × 10 field camera and a Goerz Artar 480mm/19″ lens. The Artars are apochromatic lenses and are a favorite among many of the 8 × 10 landscape photographers. They are very sharp and yet produce a smoothness across the tonal scale unmatched by other lenses. Using a long lens—1.6 times the normal length of 300mm/12″—shortened the distance between the rocks on the lower right and the peak in the distance. The front was tilted forward because the subject plane moved away from the camera in a horizontal direction.

The front-tilt adjustment helped align the focal plane with the receding subject plane. It is actually possible, especially with these longer lenses, to watch the subject plane come into sharp focus on the groundglass while using the front-tilt adjustment.

The exposure was made on Kodak tungsten-balanced Ektachrome film. This film is intended for use indoors but it can be corrected for a daylight exposure by using a #85B filter on the lens. This approach is favored by some photographers because the result is a warmer image than that produced by the daylight-balanced Ektachrome films. The softer contrast was created by giving the transparency one stop of overexposure and a less-than-normal development at the color lab. Rather than going for the deeply saturated color frequently favored by color photographers, Baer chose to obtain a softer, warmer interpretation more in keeping with his feelings about the California landscape.

The exposure was worked out with Polaroid Type 52 film and electronic-flash equipment. When the basic exposure was determined for one "pop" of the strobe, the aperture was closed down from ƒ/22 to ƒ/32, and two "pop"s were done, one with the girl in place and one without her. The foot of the person leaving the scene on the right belonged to my assistant. She had to hold very still for both exposures. After several practice exposures were made with the Polaroid film, I opened up one-and-a-half stops and used daylight-balanced Kodak Ektachrome 200 film to make the photograph used on the cover of the magazine.

THE VIOLIN AND SAXOPHONE

This photograph was made for a poster promoting a music festival sponsored by a local college. I used a 4 × 5 monorail camera with a 180mm lens. The instruments were placed on a background of dull black velvet on a platform about 18 inches from the floor of the studio. The camera was positioned on a tripod as close to the platform as possible and then aimed severely downward to give the appearance of being on top of the instruments. The careful viewer will note that the camera is actually above the lower (and partially unseen) section of the violin.

Three camera adjustments were used to create this composition. The front rise was used to include more of the saxophone. It was at the top of the frame and only appeared minimally in the groundglass with the adjustment in the neutral position.

The second adjustment was the back tilt, used to change the size relationships between the instruments. Because the camera was positioned above and closer to the violin, its size and shape dominated the image. When the top of the film plane (where the violin was being recorded) was tilted closer to the lens and the bottom of the film plane (where the saxophone was being recorded) was moved farther from the lens, the size of the violin decreased and the size of the saxophone increased. The amount of the back tilt employed was an esthetic decision; I simply tilted until the proportions felt right to me.

The third adjustment was a front tilt toward the subject plane that was moving away from the camera position. The front was tilted until the image looked relatively sharp from edge to edge and corner to corner with the lens wide open at ƒ/5.6.

The relatively small reproduction ratio made the depth of field a little bit of a problem. However, using the front tilt adjustment and an aperture of ƒ/32 ensured a crisp, clean image.

Lighting shiny round objects can be really difficult. Strobe lighting was used to illuminate this subject. In this situation, I found it necessary to build a white tent of reflector boards, sheets and backdrop material to minimize any telltale reflections of the lights, the camera, or the photographer. Polaroid exposures were made many times to check for unwanted reflections, instrument positions and proportions, and exposure before any "real" film was exposed. The final exposure was made on both black-and-white and daylight color transparency film.

THE FORGOTTEN LITTLE GIRL

This photograph illustrated the cover story of a local magazine. The topic was the forgotten foster children in the area. The art director called me because he wanted someone who could work with a 4 × 5 camera since the image had to be enlarged for the full 10 × 17 inch cover of the magazine. I used a Fujinon 125mm F8 lens, a gentle wide-angle lens on a 4 × 5 camera. I chose this focal length because it was the longest lens that could incorporate all of the important elements of the scene yet still allow me to work in the relatively cramped space of the shooting location. Because the girl was seated squarely in front of the camera, it was not necessary, or even possible, to use any of the camera's movements.

Obviously, this photograph is a double exposure. One exposure was made with the girl in the chair and a second one was made without her. Another advantage in using the view camera is the ease of making multiple exposures. The shutter-cocking mechanism is not in any way connected to the film holder, so the shutter can be tripped as many times as necessary without any fear of moving the film. This assures exact registration among the layers of exposure made on the film.

AUTUMN COLOR

This photograph was made with a 4 × 5 field camera and a 180mm (normal) lens. A slight amount of front-rise adjustment created the right balance between the foreground and the tree.

The film selected for this photograph was Kodak Ektachrome 64. Both this slow film and Fujichrome 50 have excellent reputations for producing very clean, crisp images with good color saturation. The color saturation was enhanced by putting a polarizing filter on the lens. A polarizing filter eliminates many of the reflections inherent in most scenes and allows more of a subject's color and tone to come through on the film. It creates about a two-stop loss of light. I only used it in this scene because the air was so still I didn't need a very fast shutter speed. The meter-indicated exposure was for 2 sec. at $f/22$, and the actual exposure was for 3 sec.

I made this photograph on an extended trip during which I used a great deal of color and black-and-white film. This necessitated loading and unloading film holders at night and bringing along several empty film boxes to store the exposed sheets of film. An alternative to the Ektachrome would have been Polaroid Polachrome transparency film. This 4 × 5 film rated at ISO 100 can be used in a standard Polaroid instant film holder. The transparency film and its protective covering is inserted into the holder, the protective covering pulled out, the film exposed, and the protective folder is reinserted into the holder. At that point the film can be removed from the holder and stored in any available box that doesn't have to be light-tight, until you return home or find a color lab to do the processing. Using this film eliminates the necessity of unloading and then reloading film holders every night.

FREEMARK A

THE WINE GLASSES
by Kent Lacin

This studio photograph was made as a personal assignment and promotional piece for the photographer. A 4 × 5 monorail camera with a 240mm lens was used. The camera was carefully positioned beneath the tops of the glasses so all the top rim would show all the way around the edge. A very slight amount of front swing was used to move the focal plane into closer alignment with the primary plane of the scene that extended from the nearest glass on the right to the far edge of the glass on the left. It was still necessary to use $f/32$ to obtain enough depth of field from the front glass to the rear edge of the large center glass.

The scene was lit with a small softbox on the left of the camera. The soft box is reflected on the left sides of the glasses. It was positioned carefully to define the edges of the glasses and the wine bottle. The primary light source was a light behind and below the wine glasses. Small, white reflector boards were discreetly placed around the scene to bounce light into the shadows that seemed too dark. The wine was diluted 50 percent with water to lighten the color and make the fluid more translucent. The nice bubbles in the small glass were blown into the wine with a straw just before the scene was photographed.

THE RECEIVER
by Don Satterlee

Photographs such as this are the bread and butter for a good studio photographer who is not only adept at handling the camera but clever with lighting. Sometimes the photographer develops the concept; on other occasions an art director or client sketches the scene, and the photographer is asked to interpret the image on film.

This receiver controls a satellite dish for television reception. The client asked Satterlee to come up with a space-age looking image for a large display photograph and possible reproduction in a sales brochure. In large cities photographers are frequently selected for a job based on their ability to work with a certain type of subject or because of their style.

Studio work can involve several hours or several days of set building before any photographic work is done. Here the receiver was supported by a long "L" brace that was connected to the background and overlaid with a smooth plastic material. The planets are blue balls on wooden dowels that also extend out into the set from the background. Satterlee positioned a 4 × 5 monorail camera with a 150mm (normal) lens, so that none of the braces or dowels would appear on the film. This type of planning must be done carefully so that the set doesn't have to be rebuilt or modified, which would add several hours to the shoot.

The black background was covered with tiny holes for light to shine through, thereby simulating stars in the sky.

Because the distance from the front of the receiver to the background was too great to obtain critical sharpness even

© Don Satterlee

when the lens was stopped down to $f/45$, the receiver, the planets, and the stars were all lit individually and recorded onto the film with separate exposures. Satterlee put pencil marks along the monorail to tell himself where to position the rear standard in order to achieve sharp focus for each of the objects. These focus points were carefully determined and many Polaroid exposures were made to check the lighting and the size relationships between the objects. Some studio-oriented monorail cameras have index marks along the monorail to assist in this process.

After all the tests were made, the final image was recorded onto the film. First the receiver was focused, lit and exposed; then the rear standard was moved to the predetermined point for sharp focus of the planets, and they were lit and exposed; and finally the rear standard was moved to the focus point for the stars, and they were lit and exposed.

© Kent Lacin

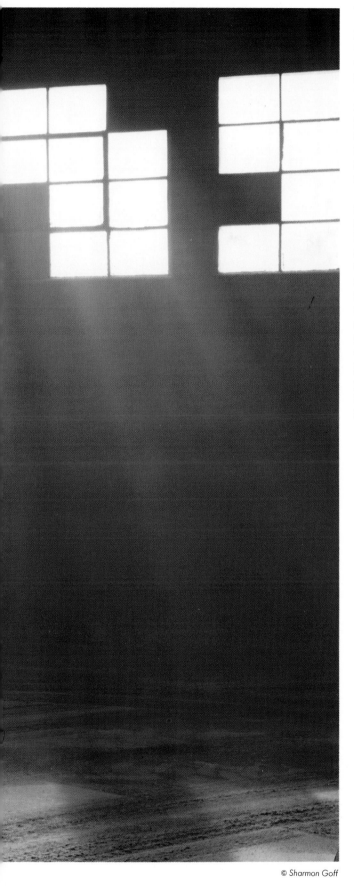

© Sharmon Goff

WEST SACRAMENTO WAREHOUSE NO. 2
by Sharmon Goff

Color work with the view camera is not limited to only commercial, studio, architectural, and portrait work. Many fine-art photographers working with color materials also use the view camera for the opportunity to work with the larger negative, to exert some control over the exposure and processing of each individual negative, and because of the adjustments that can be used in many situations. Zone System controls aren't as effective with color photography as they are with black-and-white material, but opportunities for manipulating the exposure and development do exist.

To make this image the photographer put the important shadow areas in Zone IV, which meant that the sunlight streaming through the windows landed in Zone X or XI. This kind of high-value placement generally results in window areas and streaks of sunlight registering as blank white on a color print. To lower the high values, Goff gave the daylight negative film a N − 2 development, which mean that the negative was given less time in the developer tank during the color-developing process. This reduced development allowed the sun streaks to record on the image with some feeling of substance. Because the windows were clear, it was not important to try and show detail in the clear glass. It takes making some tests and consulting with a good color-processing lab to work out the specifics of this type of film treatment, but the results can be worthwhile by making some seemingly impossible situations easier to handle.

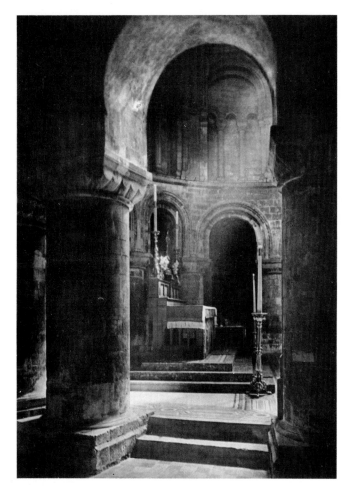

ST. BARTHOLEMEWS THE GREAT, 1917
by Frederick Evans

Frederick Evans was an English photographer best known for his pictures of English cathedrals. Most of his work was done between 1895 and 1910. Evans used a variety of cameras, including an 8 × 10 and a 4 × 5 (these are still called 10 × 8 and 5 × 4 cameras in Britain), a 6½ × 8½ (referred to as a plate or full-plate size), a 4½ × 5½ (a half-plate camera) and a 3¼ × 4¼ (a quarter-plate camera).

Evans was a strong advocate of using the longest lens possible in any situation and giving the negative full, complete exposure. He wanted detail and textural information throughout the tonal scale of the print, and always gave his negatives plenty of exposure. He made platinum rather than silver prints (today most of us use the latter for black-and-white images), which helped extend the tonal range of his prints. The platinum print creates a very long, delicate tonal scale.

EFFIGY IN DURHAM CATHEDRAL

Whenever I feel a little overwhelmed by a subject, I put my camera and tripod down and just walk around until I can get a feel for what I am seeing and experiencing. After an hour or so spent contemplating Durham Cathedral in England, I began to focus my thoughts on this area of the interior. The strong vertical lines of the columns, the pattern on the near column, the position and the pose of statue on the monument, the light coming through the window, and the darkness in the recessed spaces all attracted my attention.

After locating my spot, I set up my tripod and 4 × 5 monorail camera and selected a 180mm lens. I tried this on the camera, but it included too much of the scene, so I narrowed my angle of view by trying a 240mm. This lens included all of the important elements and excluded the extraneous ones, so it was the one I used to make this photograph. My first camera adjustment was raising the front. This allowed me to include the top of the window in the frame and exclude some people seated in the pews.

The 240mm lens, the 4 × 5 format proportions, and the camera position worked to give me just enough room top to bottom to include everything I wanted in the frame. However, I still had some empty space to the left of the left column, and it wasn't doing anything for my composition. I couldn't move closer because I would have lost either the top of the window area or the bottom of the monument. Consequently, I used the back-swing adjustment to enlarge the left column until it filled the left side of the frame.

As a result of the back swing, the right and left edges of the frame went badly out of focus. I corrected this by swinging the front of the camera about 14 degrees to the right. (My camera has degree marks for swings and tilts, but it is generally possible to see the image come into better focus across the groundglass so the markings are not essential to performing these adjustments.) The imaginary lines extending from the subject plane, the film plane, and the lensboard now all met at a single point to the right and slightly behind the camera position. Using the swing adjustments, I was able to take advantage of the Scheimpflug Rule. I still chose to use an aperture of $f/22½$ to make sure the window area and the stonework on the wall were included within the depth-of-field area.

I metered several areas of the scene very carefully. The front of the monument registered a 5, the sunlit window and portion of the left column registered a 10, the lower areas of the columns registered a 5, the upper areas of the columns were a 4, and the recessed area above the window registered a 4. This six-stop range (Zones III to IX) called for an N − 1½ exposure and development to bring the high values down to Zone VII½ where they would show the detail and texture I wanted in the final print.

With my film and film developer combination an N − 1½ development requires an additional two-thirds stop of exposure, so my film speed was lowered from 125 to 80. As a result of these manipulations, my exposure time was 90 sec. (my meter indicated 15 sec., but the correction for reciprocity failure necessitated an additional 75 seconds for Kodak Tri-X sheet film).

Printing the negative involved several manipulations. The front of the monument was dodged for 50 percent of the basic exposure, the line of sun on the left column was burned 100 percent (twice the initial exposure), the window recession was burned 100 percent (twice the initial exposure), the upper central area was burned 100 percent, and there was some burning along all four edges. Some of this burning resulted from a failure to shorten the development, which would have controlled the contrast increase that occurs when film is exposed for longer than one second.

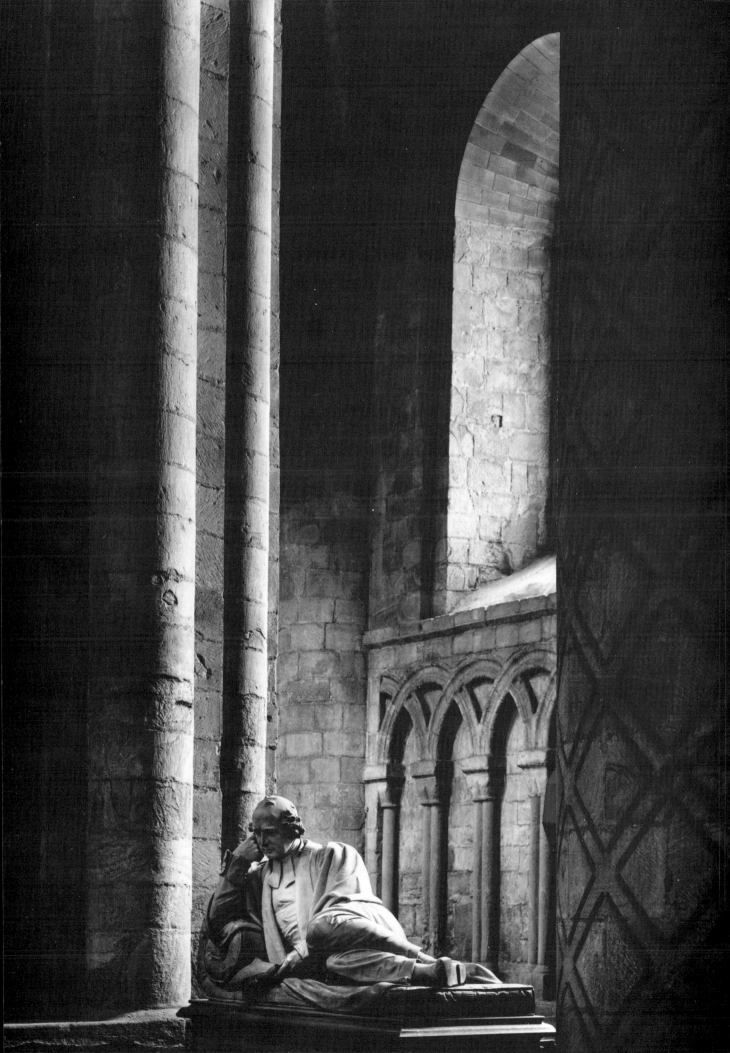

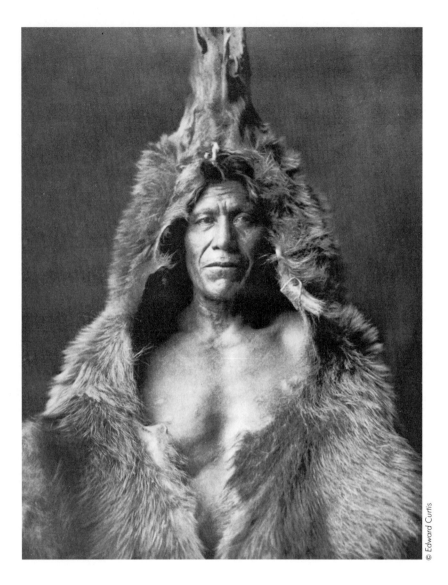

© Edward Curtis

BEAR'S BELLY, ARI-KARA circa 1903
by Edward Curtis

Edward Curtis was a commercial photographer in Seattle, Washington, who became fascinated with the vanishing American Indians. He worked feverishly from the 1890s through the 1920s to record what he felt was a vanishing way of native American life culture.

Curtis used a variety of cameras during his career. He did his early work with a 14 × 17 glass-plate camera, but by the time he made this photograph, he had settled on a 6½ × 8½ full-plate Premo view camera. This camera was made of mahogany and had brass fittings and a leather bellows. It featured front rise, fall, and shift adjustments as well as back tilt and swing. Like many of his contemporaries, Curtis worked before exposure meters were available. He calculated his exposures based on his experience and was aided by his ability to print images from less-than-perfect negatives.

When Curtis made this photograph, he was able to use dry-glass plates. The old wet plates had been replaced by this new technique for creating a light-sensitive emulsion. Dry-glass plates could be purchased or prepared by the photographer in the darkroom before being taken into the field. This innovation made the photographer's task much easier. However, glass was still used as a backing, so the problems involved in transporting these plates to and from the field still remained. Many of Curtis' plates were broken during his trips into Indian country.

ROY ELLENSBURG
by Marsha Burns

This photograph was made with a 210mm lens on a 4 × 5 camera. The setting was outdoors and natural light was the only light source. The rough edges around this photograph again indicate the use of Polaroid film. In this case, it was Type 55 Positive/Negative film. This product provides you with both a positive (print) and a negative that can be used to make additional prints at a later time.

© John Palmer

SAGRADA FAMILIA (SACRED FAMILY), ALBUQUERQUE, NEW MEXICO
by Kirk Gittings

Extreme front rise was used on a wooden 4 × 5 field camera to make this photograph. In fact, the camera's body had to be aimed upward and the tilt movements on the front and rear standards were used to make them vertical once again (see page 54).

The lens was a 210mm, and a 23A (medium red) filter was used to darken the blue sky and accentuate the white clouds and light-colored statues.

© Kirk Gittings

TIBETAN MONK
by John Palmer

Environmental portraiture with available light is generally not done in large format, but actually the view camera can create memorable portraits when it is used with care and sensitivity. This portrait was made with a monorail camera and a 150mm lens. No adjustments were used on the camera. The film was Ilford HP5, and the exposure was 1/15 sec. at f/22 1/3.

One of the advantages in using a view camera for this type of work is that the photographer can't peer at the subject through the camera because the film holder blocks the view through the groundglass. Instead, once the basic composition is created, the photographer can interact directly with the subject and concentrate on developing personal rapport.

SACRAMENTO, CALIFORNIA

I made this photograph with an 8 × 10 camera and a
120mm lens. This is an extremely short lens for an 8 × 10
camera and is the equivalent of a 58mm lens on the 4 × 5
format. The only lens of this focal length that will
adequately cover this format is made by Nikon. In this
situation, although I tilted the lensboard back, my use of
front rise caused some vignetting in the top corners of the
image area.

When using a lens this short, a wide-angle bellows is
almost essential if any camera movements are going to be
utilized. Otherwise, the camera's normal pleated bellows
will be so tight and compressed that they will restrict the
camera's adjustments. The exposure was ⅛ sec. at f/32. A
#21 filter was used to darken the blue tones in the sky.

OLD CHAIRS

Bodie is a ghost town in the eastern Sierras that has been
photographed by many people. It has been taken over by the
California Department of Parks and Recreation and is being
left in a state of "arrested decay," which means that only
enough maintenance is done to prohibit further dilapidation.

I photographed these old chairs using a Galvin 2¼ × 3¼
camera and a Fujinon 150mm lens that is 1.5 times the
normal focal length for this size camera. The film was Ilford
FP4 sheet film that I exposed at an E.I. of 64.

In this image there are two primary planes that had to be
focused: the floor of the porch that moved away from me on
a horizontal plane, and the wall of the building that moved
away from me on a vertical plane. Because I had a relatively
slow film and was completely in the shade, I wanted to use
as wide an f-stop as possible to keep my exposure time as
short as possible. This necessitated using two front-camera
movements.

To keep the floor of the porch in focus, I tilted the front of
the camera forward. The tilt was about 15 degrees, and it
gave me sharp focus along the porch floor even though the
lens was almost completely wide open. To keep the vertical
wall in focus, I swung the front of the camera about 15
degrees to the right. This gave me sharp focus along the
wall with the lens wide open.

I found I needed to stop the lens down to f/16 because the
height of the chairs presented an additional depth-of-field
problem that couldn't be solved by the camera movements.
However, using the movements saved me at least one f-stop
and allowed me to use a shutter speed of ½ sec., so I
avoided the problem of reciprocity failure in the film.

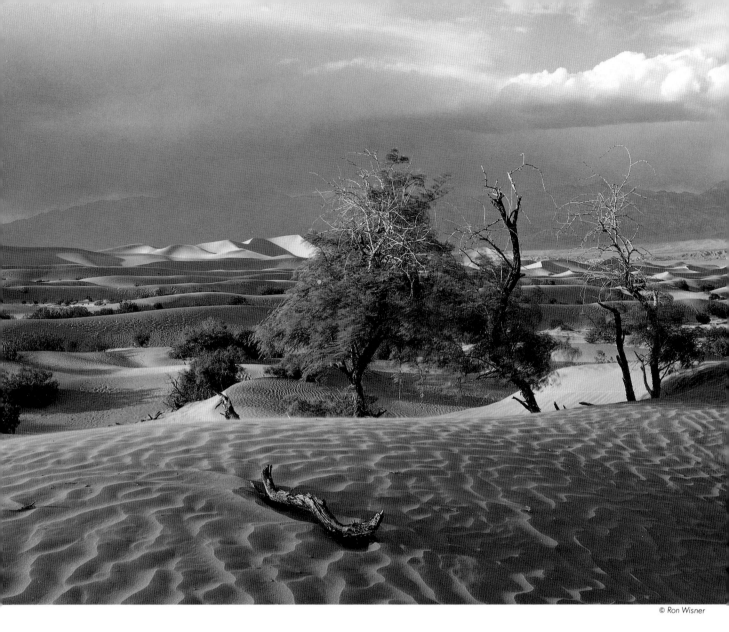

© Ron Wisner

DEATH VALLEY
by Ron Wisner

This photograph was made with an older lens, a 10-inch Protar combination. Protar lenses frequently came in sets with elements that give several focal lengths depending upon the combination of elements used in front and behind the shutter. They have become a collectors' item and, consequently, are somewhat expensive.

As with all older, uncoated lenses, they produce negatives with less contrast and edge definition than those made from new, multi-coated lenses. Nevertheless, these older lenses have a devoted following.

To some extent it is possible to make up for their loss of contrast by developing the negative for a longer than normal time. However, the slightly softer edge definition remains, even with enhanced local contrast. The use of such contrast filters as light orange to medium red can also improve the contrast and apparent sharpness.

Some front tilt was used here to create a plane of focus that extended from the top of the near sand dune to the top of the distant mountain range. A #15 (light orange) filter was used to add some drama to the sky.

JIM GALVIN
by David Brooks

This photograph was made in the studio with an 8 × 10 camera, a 360mm lens, strobe lighting, and orthochromatic film. Orthochromatic film is primarily sensitive to blue and green light. It is only minimally sensitive to the red end of the color spectrum.

Today, the principal use of this film is for scientific purposes where red sensitivity is either unnecessary or undesirable. Historically, this film was used extensively for male portraiture, because the film's low response to red tones gave men a more weathered or swarthy appearance, as seen here. Orthochromatic film can be processed in any standard black-and-white film developer.

© David Brooks

© Jim Galvin

GLACIAL POLISH, McCABE LAKES
by Jim Galvin

This photograph was taken on a backpacking trip into the northeastern section of Yosemite National Park. It may sound awkward to carry a view camera into an isolated region several miles from any roads, but a 2¼ × 3¼ view camera is relatively small and compact. In fact, even with two or three lenses, two roll-film holders, an exposure meter, and a tripod, its weight is about the same as a good 35mm system with several lenses and a tripod.

The camera was a Galvin 2¼ × 3¼ with a 14-inch bellows and monorail. The lens was 210mm, twice the normal focal length for this size camera. The film was Ilford Pan F, a very sharp, fine-grained material with an E.I. of 32. Galvin used a little front-tilt adjustment to cope with the receding slope of the granite located across a small gulley.

He measured the tonal values in the shadows under the rocks with a 1-degree spot meter and found them to have a reading of 9. The smooth, sunlit granite, polished by glaciers several thousand years ago, had a reading of 15. This gave him a six-stop spread requiring a less-than-normal development time.

TREE AND CLIFF
by Gordon Hutchings

The real difference in the portability of the field versus the monorail design becomes apparent with the 8 × 10 camera. The 8 × 10 field camera is much more practical for landscape photography. These cameras generally have 24–36 inches of bellows, which means lenses up to 30 inches long can be used for general outdoor work.

This photograph was made with an 8 × 10 field camera and an Apo-Artar 600mm/24″ lens (twice the normal focal length for an 8 × 10 camera). A very slight amount of front rise was used. The long lens was necessary because the subject was across a small ravine.

Contrary to the general belief that photographs taken with the view camera are completed only after hours of diligent work, this image was made in just a few minutes. Hutchings realized that the area's feeling would change completely after the sun peeked over the cliff, which was imminent just a few moments after this scene was discovered. He raced back to his pickup truck, instinctively put the 24″ lens on the camera with a #12 filter (referred to as a "minus-blue" filter and used here because its deep-yellow color brought out the bright yellow and orange leaves at the bottom of the frame) and put a film holder in the camera. During the 150 yards back to the ravine from the pickup, he made his decisions about camera adjustments and the probable exposure and development of the negative. A quick meter reading confirmed his intuition, and there was time for only one exposure before the sun broke over the cliff and harshly lit the rock edges and the tree tops.

Hutchings used Ilford HP5 film to make this photograph with an E.I. of 320 that happens to match the manufacturer's ISO rating. He used an N + 1 development and printed the negative with only minimal edge burning.

BUNKER HILL RENEWAL PROJECT, LOS ANGELES 1982
by Ray McSavaney

The urban landscape has become a popular subject matter for many photographers. The almost complete rebuilding of the center of Los Angeles in the late seventies and early eighties offered a great many opportunities for photographers interested in contemporary architecture and urban design. The Los Angeles City Hall is the pointed building in the center of the scene.

This photograph was made with a 4 × 5 field camera and a 90mm lens. The camera was carefully positioned so that the camera back was level left to right and front to rear, making the vertical lines of the buildings parallel to the sides of the groundglass. Then the front-fall adjustment was used to include more of the excavated area in the lower center of the frame. McSavaney used $f/45$ because he needed tremendous depth of field to keep everything sharp and because the variety of planes and objects located in the scene precluded the use of any front swing or tilt adjustments. Depth-of-field problems in straight-ahead scenes such as this one must be solved by using smaller apertures.

The contrast range in this scene was severe. The meter reading in the dark areas in the lower center of the image registered a 3, and the brightly lit sections in the windows gave a reading of 13. McSavaney ignored the light fixtures because, in reality, they are blank white so he didn't make any effort to lower them on the print. The reading of 3, which was placed in Zone 3, required an exposure time of 15 seconds on Tri-X film rated at an E.I. 400. Adding in a correction for reciprocity failure increased the actual exposure to 98 seconds.

The film was developed in a Pyrocatechol developer that has a reputation as being very good for handling extreme contrast. This developer produces a long-scaled, low-contrast negative with good separation in the very high zones between Zone IX and Zone XII. With this developer, the Tri-X film seems to have a higher-than-normal E.I. of 400 rather than the more common 160. The formula for this developer is beyond the scope of this book, but the interested reader is invited to refer to *THE NEGATIVE* by Ansel Adams, (New York: New York Graphic Society, 1981). The one drawback with Pyrocatechol is its high level of toxicity. *Extreme* care is needed to prevent any of the dry powder or the developer solution from coming into contact with the skin, so Pyrocatechol does not make a good, all-purpose film developer.

This particular negative was developed for a shorter-than-normal time and was printed on a normal grade of printing paper.

© Ray McSavaney

INDEX

Steve Simmons is an architectural photographer based in Sacramento,
California. He has taught numerous workshops in large-format and architectural
photography and has written articles for various photographic publications.
Simmons' photographs have been included in many exhibits and publications.
Since 1988 he has been the publisher and editorial director of *VIEWCAMERA:
The Journal of Large Format Photography*.